THE RHETORIC OF POWER IN THE BAYEUX TAPESTRY

The Bayeux Tapestry has long been recognized as one of the most problematical historical documents of the Norman Conquest of England in 1066. As contemporary viewers are drawn into a medieval world of unresolved tensions and conflicted loyalties, they are still affected by the work's compelling but enigmatic "voices." More than a reinterpretation of the historical evidence, Suzanne Lewis's study explores the visual and textual strategies that have made the Bayeux Tapestry's narrative such a powerful experience for audiences over the centuries. *The Rhetoric of Power* focuses on how the Tapestry tells its story and how it shapes the responses of reader-viewers. This involves a detailed analysis of the way the visual narrative draws on diverse literary genres to establish the cultural resonance of the story it tells. The material is organized into self-contained yet cross-referencing episodes that not only portray the events of the Conquest but locate those events within the ideological codes of Norman feudalism. Lewis's analysis conveys how the whole 232-foot tapestry would have operated as a complex cultural "fiction" comparable to modern cinema.

Suzanne Lewis is a professor of art history at Stanford University. She is the author of *Reading Images: Narrative Discourse and Reception in the Thirteenth-Century Illuminated Apocalypse* (Cambridge, 1995), and *The Art of Matthew Paris* (Berkeley and London, 1987).

CAMBRIDGE STUDIES IN NEW ART HISTORY AND CRITICISM

General Editor:
Norman Bryson, *Harvard University*

Advisory Board:
Stephen Bann, *University of Kent*
Natalie Boymel Kampen, *Barnard College*
Keith Moxey, *Barnard College*
Joseph Rykwert, *University of Pennsylvania*
Henri Zerner, *Harvard University*

This series provides a forum for studies that represent new approaches to the study of the visual arts. The works cover a range of subjects, including artists, genres, periods, themes, styles, and movements. They are distinguished by their methods of inquiry, whether interdisciplinary or related to developments in literary theory, anthropology, or social history.

Other Books in the Series:

Bakhtin and the Visual Arts, by Deborah Haynes

Beyond Piety, by Jeremy Gilbert-Rolfe

The Enigmatic Body: Essays on the Arts, by Jean-Louis Schefer,
edited and translated by Paul Smith

Sexuality in Ancient Art, edited by Natalie Boymel Kampen

*The Western Scientific Gaze and Popular Imagery in Later Edo Japan:
The Lens within the Heart,* by Timon Screech

THE RHETORIC
OF POWER IN THE
BAYEUX TAPESTRY

SUZANNE LEWIS

CAMBRIDGE
UNIVERSITY PRESS

12/00 BĒT/50 —

PUBLISHED BY THE PRESS SYNDICATE OF THE UNIVERSITY OF CAMBRIDGE
The Pitt Building, Trumpington Street, Cambridge CB2 1RP, United Kingdom

CAMBRIDGE UNIVERSITY PRESS
The Edinburgh Building, Cambridge CB2 2RU, UK http://www.cup.cam.ac.uk
40 West 20th Street, New York, NY 10011-4211, USA http://www.cup.org
10 Stamford Road, Oakleigh, Melbourne 3166, Australia

First published 1999

Printed in the United States of America

Typeset in Adobe Weiss 11/14 pt., in Quark XPress™ [CRM]

A catalog record for this book is available from the British Library

Library of Congress Cataloging-in-Publication Data
Lewis, Suzanne, 1930–
 The rhetoric of power in the Bayeux tapestry / Suzanne Lewis.
 p. cm. – (Cambridge studies in new art history and
 criticism)
 Includes bibliographical references and index.
 ISBN 0–521–63238–2 (hb)
 1. Bayeux tapestry. 2. Hastings, Battle of, 1066, in art.
 3. Great Britain – History – Norman period, 1066–1154 –
 Illustrations. 4. Embroidery, Medieval – France. I. Title.
 II. Series.
 NK3049.B3L48 1999
 746.44'20433'0942–dc21 97-49255
 CIP

ISBN 0 521 63238 2 hardback

CONTENTS

CONTENTS

ILLUSTRATIONS

PREFACE

The Bayeux Tapestry is one of the most powerful pieces of visual propaganda ever produced; it is also one of the few medieval works of art familiar to almost everyone in the Western world. Given the ready availability of several thoroughly admirable books on the subject, as well as a steady output of highly informative articles on various aspects of the work, why another book on the Bayeux Tapestry? Scholarly books are generally written for one of two reasons – revision or innovation. Authors either seek to redress a perceived flaw in the extant literature or feel they have something new to say. This volume falls into the latter category. I have no quarrel with the splendid studies by Michel Parisse (1983), David Wilson (1985), David Bernstein (1986), J. Bard McNulty (1989), or Wolfgang Grape (1993). As the references cited in my text make abundantly clear, my book is built upon a thick foundation of extant work. Indeed, given the ready accessibility of so many complete reproductions of the work, I have limited my illustrations to the episodes and details analyzed in the text.

My present project takes another close look at a unique medieval work of art, both fascinating and still problematic to late-twentieth-century viewers. By focusing on the art of narrative, particularly within the framework of recent film theory, I want to show how history is not reflected in images but produced by them. The pictorial narrative of the Bayeux Tapestry presents not so much an illusion of reality but reality itself. Rather than attempting to explain the narrative in terms of historical "truth," I propose to explore the work as problematic fiction, shot

through with inconsistencies and ruptures. The narrative is analyzed not only in terms of what it presents but also in terms of what it leaves out. I argue that the Bayeux Tapestry's most powerful rhetoric lies in its silences and empty spaces.

I am interested in exploring how the narrative as a whole operates as a complex cultural saga rooted in strategies of storytelling. How did the Bayeux Tapestry make itself accessible to contemporary audiences by establishing the cultural resonance of its story within the framework of such well-known literary genres as epic, chronicle, and panegyric? Framed in terms of its reception, both then and now, the Bayeux Tapestry can be seen as a fabric woven into patterns of contingency and ideology. The events of 1066 are shaped according to the most basic codes of Norman feudalism.

Assaulted at every turn by sounds and images, words and pictures, we live in an age dominated by electronic and print media. Although medieval experiences of visual and verbal messages, especially those of "stories," were perhaps less relentlessly ubiquitous than ours, they were nonetheless both powerful and influential, shaping the ways in which people felt and understood their world. As I attempt to create a sense of an embodied "reader" within the narrative of the Bayeux Tapestry, I do so in the realization that the medieval world of communication was a realm not of mass media but of specialized, privileged discourses, addressed to small, targeted, elite groups within the hierarchy of the feudal system. Although we can draw meaningful analogies to techniques of mass media familiar to late-twentieth-century audiences, the Bayeux Tapestry was not a vehicle of popular culture but an elitist work addressed to a *culture savante*. As we shall see, the Bayeux Tapestry's rhetoric of power was dependent not only upon the operation of a complex culturally coded apparatus, both verbal and visual, but also, and perhaps even more critically, upon the active engagement of its contemporary audiences as producers of meaning.

I am grateful to many people for their support. I thank my colleagues Brian Wolf and Michael Marrinan for their helpful suggestions on reading an earlier draft of the book. Special thanks go to the graduate stu-

dents in my seminars in the Stanford Art Department and the Graduate Program in the Humanities for their spirited and encouraging responses to my ideas about the Bayeux Tapestry. I am grateful to the School of Humanities and Sciences and the Art Department at Stanford for subsidizing the photographic and reproduction costs for the illustrations.

MEDIEVAL AUDIENCE, PERFORMANCE, AND DISPLAY

T HE 232-FOOT-LONG STRIP OF EMBROIDERY known as the Bayeux Tapestry gives an account of an event that had just occurred – the Norman conquest of England in 1066. In the retrospective view offered by this remarkable pictorial narrative, however, the Battle of Hastings was not meant to happen.[1] When seen in the context of wider Norman ambitions, England seems different only because it was an outright military conquest. If a more characteristic strategy had been allowed to follow its course, the increasingly close bonds between England and Normandy would have been sufficient to guarantee William's claim to become the legitimate successor to the English throne. As unanimously insisted upon by Norman sources, the childless King Edward named Duke William as his heir,[2] and it was only the unanticipated and duplicitous usurpation of royal power by Earl Harold Godwinson of Wessex that forced the invasion in 1066. This is the narrative crux that provides the visual opening in the first episode of the Bayeux Tapestry (Fig. 1).

Although the Battle of Hastings ranks as one of the most decisive military engagements in the history of the Western world, William's conquest left a jagged edge of controversy that cut deeply into the consciousness of the Normans and Anglo-Saxons who experienced the radical changes brought about by the new regime. Defensive responses to this violent rupture re-created (filtered, suppressed, transformed) the past as a way of creating and controlling the present.[3] The understanding of past events was reshaped in ways that defined past and present in

terms of a new continuity.[4] No "document" problematizes that experience more powerfully than the visual narrative represented in the Bayeux Tapestry, which is thought to have been created between 1077 and 1082.[5] Late-twentieth-century audiences are still affected by its compelling and enigmatic "voices," as they find themselves drawn into a remote medieval world of unresolved tensions and conflicted loyalties. Thus, we shall explore how the monumental visual narrative draws the viewer into a carefully constructed web of indeterminacy in which the past can be re-created and transformed.

As it distances itself from the lingering late antique conventions that prevailed throughout the early Middle Ages, the Bayeux Tapestry takes on special importance as one of the first large-scale visual narratives that can be recognized in retrospect as a full-blown medieval conception of pictorialized text. Because narrative can receive its meaning only from the worlds that make use of it,[6] my vision of the work will be a bifocal one in which I hope to recover medieval ways of seeing in the poststructuralist terms of semiotics and narratology.[7] My goal is not to add yet another interpretation of what the work means, but to explore the strategies and conventions that made meaning possible both then and now. As Wolfgang Iser and others have argued, the meaning of a text is not a definable entity but something that happens, guided by structures of effects (in text and image) and response (by the viewer-reader).[8] In the view of Stanley Fish, meaning is not something one extracts from a text, like a nut from a shell, but an experience one has in the course of reading.[9] Texts initiate "performances" of meaning rather than actually formulating meanings themselves, and it is the relative indeterminacy of the text that both allows and generates a spectrum of actualizations.[10]

The medieval audience was essential to the experience of the Bayeux Tapestry as an agonistic social drama and cultural paradigm.[11] Initiated by an irreparable breach of norm, in this case an oath sworn by Harold of Wessex, causing a crisis in William's succession to the English throne, redressive mechanisms (armed invasion) are introduced into the performance of a sociopolitical ritual in which the transgressor (Harold) is sacrificed. Within the paradigmatic framework of the discourse, the winner

of the social drama requires cultural performance to legitimate and per-
petuate his success. By involving the audience in a process of social and
plural reflexivity, the Tapestry converts and distributes particular values
and ends over a range of actors into a system of shared or consequential
meaning. In Victor Turner's words, "Meaning always involves retrospec-
tion and reflexivity, a past, a history."[12] The social drama of the Bayeux
Tapestry constructs an interpretation to give the appearance of sense and
order leading up to and constituting the crisis. The audience becomes
caught up in a network of structural contradictions and norm conflicts –
a state of indeterminacy. At the same time, the ritual performance in the
Bayeux Tapestry constitutes a declaration of form against inddetermina-
cy that can be resolved only by the viewer who finds in the narrative a
way of manifesting the self and of recognizing where power and mean-
ing lie and how they are distributed. Ritual performance thus creates a
dialectic process that transforms the viewer within the structure of its
ideological discourse.

The rhetoric of power in the Bayeux Tapestry refers not to the rules
of discourse but to a much wider, more inclusive kind of cultural con-
struction that involves a dialogic understanding of discourse and of
"truth" itself.[13] In this multidimensional work involving both image and
text, rhetoric exceeds not only documentary or referential functions but
all instrumental uses of language. Above all, the rhetoric of power ex-
ploits ambivalence and role tension in language use by multilingual
speakers and readers in the late eleventh century and their relation to
the interaction of discursive modes.[14] As we see the rhetorical power of
the Bayeux Tapestry ride roughshod over the demands of historical ac-
curacy, we become fully displaced within the peculiar realm of a me-
dieval understanding of "truth."

As late-twentieth-century reader-viewers, we find ourselves engaged
in a Foucauldian analysis of the discursive practices that constitute a cul-
ture's reality, exploring the gap between history and textuality in the
rhetoric of power.[15] Within the post-Conquest world of the Bayeux Tap-
estry, power tends to be conceived in the simple, straightforward terms
of feudal order, as structures of domination and submission, inclusion

and exclusion. Whatever acts may be undertaken are instantly inscribed within established structures of dominance. Most important is the realization that power creates "truth" and hence its own legitimation.[16] Discourse can thus be explored in Foucauldian terms, as the order of the relations of power, but not without drawing attention to the subversive and suppressed components of England's new Anglo-Norman society.

Within the framework of contemporary semiotic analysis, the Bayeux Tapestry's narrative is organized in a conventional structure outlined by Greimas but first shaped by medieval chronicles, whereby a given order of things is disturbed, bringing about a new regime.[17] Within the same contemporary critical schema, whose roots can be found in the medieval *chanson de geste*, subjects (*actants*) operate along conflicting axes of obligation and desire. In terms of context, "such plots cannot be explained *within* the rules of society because they are *about* those rules."[18] In the sense that narrative is a social transaction between the work and its audience,[19] the Bayeux Tapestry is structured as a highly self-conscious, dramatically voiced discourse. The visual and textual unfolding of the story is heavily marked by what Barthes termed "signs of the narrator," codes through which the presence of the narrator and reader can be detected within the narrative itself.[20] Each time the figures gesture not for the benefit of other characters within the narrative, but for the audience, they stop "representing" and recount aspects of the situation otherwise unknown to the viewer. Similarly, the inscriptions allow the narrator to expand the limits of the story from what the characters can observe or know, by creating distinctively different voices carrying the plot line.

Although the story or plot constitutes an invariant core or constant against which the variables of presentation (discourse) can be measured in any narrative,[21] the Bayeux Tapestry presents a particularly complex cognitive experience. Within its context of historical contingencies, the operative assumption of a story existing prior to and outside the narrative was not fictive but real. Consequently, as the narrative involves modification or effacement in its representation of events, prior tellings (other sources) become a critical measure of its distortions. On the level of intertextuality and literary genre, the Bayeux Tapestry is very much a

text about other texts. The work offered a network of ready-made, culturally produced signs that rendered the discourse transparent to its contemporary audiences.[22] Codes of accessibility can be found in the culturally generated structures we call genre. Constituting a "context" of texts, genre offers recognizable sets of rhetorical operations and discursive practices that enable the reader-viewer to treat everything in the discourse as a way of interpreting and evaluating what happens. In this way, "context" is generated by the work itself. It creates an historical site of production and reception, a performative discourse active in the present.[23]

There is now general agreement that the Bayeux Tapestry was made in England shortly after the Conquest, most likely at St. Augustine's, Canterbury.[24] The work was probably commissioned by Odo, William's half-brother, who accompanied him on the military campaign in 1066 and was rewarded with the earldom of Kent, making him the second most powerful man in Norman England next to the king.[25] Since the military conquest was scarcely complete before 1070 and the transformation of the old monarchy into a functioning component of the new Norman feudal state had barely begun, the Bayeux Tapestry can best be seen as an imaged performance text played out on a newly constructed, transitional "stage" for court audiences with residual Anglo-Saxon ties as well as strong Norman sympathies. Although Hastings was a great victory, and chroniclers talked of the conquest of England as a single battle, the Norman settlement was a long, drawn-out process. Initiated in 1067–9, William's post-Conquest policy involved nothing less than the feudalization of England and the Normanization of the aristocracy and upper clergy.[26] At the same time, the Conqueror emphasized the legality of his rule and continuity with the Anglo-Saxon past. Indeed, the complex texture of William's England cannot be understood outside his claim to be the true successor to Edward the Confessor.[27] On a more basic level, the Bayeux Tapestry assured its diverse Anglo-Norman audiences that nothing much had changed in aristocratic life since 1066. As Frank Barlow

reminds us, "There was the same lack of privacy in hall or castle, the press of servants and retainers, the stifling promiscuity . . . an even greater disdain for agriculture and a greater love of war or its substitutes – the chase, hawking and military training."[28]

Because such government-sponsored or quasi-official histories lacked the power or means to disseminate their messages widely, the term "propaganda" can have had only a very limited application for most of the Middle Ages.[29] Initially reaching only a small circle of men and women at court, the Bayeux Tapestry might nevertheless be seen as commanding a large enough audience to warrant the epithet. Notwithstanding its possible installation in Bayeux Cathedral after 1077,[30] the work was probably first made for display in secular sites in England, most likely in great baronial halls, such as the one in Chepstow Castle built by William fitzOsbern, Norman vice-regent with Odo.[31] Among his vast post-Conquest estates in Kent and Normandy, Odo could conceivably command several potential viewing sites where the 232-foot-long pictorial cycle could have been either hung or unrolled in sections on a long table.[32] We can imagine Odo possessing at least one hall of the rectangular shape and dimensions of the great dining hall of Dover Priory, with a 254-foot perimeter of interior plain walls up to a height of 12 feet with windows above, offering a large, continuous flat surface, which could have afforded visibility of the figures and inscriptions at fairly close range.[33]

Made of simple, flexible fabric, the Bayeux Tapestry can be conceived as having been designed expressly as a portable object, folded over upon itself like a ribbon and transported in a wooden case about the size of a funerary casket. Probably intended to function as a "traveling exhibition," the visualized, captioned account of the Norman Conquest could well have accompanied the peripatetic earl-bishop Odo from castle to castle and from castle to cathedral on both sides of the Channel, reaching a viewing public that included not only discrete enclaves of feudal lords and their retinues but clerical elites as well.[34] As we shall see, the circulation of texts and images within a medieval manuscript culture involved mobility of a more fundamental order than merely changing

places – the work itself tended to be basically unstable.[35] As John Fiske has recently argued, all popular culture texts are relatively "open," in the sense that they are completed only by their readers or viewers who insert them into their lives, thus giving them meaning.[36]

Despite its enormous length, the narrow strip of embroidery, only 20 inches high, was clearly designed for close viewing. At the same time that its narrative scope and sheer physical length achieves impressively monumental proportions, the relatively small scale of its inscriptions and figures demands the kind of tightly focused optical attention that enlists the intense involvement of the viewer. We shall thus center our attention on the kind of close reading (deconstruction) of episodes and sequences demanded by the visual narrative itself. Considered within its late-eleventh-century context of patron and audience, as well as its potentially wide circulation and performance function, the Bayeux Tapestry can be seen as an elaborate staging of visual propaganda, unique in its own day, addressed to a narrow but disparate range of powerful elite viewers, each of whom still had a very real stake in the controversial causes and outcome of the event that formed the center of its discourse.

Although my text centers on narratology, my purpose is not to argue theoretical positions but to bring the most powerful insights of Barthes, Bakhtin, Genette, and Todorov to bear in practical, demonstrable ways upon an exploration of narrative in the Bayeux Tapestry. The theoretical framing of my analysis is not meant to stand as a barrier to the reader's understanding. Instead, its insights, particularly those developed from film theory, are enlisted to provide a more direct access to the ways in which the work both advertises and conceals its secrets. How do the creative distortions of its images and texts open themselves to audiences both then and now? As Frank Kermode observed, the problems begin only when secrets are noticed.[37]

We read texts and look at images with expectations of meaning and closure, achieved in ways that resemble ordinary acts of communication.

Both then and now, there is a demand for narrative statements that can be agreed with, for problems that are rationally soluble. The Bayeux Tapestry remains both fascinating and elusive in its enigmatic play of surface transparency and deeply repressed secrets. Because its narrative clearly belongs to the realm of "history," both medieval and modern audiences have tried to play its game according to known rules only to be frustrated by multiple, detectable signs that different games are not only possible but essential to the formation of meaning. As conventional notions concerning the true claims of history seem to break down, the reader-viewer is challenged by the problematics of genre. Exactly what kind of text is the Bayeux Tapestry? This is the problem with which my inquiry begins.

The first chapter centers on the disturbing ways in which the text-image cycle runs counter to the sense and expectations of "history" as genre. Cast in a prose style that is self-effacing and rational, the narrative voice of the inscriptions seems to lack resonance and connotation. It soon becomes apparent, however, that the "artlessness" of the anonymous narrator is not a guarantee of factuality so much as a sign that the text is extremely artful.[38]

In the next chapter we consider how the plausibility of narrative turns on the distortion and blatant erasure of dialogue. As the viewer is called upon to fill in the gaps left by these silences, he realizes, along with Conrad's Razumov, that there may be truth in every manner of speaking. Such disconcerting "discoveries" pressure the viewer into an increasingly more active and complicit role in coming to terms with the secrets embedded in the Bayeux Tapestry's artful narrative. Running parallel to the string of mute dialogues, a relentless shifting of episodes from place to place introduces another strategy of disruption that both advertises and conceals more secrets to be uncovered in the deeper strata of the narrative. The viewer is maneuvered into a realization that the discourse is very much about mapping places of power.

The last two chapters explore the most complex, often "cinematic" structures in the designer's multiple manipulations of episode and sequence. As these close readings inevitably open onto the problematics

of context, they confront equally complex intersections with historical contingency and ideology. We thus conclude with a reassessment of the game strategy in which the tapestry's patron, Odo of Bayeux, becomes a dominant player and the viewer faces the cycle's ultimate problem of narrative closure.

CHAPTER ONE

THE PROBLEMATICS
OF GENRE

A S A CELEBRATED "HISTORICAL DOCUMENT," the Bayeux Tapestry has often been measured against a number of narratives that tell the story of the Battle of Hastings, but the work has rarely been considered as a "text" in and of itself, one among many accounts belonging to a literary genre or class of text. When its status as "text" is recognized, however, the Bayeux Tapestry can be seen as a distinctive narrative, uniquely capable of creating a challenging horizon of multiple expectations that defined its purpose or project for late-eleventh-century audiences in ways that have not yet been considered. That the designer intended to claim the work's status as text is made abundantly clear by the profusion of Latin inscriptions, describing each event as well as identifying persons and places. As the Norman Conquest inaugurated a new era of written documents in England, the Bayeux Tapestry stands at the beginning of a gradual new confidence in the written record.[1] Judging from their distinctive orthography and spelling, the inscriptions were formulated in England for an Anglo-Norman audience.[2]

Within a new Norman bureaucracy of unprecedented scale, Latin replaced Old English as the only language of record.[3] Although among the aristocracy the ability to read Latin became a necessity, most readers were literate only in a minimal or practical sense, in contrast to the fully developed literacy of "cultivated" readers.[4] After the Normal Conquest, linguistic usage in England became extraordinarily complex, caused primarily by the introduction of French as the language spoken

at court. When the Latin inscriptions of the Bayeux Tapestry were read aloud, as was generally intended for such works, the style and register of the written words would have been most likely transformed into English or French, just as a Latin charter would have been customarily read aloud in the vernacular. As Clanchy remarks, *literati* evidently interchanged languages effortlessly, using whichever one was appropriate for the occasion. Latin simply served as a common medium of literacy in a multilingual and predominantly oral society.[5]

Notwithstanding the profound effects of writing on the nature of evidence in the form of a durable and reliable record, medieval writing was still mediated by the persistent practice of reading aloud. Even educated readers preferred listening to a statement rather than silently decoding it in script.[6] On one level at least, the inscriptions in the Bayeux Tapestry functioned like a musical score, specifying the essential properties of an audible performance and setting forth what was required by the text.[7] Written Latin letters were a cue for speech, not a substitute for it. Throughout the Middle Ages, writing was speech written down, as in Augustine's oft-quoted formulation: "When a word is written, a sign is made in the eyes by which that sign which pertains to the ears comes into mind."[8] In the Augustinian phonocentric hierarchy of speaking, gesturing, listening, writing, and reading, the letter is identified as a copy of prior speech, and writing must appeal to speaking for authentication.[9] In the words of the twelfth-century writer John of Salisbury, "Fundamentally letters are shapes indicating voices. . . . Frequently they speak voicelessly the utterances of the absent."[10] In the Bayeux Tapestry this seems particularly obvious in the full stops signaled between each word, facilitating the reader's quick vocalization and translation of the script. As Michel Parisse suggests, the short, declarative statements of the inscriptions provided the script for a sound track in which a narrator "voices-over" the cinematic flow of a purely visual narrative.[11] As Parisse and Brilliant suggest, the verbal "text" of the Bayeux Tapestry would have been mediated by a speaker or interlocutor who would perform it for an audience.[12] But a critical disjunction prevailed between vernacular and script in performance, so that the Latin inscriptions can be compared to

the printed subtitles for a silent film to which a dubbed-in sound track has been added, a "voice over" giving an instant, audible translation in another language.[13]

The voice over shifts the narrative into an assertive mode. Events are not simply revealed in a camera-eye style but are recounted by a narrator who explicates what is already implicated visually.[14] The narrator creates a secondary discourse outside the visible "story," posterior in time. It is a voice that looks back but, literally speaking, cannot "see" anything in the other world of the past.[15] The Bayeux Tapestry's inscriptions constitute a covert *narratio*. We hear a voice speaking of events, characters, and places, but its owner remains hidden in the discursive shadows. The voice is nonetheless authoritative. As he exerts a special power to make independent descriptive statements, the external narrator presents a strongly conceptual view. Knowing all but not necessarily telling all, the highly selective discourse of the concealed voice regularly withholds information from the audience in the form of terse summaries. Although concision is an inherent feature of the inscription as a kind of "lapidary charter,"[16] such terse summary calls attention to itself as a solution to the problem of spanning a period of story-time that is unnecessary to detail. The truncated account declares the presence of its maker, as well as the pretension of the narrator's discourse to transmit remembered and presumably already written records.

In view of the complex maneuvers involved in making the Latin-inscribed images accessible to the contemporary viewing public, we are faced with a problematic confusion or redundancy of semiotic systems, not only verbal and visual, but linguistic as well.[17] Writing about a similar but imaginary tapestry picturing the same events leading to William's Conquest, the Norman poet Baudri of Bourgeuil sets a clear agenda for the Bayeux Tapestry's visual-verbal strategy: "In reading the writing in the inscriptions, the *true and new histories* could pass in review on the linen cloth" (emphasis added).[18] Far from functioning as a "stripped-down chronicle," the sequence of terse descriptions of what is happening in each scene declares the Bayeux Tapestry's status as a historical text, written in a language appropriate to a commemorative genre whose truth-

claim as a written record was to be taken seriously, whether the viewer could actually read it or not. Just as the lineation of certain texts identifies them as poems, the Latin inscriptions in the Bayeux Tapestry designate it as a work of historical prose.[19] The visible presence of the Latin text functioned as a critical component of its message. In every sense, the verbal text constitutes a valorization of the literal surface of the work. As fabricated verbal structures, the inscriptions offer forceful, unequivocal declarations of fact in the present tense, describing what is happening before the viewer's eyes.[20] The off-screen narration of the voice over seems simply to reproduce what is shown on the screen. The narrator's discourse is "now," but the images are located back "then" in story-time.[21]

As the designer of the Bayeux Tapestry stresses the narrative surface as a constructed text, both the medieval and modern "reader" become increasingly aware of its status as a literary genre and of the necessity of locating its "text" within a larger literary context. What is sometimes perceived to be "the truly eclectic character of its narrative,"[22] might be seen more productively in terms of intertextuality and generic complexity. Although generic thinking in terms of conceptual models was comparatively rare in the Middle Ages, functional classes of texts can be seen to have shaped how writers produced and readers responded to literary works.[23] In Jonathan Culler's formulation, "The function of genre conventions is essentially to establish a contract between writer and reader so as to make certain relevant expectations operative and thus to permit intelligibility."[24] Just as genre serves as a powerful explanatory tool for modern readers, enabling us to locate a text within a concrete configuration of other texts, generic recognition enabled the medieval reader to experience the work in an intertextual world of prior readings.[25] Rather than habitually concealing their sources, medieval texts exploited intertextual signals that could summon diffuse recollections, inviting the reader to place the text within the context of previous experiences. Medieval texts depend for their existence and meaning on other texts.[26] Frequently, truth itself is conceived in terms of being true to literary tradition – to other texts rather than to facts.[27] As we find ourselves caught

in an intertextual web woven of history and story in the Bayeux Tapestry, we are dealing not simply with a question of genre, but with a medieval understanding of the relation between truth and narrative, reality and art.[28]

Medieval texts presume knowledgeable audiences; they depend upon the recognition of a particular work as genre and the kinds of texts it resembles, from which the reader is then instructed how to read it.[29] Distinctive narrative genres, such as epic, define a frame of reference, a narrative logic, a formal structure that possesses a greater power of containment, in the sense that generic rules function as part of the structuring of social memory. The past tends to be remembered on a social level through narrative conventions that are remarkably stable and implicitly recognized.[30] But "genre" can also raise as many problems as it solves, since medieval definitions inherited from classical antiquity rarely fit the kinds of texts in current medieval use.[31] The conventional patterns and styles offered by most medieval texts reveal an interpenetration of genres that offer diverse rhetorical registers and rich layers of nonliteral meaning. Such possibilities of generic manipulation take the text beyond imitation and pastiche, as they imply an audience with constructed expectations about how texts represent the past.[32] As Ruth Morse rightly argues, medieval readers were neither stupid nor credulous.[33] Given that the historian's right of invention did not invalidate the truth of what he wrote, the alert interpreter was constantly on the lookout for what he was supposed to be reminded of and in which texts he had seen or heard it before, creating patterns of intertextual recognition capable of framing the reader's understanding.

Although modern scholarship on the Bayeux Tapestry has focused much of its energy on determining the degree of "truth" or facticity that can be claimed for its striking account of the Norman Conquest of 1066, the question probably would have been a matter of indifference to medieval viewers. "Truth" about the past had a very different resonance and valence in the medieval experience. The Bayeux Tapestry is not a straightforward or reliable account of the events in the order in which they occurred.[34] Consciously distancing itself from the extended

chronological expanse and annalistic structure of monastic chronicles, the narrow focus on the single event of the Battle of Hastings provides a sustained theme and subject characteristic of "literary history."[35] Indeed, the Bayeux Tapestry manipulates the narrative to alert the audience to recognizable literary conventions.[36] Often overriding the chronological sequence of events, the author-designer worked the "facts" into a story (récit) on one level, interlaced with an interpretive discourse on the other.

Given the highly selective, often unreliable manipulation of historical material inherent within medieval representation – both word and image – it no longer seems useful or even feasible to measure the authenticity or assess the sources of the Bayeux Tapestry. We might take a more productive approach by exploring questions of rhetoric and agenda to assess its extraordinary power to move and compel audiences to become complicit in the visual argument. Beginning with a simple but striking linguistic shift in rejecting the vernacular of the *Anglo-Saxon Chronicles*, which had been promoted as part of an insular royal policy of cultural revival begun under Alfred the Great, the Bayeux Tapestry's Latin, however rudimentary, catapulted its audience into a new historiographical regime following the Norman Conquest.[37] By creating a recognizable "literary history," the designer of the Bayeux Tapestry aligned himself with a class of writers common in France but rare in England, official or semiofficial historians writing at the command of a royal or aristocratic patron.[38] Indeed, the Bayeux Tapestry's status as history in and of itself constituted a claim to the common intellectual stock of post-Conquest feudal society. However, as Marc Bloch pointed out, by a curious paradox, through the very fact of the new Anglo-Norman respect for the past, history came to be reconstructed as the new feudal society considered it ought to have been, that is, as a new and present "reality."[39]

What is unclear today is what kind of "literary history" the Bayeux Tapestry was intended to represent to its literate and semiliterate court audiences. As its narrative strategies involve generic models in the contemporary Norman *gestae* composed for William the Conqueror, and epic *chansons de geste*, such as the *Song of Roland*, as well as older, more venera-

ble traditions of Latin panegyric, the narrator seems tacitly to defer to some prior work or "pre-text." At the same time, he exploits the problematics of genre to construct a multilayered narrative frame and to create a space within which he can manipulate his "true" tales about the past. Diverse conventions of narrative implicate his representation in a complex series of displacements. Intertextual references create a dynamic relationship between present and prior texts, suggesting a parallel narrative, a dialogic commentary upon the text, sometimes subverting, sometimes reinforcing, but always intervening in its meaning.[40] In the slippage between event and representation there is room for maneuver and invention, not only for the designer but for his audience as well. As we shall see, generic complexity and the narrative indeterminacy it creates in the Bayeux Tapestry can be seen as a way of mediating tensions created by a culture uncomfortable with the naked bias of propaganda, at one extreme, and the allegorical interpretation demanded of freestanding fiction, at the other.

HISTORY

Writing in the twelfth century, Conrad of Hirsau defined history as "something seen . . . for the Greek *historin* is *visio* [sight] in Latin. The writer of history is said to write of events he has witnessed."[41] Although the visual component of such eyewitnessed history was conventionally left to the medieval reader's imagination, the Bayeux Tapestry recounts its historical narrative as a dramatic material visualization of witnessed events. In a very real sense, the cyclical imaging of history defines the viewer along with the narrator as an "eyewitness," valorized since the time of Isidore of Seville as the most compelling guarantor of historical truth.[42] The apparently straightforward truth-claims implied by medieval notions of eyewitnessed history, however, were by no means as simple or unproblematic as they might seem. Because history was defined throughout the Middle Ages as inherently allied to the literary constructions of fiction, writing and reading about past events were problematized and inevitably made more complex in ways that more

closely approach our own poststructuralist notions. In Paul Ricoeur's for-
mulation of the double meaning of "history," the word refers to the
events of the past, things done (*res gestae*), and at the same time to their
representations.[43]

For the Middle Ages, history was a literary genre, distinguished from
other narrative texts only by the presumed "truth" of its content. The
medieval expression of this idea can be seen in Isidore of Seville's inclu-
sion of history in the category of Grammar, the third component of the
trivium that embraced all literary studies.[44] "History" thus comprises a
secular category of long, verisimilar narratives. But in the conceptual
space of the Middle Ages, where there was no exterior criterion of ver-
ifiability beyond the memory and judgment of the reader: "true" might
mean "in the main," "for the most part" true, or even "it could have hap-
pened like this."[45] Since historical writing was openly practiced and per-
ceived to be a narrative imposed on the events, patent fictions were of-
ten presented as part of a true account. If problems of factuality cannot
be resolved to the satisfaction of modern readers, how did medieval
readers negotiate their way through literary history's constant elabora-
tion toward fiction?

If history was defined by its content of *res gestae*, understanding was
largely determined by the manner of its *narratio* as literary genre. Rhetor-
ically trained readers learned to understand by recognizing how to in-
terpret particular kinds of text; the eyes and ears of alert readers were at-
tuned to patterns of learned expectations.[46] By the same token, medieval
authors depended on shared habits of reading.[47] The meaning of a pas-
sage or even of a whole work might ultimately depend upon the reader's
recognition of its place in a familiar scheme of style, method, and organ-
ization.[48] Within a given range of licensed invention, historical texts
were first read as eloquent and elegant representations before they were
judged to be true or false. Historical "content" thus referred to a com-
plex intersection of past events and their interpretations, intended to be
recognized and understood in accordance with rhetorically related
habits of understanding acquired in the course of a medieval Latin
education.[49] Texts formed a meaningful context of conventional repre-

sentations, generated by subtle but recognizable colorations from chronicle to prose legend to *chanson de geste*. As we explore medieval history-as-story or "history-telling" and its progressive concern for reaching and holding an audience, an inevitable intertextuality emerges in the complex relationship between claims to be telling the truth about the past and conventional patterns of fictional narrative.[50]

Although the Bayeux Tapestry's intersections with the Norman-biased *Gestae* of William of Jumièges and William of Poitiers have been demonstrated repeatedly and with compelling conviction, the nature of the relationship that connects the Anglo-Norman work produced for Odo of Bayeux with the continental historians writing for William the Conqueror have been only vaguely defined. The ostensible overlap belongs exclusively to the realm of event description, such as Harold's journey to Normandy, William's Breton campaign against Conan, and the centrality of Harold's oath.[51] Notwithstanding the impressive number of such intersections, we cannot legitimately speak of "borrowing" one from the other. Rather, the Bayeux Tapestry and the Norman *Gestae* can be seen as contemporary historical projects drawing upon the same pool of oral and written accounts by eyewitnesses and secondhand observers. In terms of genre, or "literary history," they emerge as following parallel but independent and even unrelated tracks. In contrast to the ambitious scope of the *Gestae,* which ground their projects in lengthy narratives dealing with the origins of the Norman dukes, the Bayeux Tapestry inaugurates its discourse by focusing on Harold of Wessex, William's rival to the English throne, and his relationships with King Edward the Confessor and the duke of Normandy in the years immediately prior to Hastings. Although all three accounts arguably defend William's claim, the Norman sources adopt the characteristic biographical form of the *Gesta,* dominated by the single major figure of the Conqueror rather than focusing on the event of the battle and its precipitating causes. All the accounts are ostensibly centered on the problematic transmission of royal power, but the Bayeux Tapestry's agenda becomes demonstrably more complex through its digression to the role played by Odo in the un-

folding of the drama, a role that remained largely unacknowledged in the *Gestae* commissioned by or dedicated to his half-brother William.

In several respects, however, the Bayeux Tapestry aligns itself with the enterprise of William of Jumièges. In contrast with the polished, self-conscious Latin of his contemporary William of Poitiers, William of Jumièges claims to be writing in a plain and intelligible style. Like the simple declarative Latin sentences that accompany the scenes of the Bayeux Tapestry, the *Gesta Normannorum Ducum* makes itself accessible to the minimally literate reader through simple grammatical constructions and rudimentary vocabulary. Even William of Poitiers makes an ostentatiously declared rejection of the poetic embellishment for the bare facts of a "meager prose."[52] On another level, the discursive change signals an ideological initiative. As Gabrielle Spiegel argues, prose histories emerge as a courtly literature of "fact" created for the new Anglo-Norman aristocracy to explore and valorize its post-Conquest hegemonic aspirations.[53] The flatness and insistently prosaic character of the Bayeux Tapestry's inscriptions, as opposed to the early medieval convention of setting the *tituli* accompanying images in rhymed verses, seem calculated to create not only the effect of easy accessibility but a more forceful claim to veracity.[54]

In addition to espousing the ostensibly superior accuracy of prose, the terse brevity of the Bayeux Tapestry's narrative inscriptions shifts its rhetoric toward the purported facticity of a chronicle. As the chronicler Matthew of Westminster later admonished his readers in describing the much later battle of Lewes (1264), "Let a poet enumerate all the various occurrences of the day with more license or at greater length . . . but brevity keeps us in by a much stricter law, and does not allow us to say how each thing happened, but only what took place."[55] Strung together as a relentless series of episodes, the text acquires a "flattened out," unmediated texture that tends to obscure the more complex shape of its "story." Nonetheless, the narrative takes on the essential shape of the occasional genre of medieval chronicle that is limited, like the Bayeux Tapestry, to a single line of action in which the representation of event and

story is founded on the implied perception of a preexisting situation, an intrusive disturbance, and its consequence.[56]

Modes of perception fundamentally different from ours had a profound impact on the medieval historian's conception of causality. Since action and change inevitably disrupt the status quo, chroniclers were primarily engaged in reporting events that should not have happened. The universal aristocratic imperative to enlarge one's personal estate or kingdom obviously compelled men to create disturbances, while at the same time positing a stable order as the proper condition for the world outside the aggressively expanding individual self. Here we find ourselves entering Jameson's ideological subtext of "absent causes," the illusion of causality in history.[57] As William Brandt argued, medieval history is shaped by a fundamental incoherence that resolves itself in a search for stability and order.[58] The narrative of the secular or aristocratic chronicle thus owes its organization not primarily to a mode of preparation but to a value system or ideology.

Self-proclaimed "documentary" representations of the past create an effect of presence. Indeed, we might argue that one of the major projects that the Bayeux Tapestry shared with Anglo-Norman history was to make the past present in order to show that the past already belonged to a coherent new order of feudal values. As Paul Zumthor put it,

> History was only a more profound form of memory that added substance to the present and projected it into the future as a more intense form of being. It was conceived both as the milieu in which the social group existed and as one of the ways in which the group perceived and knew itself.[59]

Because virtue is found in specified status relationships within the feudal system,[60] the Bayeux Tapestry's theatrical "staginess" and exaggerated gestures provide a totally "natural" narrative environment for protagonists who were basically conceived as actors in a scripted performance coded to give meaning to behavior within its very narrow range of human motivation and experience.[61] "History" in the Bayeux Tapestry as-

serts continuity, especially as a repository of rights and privileges, since the precedent of ancestral deeds could be used to argue for or justify current claims to rank, land, and prestige.[62] One of the Bayeux Tapestry's most powerful rhetorical strategies toward this end was to align itself with the epic genre of the *chanson de geste*.

EPIC

In the Bayeux Tapestry, the text unfolds gradually, similar to an epic bearing within itself its own sense of purpose.[63] The most widely accepted current opinion is that French epic appears in its earliest form toward the middle of the eleventh century, that is, at roughly the same time as the Bayeux Tapestry, and that its point of origin seems to lie in northern France, particularly in Normandy.[64] Within the new genre, events supplied by history are subjected to profound distortion and deformation caused by the text's internal requirements and the desire to introduce allusions to the contemporary world.[65] As a precisely controlled programmatic discourse, the *chanson* succeeds more powerfully than history in dramatizing the agonistic struggles of its protagonists.[66] However, as Nichols and Zumthor have argued, the driving force of epic narrative is not human character but the feudal order and its values.[67] As the narrative balance shifts from result to process, the discourse opens to greater audience participation, inviting the viewer to take sides with and against the characters. Like the epic *gestes*, the Bayeux Tapestry was not intended to be read but declaimed, but it was not a *jongleur* who made the rounds from castle to castle but the visual narrative itself.[68]

Notwithstanding the critical differences in the perception of "truth" in prose as opposed to epic poetry,[69] it might be useful to compare the Bayeux Tapestry with the only other surviving "text" that centers as narrowly on the Norman Conquest. Written by Guy, bishop of Amiens, shortly after 1066 and perhaps dedicated to Lanfranc,[70] the *Carmen de Hastingae Proelio* is a literary work in the well-known genre of Latin epic written in verse for a contemporary audience.[71] Unlike the Bayeux Tap-

estry, the *Carmen* begins *in medias res* with William en route to England. Perhaps more transparent than its historical prose counterparts in the Latin *gestae* are obvious displays of rhetoric designed to locate the work in the classical epic tradition in praise of a hero. As the *Carmen* opens, William, weatherbound, despairs and weeps, but the poet assures the reader that, in the same way that the English could not deter him from claiming his ancestral kingdom, neither the sea nor rocky shore could stop his voyage across the Channel. Just as Orderic Vitalis, writing ca. 1125, readily recognized the epic cast of the *Carmen de Hastingae*,[72] similar rhetorical strategies have been recognized in the Bayeux Tapestry by modern critics who relate its narrative structure to the *chanson de geste*.[73] Twelfth-century writers, such as Wace and William of Malmesbury, even assert that the *Song of Roland* was sung or recited to the Norman troops at Hastings.[74] What is significant here lies not in the historical accuracy of their claim but in the twelfth-century idea that William's mission in England could be framed within the same ethical and political structure valorized in *Roland*'s account of the epic struggle between Charlemagne's most loyal and traitorous vassals. Indeed, the secular setting of the baronial hall for the display of the Bayeux Tapestry and the open battlefield space for the recitation of *Roland* address the same warrior audience in contrasting pre- and post-Conquest circumstances.[75]

The reality of epic depends almost entirely on its social function in a lived world. It is important, therefore, to consider the imaged narrative as a semiotic system, a sign and carrier of meaning that exploits a generic structure into which "everything comes to insert itself in order to arrive at a particular meaning."[76] Within the descriptive framework of epic, we can then ask how the designer structured the work by playing out a limited number of possibilities defined by the genre in such a way that the viewer's perception and understanding are registered in a conventional trajectory of expectations. Within Jauss's suggested "norms" of the epic genre,[77] the Bayeux Tapestry's "author" can be seen retreating behind the material, so that the events seem to narrate themselves. The simple declarative statements of the Latin inscriptions, such as "Here the messenger comes to Duke William (HIC VENIT ANNUNTIVS

AD WILGELMVM DVCEM)," seem noncommittal, neutral purveyors of un-interpreted, "objective" information. Impersonal discourse relates to the past and is driven by a single objective – to tell a story. Its demonstra-tive existence is presented in transitive, present-tense verbal phrases, erasing all links between the author and his text as well as between the text and its public.[78]

At the same time, the silhouetted gesturing figures perform or mime the text for an audience comparable to that assembled for the recitation of a *chanson* by a *jongleur*. Working against the grain of the present tense in the Bayeux Tapestry's inscriptions, the perception of epic distance is supplied by the viewer rather than the text. The outcome of the story is known, and the events belong wholly to the past, however recent. The suspense centers not on the story itself but upon its telling, its rhetori-cal strategies, its interpretive discourse. As we have seen, the impact of the deviation from epic verse to prose and from vernacular to Latin, as well as the shift to a plain, paratactic style, alert the reader-viewer to more insistent claims of "facticity" and truth. They create expectations of the unbiased reporting of events encountered in historical genres (*ges-tae*, chronicles) as opposed to those embedded in the quasi-fictive world of epic. In its temporal and spatial breadth, however, the Bayeux Tapes-try clearly belongs to the realm of epic. The action centers upon the sin-gle archetypal event of the epic battle, and the plot line is carefully con-structed so that events, generated by a seemingly minimal cause, are seen to grow into a catastrophe. Thus, the first part of the Bayeux Tapestry's narrative, concerned with Harold's journey to Normandy, is by no means a simple chronicle of events, but an explication of Harold's feudal obli-gation to William, so that when the English earl accepts the crown after Edward's death, the full depth of his treachery can be measured by the medieval spectator.[79] Within such a generic framework, Harold's coro-nation and Halley's comet can be perceived as epic signs intersecting at a dramatic juncture to become the turning point of the narrative. The inevitable consequences are then played out in the Norman invasion, the battle, Harold's death, and William's victory. With the outcome never in question, the entire story is raised above the level of simple narration.

23

The ramifications of the Battle of Hastings encompass a world order, and the protagonists represent the respective fates of the Anglo-Saxons and Normans within a newly configured England.[80]

As in *Roland*, characters function almost exclusively as agents of the larger discourse. At the same time, they discover and predicate for themselves the valence of their actions. They are permitted to question, as when William takes counsel with his vassals, and to make mistakes, as when Harold accepts the crown. Such ambiguities and errors become evident only in retrospect as their consequences unfold. In epic, the narrative strategy derives from the intention not simply to represent what was known of the event but, serving a more subtle and exemplary purpose, to enable the text to overcome the foreknowledge of the audience and to reveal problems of knowing or recognition posed for the characters.[81]

Among the exclusively aristocratic and royal characters required by the genre, a symmetry of power is contrived between the two protagonists by elevating Harold to William's rank of *"dux,"* although he was in reality only earl of Wessex, not "duke of England," as he is insistently styled in the tapestry's captions prior to his becoming *"rex."* Further epic symmetries in the delineation of character have been observed in stressing Harold's bravery and generosity in rescuing one of William's knights from the quicksand near Mont-Saint-Michel, thus making him a worthy opponent in the eyes of the audience.[82] But it is William who emerges as the larger-than-life epic hero at Hastings, when he exhorts his men to fight "valiantly but sensibly" (*viriliter et sapienter*), and the duke himself triumphs as a paradigm of feudal virtue, *sage et preu*, taking counsel with his vassals before taking a course of brave action.[83]

Although incidents and details are determined by the memory of eyewitnesses and other "historical" accounts, the representation of the reality of the outer, physical world is minimally evoked by a few signposts (pine or olive trees). The densely twisting trees that appear in the Bayeux Tapestry, however, do not seem to serve the same function of "epic markers" as those in *Roland*, but, like the Latin inscriptions, play a grammati-

cal, punctuating role by marking the boundaries between episodes in the narrative. Place markers for important events in the Bayeux Tapestry are signaled by architectural frames rather than trees. As in all medieval narratives, acts are differentiated through symbolic gestures and underlined by familiar *topoi*, such as the dramatic portent of the darkness at noon in *Roland* and the comet following Harold's coronation in the Bayeux Tapestry.[84]

As Auerbach pointed out, all events are types enclosing their own interpretations within themselves.[85] The Bayeux Tapestry contains a rich sequence of *topoi*, where set pieces, such as the dangerous crossing of a river near Mont-Saint-Michel, form the basis for the audience's participation in a text that can be directly felt as part of a common heritage.[86] Such *topoi* as the ruler taking counsel, the embassy, or the horrors of death in battle operate as referents, and thus have allusive rather than descriptive power. Unlike the modern cliché, they achieve a concentration of meaning through an almost limitless range of imaginative displacements,[87] so that, for example, for the medieval viewer, the mutilation of Harold's corpse will take on a stunning chain of resonances.[88]

The Bayeux Tapestry's insistent litany of inscribed names of known persons and places invokes a reality that belongs to the realms of both *res gestae* (history) and epic. Although the events of the Norman Conquest had already become legendary within living memory of 1066, the Bayeux Tapestry's narrative lays an epic claim to historical truth and the presentation of past acts for enduring memory. In its representation of an heroic ideality, the visual narrative offers elite court audiences on both sides of the Channel an interpretation of history intended to be experienced and understood as a *memoire collective*, capable of defining political and social identity within the present social reality. In its epic guise, the Bayeux Tapestry is designed as a primary form of historical transmission in which a medieval version of Ranke's notion of national history of an ideal past (*le passé tel qu'il eût dû être*) is elevated and projected onto a mythic screen so that it can be transformed into a system of ideological explanation.[89]

PANEGRYIC

Because medieval literary genre can be limited not by a fixed protocol of narrative strategies alone but rather by a horizon of expectations constructed for the reader, paradigmatic shifts and mergers of genre signal paths of new meaning for the same targeted reader. Just as the Bayeux Tapestry's prose form and plain style consciously divert its epic character from "fictive" connotations, the narrative is structured on the model of another important and accessible genre of "literary history," the encomium, or Latin panegyric. Closer than the Carolingian examples usually cited, the so-called *Encomium Emmae Reginae,* written by a Saint-Omer cleric during the reign of Harthacnut (1040–1),[90] constitutes a singular generic incarnation that not only offers internal and external links between England and Normandy in the generation before Hastings, but also reveals compelling rhetorical and ideological parallels with the Bayeux Tapestry. Whereas the work clearly belongs within a genre defined by its embellishment and hyperbole, the poet nonetheless begins with a rhetorical truth-claim by declaring that, when writing the deeds of any one man, the author would never run the risk of inserting a fiction.[91]

Commissioned by Queen Emma, sister of Duke Richard II of Normandy, first widow of the Anglo-Saxon King Æthelred, then of King Cnut the Dane (d. 1035), the Latin prose work gives a continuous, almost contemporary account intended to promote the legitimacy of her son, Harthacnut, as heir to the English throne. Following his military victory over Harold Harefoot, Emma's son supplanted Cnut's illegitimate older son by his Anglo-Saxon concubine Ælfgyfa. Like Odo's tapestry representation of the Norman Conquest, the panegyric does not locate the personage of its patron at the center of the narrative, but focuses instead on figures legitimating the royal power upon which he or she depends. Directed against Edward, Emma's son by Æthelred and then pretender to the throne,[92] the *Encomium* engages in a series of egregious distortions to construct a moral tale of how an unjustly seized kingdom is restored to its true ruler, a struggle cast in Augustinian terms of the *per-*

vasor iniustus conquered by the righteous *rex iustus*.[93] As in the Bayeux Tapestry's account of William's conquest of England, the *Encomium*'s dramatis personae function exclusively within roles narrowly defined by the problematics of the English succession. In contrast to Latin panegyrics aimed at preserving the memory of their subjects for posterity, the *Encomium* pursues an openly political agenda in addressing a state of ongoing crisis.[94] As in the Bayeux Tapestry, the centerpiece of the narrative is located in an oath excluding all other pretenders to the throne.[95] Just as the appearance of the comet is treated in the Bayeux Tapestry as a portent of Harold Godwinson's doom, a similar epic *topos* appears in the encomium in the guise of a sudden and terrible storm.[96] Harold Harefoot dies, and messengers arrive with the news that the English nobles wish Emma's son Harthacnut to take back the kingdom that was his hereditary right.[97] Like the Bayeux Tapestry, the *Encomium Emmae* was written with a defensive purpose at a time when it was necessary to fortify a threatened position. It is important to remember that the years immediately following 1066 were equally marked by violent unrest and threat of insurrection by an insubordinate, vanquished English population.

The ethos of Emma's *Encomium* represents the foundation of an elitist ideology of a military ruling class that gloried in its battle prowess. The panegyric text both inaugurates and celebrates the ethos of the Norman ducal family that triumphed through predation, expansion, and conquest only twenty-five years later.[98] To evoke the full flavor of the situation in which Emma lived out her second marriage, as well as its relevance to the post-Conquest context of the Bayeux Tapestry, it should be pointed out that Cnut the Dane had become English King as the result of a massive and ghastly campaign that culminated in the bloody battle of Ashingdon. As if it were a harbinger of the Anglo-Saxon fate following the Battle of Hastings, the *Abingdon Chronicle* reports that all the nobility of England were destroyed.[99] As Eric John remarks, the *Encomium* was written for contemporaries in a political crisis that would take another generation to resolve.[100] Addressed to the last generation in England before the Conquest, the encomiast's rhetoric can still be seen to resonate after 1066 in the visual narrative of the Bayeux Tapestry.

Closer in date to the Bayeux Tapestry is the *Battle of Maldon*,[101] an Old English poem celebrating an important turning point in the reign of Æthelred in which contenders for royal power fight to the death with dignity and honor. Like the Bayeux Tapestry, the story is written as a series of vignettes. As David Wilson argues, a prototype for the Bayeux Tapestry can also be seen in the tendency of English heroic poetry to see both sides of the story. Like the *Battle of Maldon,* the narrative presents a choice between two courses of action, both wrong but one inevitable – Harold's choice between breaking an oath to William or disobeying the command of the dying King Edward.

On the post-Conquest side, another Latin panegyric provides a bracketing closure to the generic framing of Odo's project by situating the Bayeux Tapestry itself at the center of its narrative. Written between 1099 and 1102 by Baudri of Bourgueil for Adela, countess of Blois and daughter of William the Conqueror, the *Adelae Comitissae* describes an imaginary hanging very like the Bayeux Tapestry. Indeed, it has been argued that Baudri had probably seen it and edited its narrative to focus on William, filling out details with borrowings from other accounts, such as the *Carmen de Hastingae* and William of Poitier's *Gesta.*[102] In constructing an imaginary work of art associated with the ruler as a vehicle for his praise, Baudri uses a familiar *topos* belonging to the conventions of earlier Latin panegyric.[103] Just as Adela's pleasurable recognition of the Bayeux original in Baudri's literary fabrication formed a critical component of the poem's intended reception, we might imagine the Bayeux Tapestry's audiences experiencing a similar recognition in the troping of the same familiar literary *topos,* as the entire work of art itself could be construed as panegyric.

Adela's *velum* was imagined to be more truly a tapestry than the Bayeux version's embroidered representation. The striking contrasts that can be drawn with Baudri's hanging – woven of gold, silver, and silk, studded with pearls, and destined for the privacy of the countess's bedroom – bring into sharp focus the utilitarian and public character of the Bayeux Tapestry. Baudri's most provocative and radical departure from his public paradigm, however, is his insertion of full-fledged speeches into a nar-

rative originally dominated by the enigmatic silences of its protagonists. Although the panegyrist's tapestried "stories" are, like those in the Bayeux Tapestry, all accompanied by *tituli*,[104] the oratorical and dialogic interpolations move his project away from describing a visual narrative to writing in a purely literary mode. The move takes him from *ekphrasis* back into the world of the epic *geste*.

In contrast to the Bayeux Tapestry, the main narrative of the *Adelae Comitissae* begins with the council called by William to gain support for the invasion of England, the first of several heroically proportioned speeches that now constitute a major component of the new discourse. Indeed, it can be argued that the first third of the Bayeux Tapestry's narrative, extending from Harold's mission to Normandy to his coronation following the death of Edward, has now been recast into the content of William's justifying speech.[105] The text is introduced by a prologue first referring to Duke William's difficulties in establishing and then maintaining the power of his duchy in Normandy, followed by a long description of the comet in the spring of 1066 and the people's dumbfounded reaction to it.

Baudri's maneuver allows us to conjecture about the kind of spectator involvement demanded by the Bayeux Tapestry, for the visual narrative is almost meaningless without the voices and speeches imagined by the encomiast. Adela's participation has been rendered totally passive by Baudri's translation of a visual narrative into pure text, now supplied with set speeches and dialogue that not only clarify but interpret the action. In contrast, the Bayeux Tapestry's viewer is virtually pulled into the story. As we shall see, he or she is required to perform a kind of imaginary ventriloquism, animating the mute protagonists into patterns of meaningful utterance. At each juncture of dialogic silence the viewer is required to enter actively the lists of political controversy, to make critical choices and decisions, to imagine, construct, and thus endorse resolutions to conflicted issues still festering between partisans of the English and those of the Normans in the tense years following 1066.

NARRATIVE STRATEGIES
AND VISIBLE SIGNS

T HE BAYEUX TAPESTRY'S LINE OF ACTION IS frequently interrupted by speeches, staged within intrusively elaborate architectural frames. The resulting narrative structure might strike the modern spectator as fragmented and even disjunct in its paratactic oblivion to the need for connective tissue and discursive flow. For the medieval viewer, however, a course of action was not complete until it had been located in a particular human will.[1] In historical texts, epic and panegyric, speeches as well as places are clearly explanatory. They locate the origin of the ensuing sequence of events for the reader. Although the conflict leading to the Norman invasion has an overall structure, each party to the conflict pursued his own line of action, initiated by an act of individual determination. Opposing forces remain distinct from one another in the narrative, but at the same time they establish a complicated network of relationships bearing upon a single action or objective. Indeed, each component of the visual narrative, however opaque or seemingly "decorative," functions to enable the viewer to create meaning within a complex matrix of narrative strategies and visible signs.

SILENT VOICES

The most distinctive and obvious strategy that separates the Bayeux Tapestry from contemporary texts telling the same story is its material visualization of the events. In a sense, the cyclical imaging of events defines

the viewer as an "eyewitness." What has gone largely unnoticed in the Bayeux Tapestry's narrative, however, are the kinds of gaps and inadequacies that draw the viewer into active transactions within the narrative. The plot line is frequently punctuated by speeches, but the inscriptions almost invariably fail to inform us of what is being said. The protagonists remain mute. On the visual surface, their verbal exchanges have been silenced. The viewer is confronted not simply with the absence or omission of details, but with the eliding of voiced utterances necessary and indeed central to the meaning of the discourse. Whenever dialogue or speech is introduced into the stream of events, the viewer is given no clue as to what the protagonists are saying. These striking silences occur at a dozen critical junctures in the narrative. At these moments, gestures and miming by the characters open the text to active intervention by an audience obliged to supply what is missing.

The silences perforate the text by directly implicating the reader-viewer. Dialogue in itself evokes an idea of oral, not written, interaction. When written, verbal exchange takes on a metaphoric quality, so that dialogue unfolds within the spaces between two human beings conversing.[2] In the Bayeux Tapestry, those spaces are empty, waiting to be filled in. Although the silences challenge and even violate the invisible scrim that is presumed to exist between any given work and its audience, such a move would have seemed "natural" to the expectations of the late-eleventh-century court circles who saw Odo's tapestry. Within medieval conventions of reading, the viewer is being invited to participate in the familiar rhetorical move of *amplificatio*. Given the generally indeterminate status of direct speech as a fabrication or reconstruction in almost every medieval historical narrative, inserting dialogue was standard procedure for authors and not uncommon for readers.[3] Many of the most famous speeches that survived from antiquity were not transcribed verbatim but were carefully composed simulacra, revisions, and expansions of speeches that might have been delivered.[4]

When speeches are put into the mouths of historical characters, certain classical criteria of plausibility are inevitably invoked.[5] Quintilian, for example, advises the creation of necessary fictions, but they should

be both plausible and circumstantial, and, if possible, fit closely with what is true.[6] He goes on to stress the importance of restricting inventions to what is unverifiable, to things that cannot be checked and immediately disproved. Attributing words to the dead is always a good strategy, but one might also "quote" the speech of someone living whose interests will be served by it.[7] When the Bayeux Tapestry's designer chose to silence the dramatic presentation of arguments through dialogue, he found a way of providing his text with authority without having to judge or give an opinion of what was being thought about a still bitterly contested set of issues. Instead, he invoked an unspoken but powerful social snobbery by privileging his audience to make those critical decisions for him.[8] In this respect, as T.A. Heslop has suggested, the work is a "masterpiece of diplomacy."[9]

Notwithstanding the political sensitivity involved in the strategic employment of silent voices, semantic gaps requiring the reader to supply what is missing from the text occurred in all genres of medieval literature after 1100.[10] The Bayeux Tapestry's precocious insistence on its own incompleteness gave medieval viewers a power over the text unknown to their modern counterparts, so that their additions could quite literally create a new text. As Robert Sturges has argued,

> It is not a question of finding what is hidden in a text but of adding to it that which is not yet there. . . . Interpretation becomes a metonymic process for the reader. True meanings are not found by means of metaphorical substitution, as in allegory, but by completing the partial truth found in the written text by comparing the ambiguous passage with an earlier and fuller version of the same events.[11]

Thus, we shall see the Bayeux Tapestry launch its narrative in the very first episode by opening itself to the aggressive intervention of the viewer.

King Edward and Harold at Westminster

Like an elaborately sculptured church portal, the opening sentence of a medieval text is always highly formalized.[12] In the Bayeux Tapestry, the

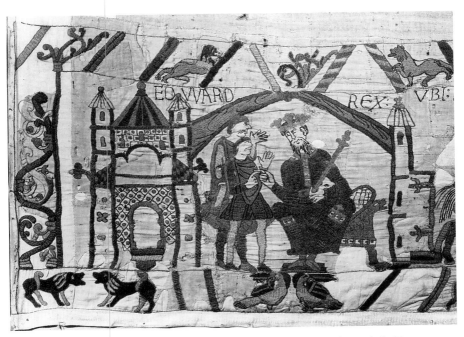

Figure 1. King Edward and Harold at Westminster. Bayeux, Musée de la Tapisserie (photo: Giraudon/Art Resource, NY)

dramatic narrative begins with a set piece as King Edward speaks to Harold within the splendid setting of Westminster Palace (Fig. 1). It is the catalytic scene that initiates the ensuing series of events, the engine that drives the rest of the narrative. It opens an enigmatic space of dialogic silence that fixes the semantic axis of the work. Because the viewer must supply the missing speeches, he or she becomes complicit with the designer in telling the story, creating a discourse, and, at this critical, primal moment, in defining the cause that generates the narrative that will unfold as a consequence of what is being said.

Further dramatizing its significance, the verbal exchange is enclosed within a palace, fixing a set of power relationships between the two initial protagonists in England. As he looms over Harold Godwinson, only Edward is identified by inscription. Although Harold was a powerful earl

described by one Norman chronicler as second only to the king and actually dominant in influence and power over the weak ruler, his dwarfed scale signals that he is, for all his military power and exalted position, nonetheless a royal subject, a vassal.[13] In a sense, Harold's relationship to Edward has already been rewritten in the feudal terms of William's Norman power.[14] As Edward is enthroned in the center of the great palace, scale, crown and scepter, inscribed name, title, and commanding position create a nexus of visible signs indexing not only his power and status as king but his pivotal role in the narrative. Only when Harold moves outside the orbit of the immediate royal presence, riding away toward his own realm of power (Fig. 4), does he acquire identity and status, as his companion points to the inscription VBI HAROLD DVX ANGLORVM.

Because the viewer was assumed to be familiar with other versions of the story, the narrative opening clearly calls for a partisan response in supplying the missing speech. The spectator must choose either a Norman or English version. Fortunately, the medieval viewer's choices have been documented by contemporary sources, so that we can know fairly accurately what they were. If the viewer wished to bend Edward's intentions toward the Norman side, he could adopt the position taken by the contemporary *Gesta Guillelmi* of William of Poitiers. Although the Norman chronicler rejects the risky strategy of reconstructing direct speech, an impersonal, omniscient voice informs the reader that,

> Edward, king of the English, who had already established William as his heir and whom he loved as a brother or a son, gave a guarantee more important than anything said hitherto. He resolved to forestall the inevitability of death, for whose approaching hour this holy man, seeking heaven, made ready. To confirm his former promise by a further oath he sent to him [William] Harold, of all his subjects the greatest in riches, honor and power, whose brother and nephew had previously been accepted as hostages for the duke's succession. This was a most prudent move, for his power and authority might be expected to contain the dissent of the entire English people if in their faithless inconstancy they were moved in any way to rebel.[15]

Edward's speech might then be supplied by the Norman-biased viewer as follows:

> I Edward, king of the English, by divine disposition lacking an heir, send you, Harold, earl of Wessex, on a mission to Normandy, to confirm my promise of the crown to Duke William. You shall swear fealty to him concerning the succession of the throne and confirm it with an oath.

On the other hand, the Bayeux Tapestry's pictorial representation could have elicited a response closer to the short speech invented by Eadmer of Canterbury, the first English writer to describe the event, forty years later.[16] Within the framework of an opposing view, the opening scene can be seen to represent the wise and prescient king predicting a tragic outcome and warning Harold against the journey to Normandy, as Edward can be seen to be saying:

> I will have no part in this: but, not to give the impression of wishing to hinder you, I give you leave to go where you will and see what you can do. But I have a presentiment that you will succeed in bringing misfortune upon the whole kingdom and discredit upon yourself. For I know that the duke is not so simple as to be at all inclined to give them [hostages] to you unless he foresees that in doing so he will secure some great advantage to himself.[17]

The uncertainty surrounding the inaugural episode in the Bayeux Tapestry formed a lingering legacy for the next generation of historians writing in the twelfth century. In his *Roman de Rou*, Wace tells the reader that Harold wanted to go to Normandy to bring home hostages, but Edward forbade him and advised him not to speak to William "for fear he would be drawn into a snare." With typical medieval candor, however, Wace admits to his readers,

> So, at least, I have found the story written. But another book tells me that the king ordered him to go, for the purpose of assuring duke William, his cousin, that he should have the realm after his death. How the matter really was I never knew, and I find it written both the one way and the other.[18]

The critical lesson to be drawn from this lengthy tracking of sources in contemporary and later medieval texts is not so much to establish the fact of an historical ambiguity and its documentary incorporation into the design of the Bayeux Tapestry, as to show how the designer exploited this space of narrative uncertainty as a rhetorical strategy to pull the viewer into an active, complicit role in the process of representation. The dramatic isolation of this moment of *aporia* at the beginning of the story alerts the knowing and presumably biased viewer to withhold judgment until the end. This strategy builds on a familiar notion of the circularity of meaning in discourse. The beginning thus acquires meaning only in retrospect of its consequences, so that the viewer knows he or she will be required to reinterpret this silent scene at the end, when an explicit disclosure will create an altered reference that was not initially apparent.[19]

The frequent moments of silent dialogue and their resulting points of *aporia* create an effect resembling the freeze-frame in film, informing the viewer that the narrative will center just as much on character as on action. Contrary to the Aristotelian structuralist view that characters are products of plots and are defined by their participation in a sphere of action, Barthes argues that reading character in narrative is a "process of nomination," that is, definition by naming culturally coded traits.[20] In the Bayeux Tapestry we never know the transient moods and feelings of the characters, only our own; what is passing through a character's mind at a specific moment is unknowable. The audience must then construct its ideas of character from evidence stated or implicit in the discourse. Character traits exist at the story level, and the whole discourse is expressly designed to prompt their emergence in the reader-viewer's consciousness. Narratives demand of the audience the capacity to recognize certain behaviors as symptomatic of character. Names for such traits are socially invented signs of what is going on in the depths of human nature. In the Bayeux Tapestry, the spectator's conceptual point of view overrides that of the characters and indeed defines them.

In the first episode and throughout, Edward is indexed as "king" and Harold as "duke," by simple statements in the inscriptions. But on a more

profound level, it is the relentless deictic reiteration of proper names that gives impetus to the ways in which the voice-over narration enables the audience to define character. As Barthes suggests, yet-to-be-discovered traits inhere in the proper name of a character as a mysterious residue:

> As soon as a Name exists to flow toward and fasten onto, the scenes become predicates, inductors of truth . . . and the Name becomes the subject. . . . What is proper to narrative is not action but the character as Proper Name: the semic raw material . . . completes what is proper to being, fills the name with adjectives.[21]

As the audience continues to experience the visual-verbal discourse of the Bayeux Tapestry, each name – Edward, Harold, William, and Odo – becomes a kind of ultimate residence of character, not a trait but a locus of traits.[22] As we shall see, it will be the name "Harold" that will form the magnetic nucleus of the viewer's search for the key that can unlock the problematics of character in the drama as a whole. In attempting to find the exact combination of trait-names to sum him up, the viewer becomes caught up in an uncertain pursuit, in what Barthes called a "metonymic skid." Indeed, "enigmatic" will turn out to be the ultimate and most potent of Harold's traits as the hero/villain of the Bayeux Tapestry's discourse.

Nowhere is the uncertainty of Harold's character more apparent than at the most critical point in the drama, when he swears an oath on relics at Bayeux (Fig. 30). Within the tapestry's regime of imposed silences, only the viewer can supply the content of Harold's contested oath. Instead of expressing a collective experience that can serve as a point of consensus,[23] the Bayeux Tapestry engages another drama of politics. By foregrounding the complex dynamics of social conflict and power relationships involved in all performances, the strategy of silent voices thematizes the problem of divergent response.[24]

Albeit rarely acknowledged, silence functioned as a powerful ideological tool in the sociopolitics of the Middle Ages.[25] As an effective way to avoid the unwelcome implications of a refractory reality, the strategy of silence offers an illusion of choice, a way either to avoid, expand, or

close the gap between ideological preference and the imperfections of the real world. In the Bayeux Tapestry, the implicit acknowledgment of social conflict and resistance to the new dominant culture of Norman feudalism set the stage for the viewer to become an active participant in moments of ideological collision. Within the framework of a repressive mass culture, both inclusion and exclusion can be seen as possible outcomes of any given performance.[26]

Although the strategy of requiring the viewer to supply all the voiced utterances within the narrative runs the risk of misinterpretation,[27] the impact upon the audience becomes all the more powerful. The viewer is being encouraged to experience the work on an ideological cutting edge by appropriating and exploiting the liminal spaces of self-definition and empowerment. Independent of the manner in which it is represented, the act of speech tends to acquire extraordinary significance in medieval narrative. Spoken words constitute a special text to which the speaker will be held without latitude of interpretation.[28] Given the dangers that can arise when utterances are taken so literally, words are presented or withheld as risks or traps – potentially fatal, however harmless they may have seemed when spoken. Because sentiments ran high on both sides in post-Conquest England, the viewer is forced to take sides with or against the protagonists and their positions.[29] The visual discourse is structured as a sequence of carefully constructed spaces of narrative uncertainty, moments of critical displacement in which the viewer is asked or required to transfer partisan sentiments and convictions onto the protagonists by giving voice to their otherwise silent utterances. As Ruth Morse has argued, this kind of instrumental use of the past creates an account that can be manipulated on moral and ideological grounds within the parameters of acceptable medieval practice.[30] The material and linguistic realities interwoven by designer and viewer into the fabric of the text we call the Bayeux Tapestry create not a "record," but a moment of inscription in which the past is internalized and its meaning fixed. As each viewer's dialogic performance is incorporated into the visual narrative, the power of its representation depends in large part on a strategy of intervention as well as on the rhetoric of inclusion, exclusion, distor-

tion, and displacement. In David Bernstein's view, the designer of the Bayeux Tapestry was a "consummate master of double meanings."[31] An important dimension of my present project is to explore how he achieved that effect and to what end.

The silences perceived within the narrative interstices of the Bayeux Tapestry become as significant as the spaces filled with action. What initially needs explaining is why we should be confronted with this kind of interpretive problem in the first place.[32] As late twentieth-century reader-viewers, we find ourselves within a Derridean world of textual incompleteness. We perceive in the Bayeux Tapestry's "text" neither "history" nor "presence," but an *effect* of presence created by textuality. Writing and imagery absorb the social context into a textually framed experience that is made present by its absence.[33] My analysis therefore aims at tracking the logic of censorship at work here. Silence is a language that hides what it displays beneath its own reality; it is a narrative gesture or code that designates through its very process of negation and avoidance what has been forbidden or withheld.

In the sense that it is historically unique, an utterance is an historical event that must be defined and described within the context of its particular occurrence. The historical "context" of something being said not merely surrounds it but literally brings it into existence.[34] As the Bayeux Tapestry creates contexts of utterances without disclosing their content, the viewer is required to provide a causal conception of meaning, located exclusively in a historically determinate context. The visual structure of speech is thus a representation not of spoken expression but of an historical text, of history as inscribed discourse.[35] Within a viewing context that was spatially and temporally close to the events represented, a medieval audience standing in a great feudal hall was placed in a peculiarly reversed or troped relationship to the speakers within the narrative. Instead of being obliged to listen and then respond as an instrument of the protagonists' interests,[36] the viewer tacitly agrees to reconstruct what is being said according to his or her understanding of what is meant, and thus becomes an active participant in creating a new text, a new fiction – an illusion of specular power.

CHANGING PLACES

As we have seen, the spectator's cognitive reconstruction of the Bayeux Tapestry's story line depends on the number and nature of the interconnections he or she is able to discover among the visual signs offered. Along with the visualized but mute speeches, another overlooked but striking narrative strategy concerns places or sites of action. To move through the long work is to travel not only through time but through the spaces of a carefully mapped political landscape. As emphatically proclaimed by its very shape, there is no vertical hierarchy of "reality" or being – everything exists on a horizontal, earthly plane, framed within upper and lower borders inhabited by birds, beasts, and human figures. The only exception occurs with striking dramatic force when the hand of God descends from another realm to designate and bless the newly constructed abbey church at Westminster as the destination for Edward the Confessor's burial (Fig. 34).

The visual narrative locates events in places rather than in time, so that chronological sequence depends largely upon locational connections or, more accurately, disconnections. This is made abundantly clear by the insistent and seemingly redundant repetition of the locational vocatives HIC (here) and VBI (where) introducing each new episode. They can be understood as hybrid locutions in a Bakhtinian sense, mixing two distinct semantic fields without signaling any boundary but serving a double discursive function.[37] As Richard Brilliant observes, the conventional formulae now serve as powerful demonstratives, locking oral and written language together in the visual field for a series of significant moments, as the narrator draws the viewer from place to place.[38] The sense of time past, normally evoked by temporal clauses referring to a sequential story line, is elided by the immediacy of "here-and-now" in the pictorial narrative. In referring to the image itself as a discreet physical space, HIC connects place and time in the present moment of performance at which the viewer is actually present. As we shall see, adjustments in the story line resulting from its adaptation to a spatially grounded series of site-specific places will cause the spectator to follow

what happens with a different understanding of its relationship to cir-cumstance and event.[39]

As the eye scans the horizontal expanse of the Bayeux Tapestry, each site is carefully defined and identified by an inscribed place-name, as if to reify imaginary moves through a panoramic space. Punctuated by fic-tions of luxury in elaborate architectural monuments and stylized trees, privileged spaces are opened to the elite spectator on a scale beyond immediate practical access, unfolding the possibilities of recent history relived. The viewer is invited to make an imaginary journey, following an itinerary that takes him or her from England across the Channel to France and then back again. As the embroidered hanging might shape itself for viewing to the configuration of a rectangular room, the narra-tive ends close to the point where it began. The Bayeux Tapestry's map reads horizontally, like a textual itinerary, a list of places unfolding from left to right: from Westminster to Bosham, Ponthieu, Dol, Dinan, Mont-Saint-Michel, Rouen, Rennes, Bayeux, Dover (?) to Westminster to Nor-mandy, then back again to Pevensey and finally to Hastings. In spatial or topographical terms, the narrative is structured as a series of flows and stops, relay and anchorage.[40] On one level, one might imagine the vi-carious spectator-traveler making a secular pilgrimage through space and time to the church-shrine of Battle constructed at Hastings after 1066, in much the same way as modern American "pilgrims" travel to the sites of the Civil War now memorialized by the National Park Service at such places at Appomattox or Gettysburg. For the contemporary spectator of the Bayeux Tapestry, Battle was not a site of religious theophany but the manifestation of sociopolitical power stemming from the triumph of a new feudal order.

On another, more compelling level, after the Norman fleet reaches England, the Tapestry's sequence of places can be perceived as mapping a Crusade. With William at Hastings leading an "international" force un-der a papal banner and with consecrated relics around his neck, the Nor-man invasion can be perceived as a Holy War.[41] The papal insignia ap-pear for the first time[42] when William's forces land at Pevensey, thrust into the inscribed place-name in an aggressive metaphorical gesture of

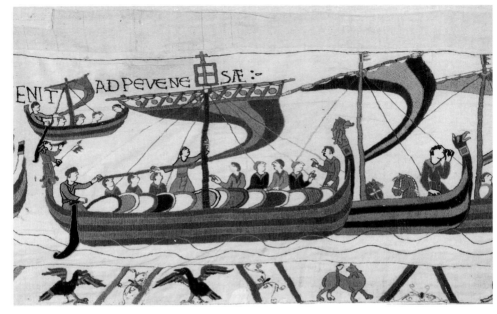

Figure 2. Norman Ships Approach Pevensey. Bayeux, Musée de la Tapisserie (photo: Giraudon/Art Resource, NY)

"invasion" (Fig. 2). The last display of the emblem marking the Norman venture as a Crusade dramatically coincides with the turning point of the battle (Fig. 41). When William reveals his face to the troops, Eustace of Boulogne points to the duke and raises the papal *gonfanon*.[43]

The post-Conquest settlement of England, especially after the rebellions of 1069–70, depended on the feudal reorganization of land tenure. As William I took literal possession of all the land within his realm, he reallocated the greater part to new Norman tenants, thereby bringing territorial control into the new feudal order. Forfeited English land was granted to the victors of Hastings in return for continuing and permanent military service.[44] In the first decades following 1066, William's successful rulership of England depended not only on the loyalty of feudal vassals but also on full military control over strategic centers and consolidation of feudal power over castles and the knights who held them

in fief.[45] At this stage, land owning and military control of royal lands were the chief responsibility of a small inner circle of royal advisors, among whom was Odo of Bayeux.[46] The reorganization of land after the Conquest began with the confiscation of territory belonging to King Harold and his family: Odo became tenant-in-chief of most of Kent; Pevensey, the strategic site of the Norman landing, was given to William's other half-brother, Robert of Mortain.[47]

Although the set-piece designation of place constitutes a commonly invoked literary convention of medieval *descriptio,* the significance of an event could be differently valenced or transformed when it was identified with a specific site.[48] As we have already seen in the initial episode (Fig. 1), the more important the place *qua* place, in this case, Westminster Palace, the more significant the event. Like film, the Bayeux Tapestry insinuates exposition and description into the same line of running narrative. But description, especially detailed architectural framing, interrupts and freezes the time line of the story. Events are stopped, although reading- or discourse-time continues.[49] Whereas events move too fast in cinema to permit the contemplation of visual detail, such narrative pressure is absent in the Bayeux Tapestry. As we shall see, the viewer is invited not only to adopt an almost automatic but pragmatic stance in singling out only those details that seem salient to the plot, but also to formulate a social and political conception of place.

As spaces are measured and marked by architectural monuments, a diagrammatic topography defines significant patterns of human organization and control. Especially where human activity is integrated into locations defined by architecture, such place-markers can serve a broad range of narrative purposes to embrace the ideology of political self-advertisement.[50] In the Bayeux Tapestry, the specificity of topographical inscription confers a sense of reality upon descriptive *topoi* that would otherwise remain within the sphere of literary convention.[51] Although its historical reality is generally accepted,[52] the elaborate prologue to the Norman invasion constituted by Harold's journey to Normandy can be seen as a transparent narrative strategy to generate a series of geographical and hence visual juxtapositions and interactions between Earl

Harold of Wessex and Duke William of Normandy, the two men who confronted each other across the Channel as potential rivals for the throne of the childless king.[53]

Through the serial repetition of a single architectural type of fortified residence, the physical spaces of the Bayeux Tapestry are temporally propelled into the post-Conquest world of feudal castles. The Norman warrior elite who won at Hastings quickly overran southern England, which it controlled by building castles. Through the anachronism of an order of buildings scarcely known in England before 1066,[54] strange places are made to seem familiar; architecture instantaneously domesticates the alien past in a series of place-markers that are also signposts of Norman tenure and power.[55] In the sense that, like knights, castles were a principal means whereby the Conquest was achieved and perpetuated,[56] their topographical preponderance in the Bayeux Tapestry constitutes a powerful colonizing strategy that situates the viewer within an inevitable future post-Conquest Norman landscape.

To the generation of Orderic Vitalis and his contemporaries in Normandy, the importance of castles for both attack and defense was almost axiomatic. His account of William the Conqueror's first campaigns of subjugation in England after 1066 is frequently and regularly punctuated by the construction of strongholds.[57] Thus, in the first episode of the Bayeux Tapestry, the great hall of Edward's palace at Westminster is anachronistically represented as a Norman stone-built, ground-floor structure with angle turrets at the four corners. Similarly, Earl Harold's manor house at Bosham (Fig. 5) is shown with an external staircase at right angles to the building, analogous to the later Norman design of Rochester Castle.[58] When Harold returns from Normandy to England, however, his port of arrival is marked by a distinctive Anglo-Saxon structure, termed a *burhgeat*, consisting of a freestanding building of two stories with larger openings in the upper level.[59] Following directly upon the episode of Harold's oath, the building might have been intended to be read as the eleventh-century gatehouse to Dover Castle, a site that figured prominently, by Norman accounts, in the feudal agreement set forth by William.[60]

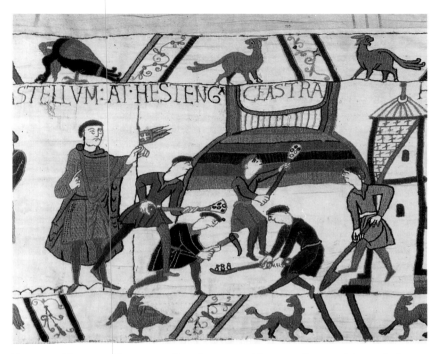

Figure 3. Normans Construct a Fortification at Hastings. Bayeux, Musée de la Tapisserie (photo: Giraudon/Art Resource, NY)

Fortifications were intended to be perceived not only in terms of their military importance, but also in terms of their symbolism.[61] It is no accident that, in the Bayeux Tapestry, prior to the Battle of Hastings, the Normans are shown constructing a *castrum* consisting of a great earth mound or motte surmounted by a timber superstructure (Fig. 3). Standing as the very symbol of feudal lordship,[62] its building is followed by the burning of a house from which a woman and child flee. The quickly and easily constructed motte-and-bailey castle protected no community; only the military elite quartered there.[63] As a highly effective instrument of control both during and after the invasion, the castle's paramount mission was to threaten and to subdue the surrounding countryside. By the time the Norman army departs for the battle in the

Tapestry's visual account, Hastings is marked by a multistoried stone structure, fortified with a tower and huge gate, standing as a proleptic sign of impending Norman victory and territorial appropriation. As we shall see, the Bayeux Tapestry creates on at least one important level an ideological discourse about the territorial claims of the new Norman feudal power in both France and England.

The contemporary viewer would also have recognized in the Bayeux Tapestry's maplike network of places familiar conventions of the journey in the *chanson de geste*.[64] Structured as points of arrival and departure as well as names of places passed, the sequence of geographical locations epitomizes the epic scale of the narrative as spectacle; motion through space operates on an important metaphorical level so that the transitions between places represent moral transitions.[65] As in the *chanson de geste*, the circuitous journeys back and forth across the Channel acquire the potential for transforming the spectator-reader's point of view as he or she is invited to share the emotional gratification of heroic conquest from a shifted perspective. Within the framework of the epic itinerary created for the Bayeux Tapestry, the aim of description is not to reproduce the visual world but to establish a structure of information that allows the reader-viewer to re-create an imaginary realm with reference to experiences of the real. As we have already seen, visual images of social institutions such as the feudal castle shape the map of the viewer's own post-Conquest world.

Harold at Bosham

The Bayeux Tapestry's first episode of locational transition comprises a cluster of events connected with Harold's arrival and departure from Bosham: Harold rides to the hunt, then prays outside a church, banquets with his companions, and embarks across the Channel. The moment he exits through the gates of Westminster and enters the territory of his own earldom of Wessex (Fig. 4), Harold's status as well as visible stature are dramatically transformed from a humble and anonymous royal servant to the powerful and famous "duke of England," leading an entourage

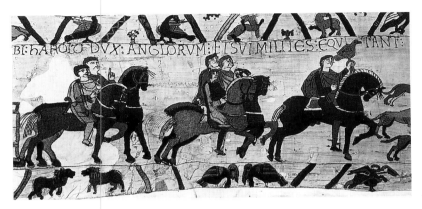

Figure 4. Harold and His Men Ride to Bosham. Bayeux, Musée de la Tapisserie (photo: Marburg/Art Resource, NY)

of "knights": VBI HAROLD DVX ANGLORVM ET SVI MILITES EQVITANT AD BOSHAM. To draw the viewer's attention to the political implications of the transition, one of Harold's men points to the inscription of the distinctive post-Conquest, Norman-style titles that prevail throughout the work.[66] In the first moment of the sequence Harold exerts his pre-Conquest territorial privileges by hunting with his hawk[67] and dogs in the forest at Bosham, visually indexed by an elegantly interlaced tree whose branches interrupt and merge with the inscribed place-name. Here and elsewhere throughout the work, as in any medieval text, the natural world functions only to provide a framework for human action.[68]

As Frank Barlow remarks, we cannot know to what extent hunting was monopolized by the king or nobility prior to the Norman Conquest, but nobles very likely had the right to hunt over their own estates.[69] After 1066, however, the Norman kings tended to monopolize hunting and reserved to themselves the right to hunt not only over the royal demesne but also over the estates of their barons and other landholders. Within the framework of post-Conquest notions of feudal and royal power, Harold's aggressive assertion of his rights as hunter might be read as a proleptic reference to his later appropriation of the English crown and

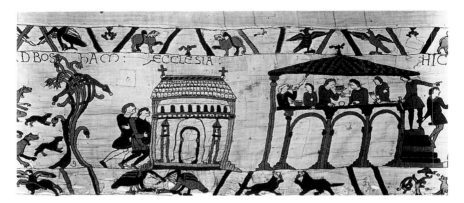

Figure 5. Harold at Bosham. Bayeux, Musée de la Tapisserie (photo: Marburg/Art Resource, NY)

all its attendant privileges. In the last event of the cluster where the earl of Wessex and his companions embark from Bosham (Fig. 6), he takes his hawk and hunting dogs with him to Normandy. Even within the political economy of pre-Conquest definitions of territorial claims, Harold can be seen to declare his intention to "poach" on another noble's land.

Harold is nevertheless depicted in the next two scenes (Fig. 5) as faithfully fulfilling his duties as a noble lord, first kneeling in prayer outside the church at Bosham and then at banquet, eating and drinking with his knights. That the earl of Wessex is shown outside the church may be significant in suggesting a less-than-perfect spiritual state or, more plausibly, the two figures might have been positioned so that the dominant identifying feature of the great chancel arch could be displayed on the interior of Holy Trinity Church.[70] Anglo-Saxon culture seems to prevail at Harold's banquet: as the earl engages in an intense discussion with one of his men, the others drink from horn vessels similar to those found at Sutton Hoo.[71] Contrary to Norman custom, they eat in an upper room of a manor house not fortified with towers.[72] Clearly paired, as they are framed by Harold's arrival and departure, the church and manor-house at Bosham function together as important landmarks of place, identifying the Godwinson estate.

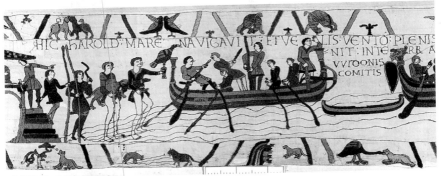

Figure 6. Harold Embarking across the Channel. Bayeux, Musée de la Tapisserie (photo: Giraudon/Art Resource, NY)

What transpired at Bosham is not reported by contemporary Norman sources. Only Wace, who had probably based his account on what he saw in the Bayeux Tapestry (Fig. 6), later reports that "he [Harold] made ready two ships and took to the sea at Bodeham [Bosham]."[73] It is thus possible that Odo's tapestried narrative is unique in identifying Bosham as the specific port from which Harold sailed, suggesting that some particular importance might have been attached to the site. According to the Domesday text,[74] the manor at Bosham was held by the Godwinson family in King Edward's day. Because it commanded the harbor at Chichester, Bosham was one of the more important ports on the Channel. The vast lands belonging to Harold's family along the Sussex coast were concentrated at strategic points controlling the Channel and the North Sea, reorienting England's interests toward Normandy and Flanders and enabling the Godwinson earls to gain wider influence and power.[75] Not only was Bosham a site of strategic importance to Harold's power base in England, but also the manor and church were reportedly acquired by his father Earl Godwin in the 1050s by unscrupulous means and trickery;[76] it was from this Sussex port that he and his family fled when driven into temporary exile by King Edward. As Shirley Ann Brown suggests, the singular depiction of Bosham at the outset of the Bayeux Tapestry's narrative may have been intended as an allusive index to Harold's char-

acter. Just as his father had rebelled against Edward and had taken what was not rightly his, namely the Bosham estate, the son can be seen to continue a perfidious Godwinson tradition by seizing the English crown. Interestingly, after 1066, Bosham was one of the legacies that came into the hands of the Tapestry's patron, Odo of Bayeux.

The cluster of Bosham events shows Harold in constant transition, marked by a number of conventional moves, first through the gate of Westminster palace (Fig. 4), then descending the stairs of his manor house, and finally embarking on a boat (Fig. 6), so that he is seen making a triple departure from England in full-scale epic style.[77] In terms of linear movement through the horizontal, mapped spaces, Edward remains fixed in England but eventually disappears into the mists of memory as a defunct but sacred relic of the past, firmly fixed in his burial place at Westminster. In contrast, Harold is characteristically unstable, moving first from England to Normandy and then back again. However, it is William who initiates and commands a trajectory of conquest aimed in only one direction, from Normandy to England, the targeted goal of his single-minded ambition.

SCENIC EPISODES

Within the medieval narrative economy of the Bayeux Tapestry, the story is characteristically conceived in terms of episodes or relatively discrete moments in time and place.[78] Loosely held together in a linear sequence, they are of short or long duration and consist of silent dialogue or described action. Episodes are defined textually by the grammatical closures of their accompanying inscriptions. Since the designer tends to cluster together two or three consecutive actions, the inscriptions serve as the only reliable guide to what constitutes a single scenic episode.[79] The provisional caesuras created by periodic statements are then reinforced by bracketing architectural markers, trees, and shifts in the directional movement of figures. The episode can thus be experienced as a segment of time, its unity as a single occasion. In the end, these occasions are considered only part of a unified narrative time because of

the implicit chronology or plot line that makes them a sequence. Although individual scenes in medieval texts are introduced most commonly by temporal clauses such as *cum, dum,* or *tunc,* marking the relative position of events in time, those in the Bayeux Tapestry, as we have seen, are opened by the locational signifiers HIC or UBI.[80]

Functioning on the surface, on the level of manifestation, episodes have no meaning outside the context of the narrative.[81] Within the overall coherence of the text, as Peter Haidu points out, episodes tends to be modular in form and serial in content. As basic actions involving travel or the physical displacement by land and sea are repeated, their meaning is transformed with each new context.[82] As we shall see, basic actions representing physical powers – to imprison, free, kill, or save – operate in seriatim on a similar narrative level. This does not mean, however, that we can assume that the Bayeux Tapestry's narrative was always experienced as a chronological whole from beginning to end. As with all well-known stories, episodes could be singled out for isolated performance or "reading." Particularly within the context of medieval oral traditions, linear textual progression was probably elided more often than not by the performance of isolated episodes.[83] Following the suggestion of John Foley, we might find a useful paradigm in observing the present-day Bhopa, who performs an epic by singing and dancing single events from the "whole story" in front of a tapestry on which are depicted scenes from the larger epic, using a pointer made of peacock feathers to indicate which episode he will perform from among the many visually represented behind him.[84]

In any narrative, events or episodes have a logic of hierarchy. In classical narrative, only major events function as part of the chain or armature of contingency, as they advance the plot by creating crossroads in direction. Whereas such nodes or hinges in the structure cannot be deleted without destroying the narrative logic, minor episodes are expendable, since their primary function is to fill in details. In the medieval and essentially anticlassical narrative structure of the Bayeux Tapestry, the visual discourse moves from one heavily weighted major event to the next with a concentrated, relentless force. Unrelieved by lighter mo-

ments of dispensable elaboration or expansion, each and every frame strikes the viewer as potentially loaded with meaning, as a proleptic branching point that might force an action or decision into one or two possible paths. Within the paratactic structure of fast cutaway, the viewer can never be certain that what might at first glance seem secondary will not turn out to function as a major foreshadowing. For the tapestry's audiences, the anxiety of suspense was a reflex not of uncertainty about outcome, since that was already foregone and known, but of uncertainty about how. It is within the subjunctive realm of proleptic possibility that the episodes of the Bayeux Tapestry acquire narrative weight.

Although all medieval narrative consists almost exclusively of scenes,[85] the scenic conception of episode dominates the Bayeux Tapestry for the obvious reason that the "text" is fully visualized in terms of specific spaces and gestures. The narrative shows and tells in a simultaneous process of mimesis and deigesis. On the other hand, medieval texts tend to tell a story in the same curiously timeless terms, so that narrative is often perceived surprisingly like a picture. Episodes are constructed of visualized figures, grouped, balanced, and contrasted in various ways, so that the unity of the work is more that of the complex image than that of a *récit*.[86] The designer-narrator lets the story speak for itself, creating the illusion that the viewer-reader is witnessing the events he describes in images and words, an implicit narrative gesture inviting us to see for ourselves and form our own reactions and judgments.[87] The scenic episode represents a transaction between particular characters in their own words and actions, without the mediation of an authorial commentary. As we saw in the initial scene of Harold before King Edward, the pantomime of setting and gesture conveys the drama of the situation. Within the ceremonial of the medieval courts, royal insignia carried complex social and ideological meanings encoded for a contemporary audience, so that, when the king speaks, his voice is coming from a man invisible behind the regalia – his words come from a power greater than the man himself.[88]

In the absence of direct speech, as we have seen, the Bayeux Tapestry's scenic episodes are staged exclusively by gestures, a strategy that is

seldom used in textual narrative. Instead of being the subject of dialogue, gestures more traditionally accompany speech, to indicate the narrator's dramatic conception of the scene. As Otto Pächt argued, gestures in medieval art are rarely organically related to the action of the figures; they are used as signposts, guiding the viewer and helping him or her to grasp the significance of the story.[89] In the frequent scenes where other characters point to the protagonists, their gestures are addressed to the beholder. In an oral tradition of theatrical performance, the actors of the drama are thus speaking to us, not to their fellow actors on stage. Normal gestures are stylized; movements are cadenced into memorable rhythmic cycles. The body constructs a rhythmic grid against which the narrative images are externalized. In contrast to the audience's cognitive concern with plot, the response to patterns of mimed gesture is wholly emotional.[90] Silent movements create a dance that connects the narrative to its audience, making possible the communication of a message that is, in essence, a renewed sense of order.[91]

Given the critical importance of gesture and movement, the minimal, sketchlike forms of gestural staging in the Bayeux Tapestry's scenic episodes display a surprising lack of physical precision to the modern eye. As in the inaugural scene at Westminster, very short scenic units are crammed full of silent dialogue, physical action, and significant objects. Because signifiers are clearly overwhelmed by the signified, and the surface elements of the scene carry a disproportionate load of abstract and emotional significance, it becomes difficult to experience the scenic episode as a unit of meaning, for the point of the narrative operates far below its surface.[92] In the Tapestry's narrative style, the scenic episode tends to be reduced to a "fascinating but skeletal diagram." Although the story-space, like that in film, is literal, the characters seem to function in a space that exists abstractly at a deep narrative level, in the kind of space projected in the mind's eye of a reader. In film, the visual point of view is always here, fixed and determinate precisely because the camera always needs to be placed somewhere; but in the Bayeux Tapestry, as in verbal fiction, we are given a visual bearing that represents a uniform and generalized perspective.[93] Scenes are observed as if they unfold on a

stage proscenium from a fixed, medium-distant position. Every movement is encoded and therefore instrumental, not interesting in itself. The minimal staging of the entire scene alerts the viewer to the abstract meanings that make up the real interest of the story – its discourse. As Joaquín Martinez Pizarro points out, medieval narrative is vivid and dramatic to a degree that is incompatible with its meager range of sensory content.[94] At the same time, this paradox defines what is unique in medieval style. As we shall see, the scenic episodes in the Bayeux Tapestry are units of dramatized meaning, schematic in the extreme, yet emotionally powerful.

Much of the narrative tension is generated by frequent scenes in which the action seems literally arrested, as in the first episode in which Harold speaks with Edward at Westminster (Fig. 1). As the two protagonists face each other within a tightly enclosed space, the momentary closure creates an effect resembling the "freeze-frame" in film, not a description but a kind of "congealed iteration of future behavior." Within the framework of illusory story-time, a moment when nothing moves is still felt to be part of the temporal whole – in Chatman's apt simile, "Just as the taxi meter continues to run as we sit fidgeting in a traffic jam."[95]

Harold and Count Guy at Ponthieu

Harold's expedition to Normandy is interrupted by a literal diversion as his ship is blown off course and he lands instead at Ponthieu, where he is captured and briefly held for ransom by Count Guy. Although this sequence of four inscribed episodes seems to introduce a needless complication to the main business of Harold's meeting with William, and is indeed ignored by the Anglo-Saxon sources, it forms a salient part of the contemporary Norman accounts as well as the later Anglo-Norman versions offered by Eadmer and Wace.[96] In the Bayeux Tapestry, the sequence establishes a pattern of events moving the action through space and time: voyage, landing and seizure, escort to a castle, ending with a silent colloquy between the two protagonists, Harold and Guy. The sequential paradigm will be repeated with variations throughout the long

visual narrative. More important, a number of contradictory elements are introduced that tend to work at odds with other historical accounts, creating subversive perforations that cause the viewer to "see through" the surface fabric of the story and to reassess the meaning of what happened at Ponthieu.

Although Harold's mission was ostensibly a peaceful one, he is shown sailing in a war galley filled with shields (Fig. 7).[97] He is then shown standing alone in the prow of a landing craft, carrying a lance as he commands the ship to be brought ashore. No wonder that Count Guy commanded his seizure (Fig. 8). With the ship's anchor at Harold's feet, his journey is now brought to an abrupt halt at the water's edge; he is immobilized by two soldiers and approached by the count and his army. Although William of Poitiers complained of Guy's "barbarous practice of seizing the high and powerful to be held for ransom,"[98] and Wace is outraged that Harold is imprisoned without cause,[99] we see Harold being treated not as a prisoner but with the utmost courtesy as a guest, apparently in accordance with the conventions of ransom widespread among Norman knights.[100] Harold thus finds himself in a truly "alien" terrain, a world where private wars were endemic among the nobility and where Anglo-Saxon codes of conduct were no longer honored.

Although an accepted part of knightly conduct, capture for ransom was restricted to theaters of combat warfare. In these terms we can now see the point of the Bayeux Tapestry's interpolation of weaponry into Harold's expeditionary force. He is clearly cast as an alien intruder, a potential military invader who prefigures and indeed provides just cause for the future invasion that will proceed in a reverse direction. The shoreline near the mouth of the Somme where Harold is captured within the comté of Ponthieu ceases to be neutral ground;[101] it becomes the first threshold of armed conflict. The juxtaposition of the two shorelines bordering the Channel locates Harold in a liminal role, drawing the viewer into a realization of his larger situation vis-à-vis the English succession, as well as the marginal, that is, dubious nature of his actions.

Working at odds with William of Poitiers' characterization of what happened and in contradiction to the inscription declaring that Harold

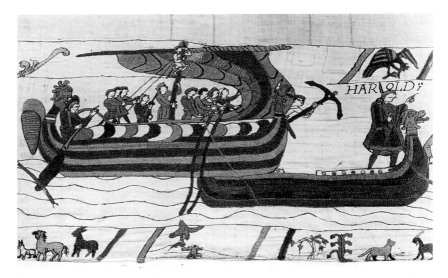

Figure 7. Harold Lands at Ponthieu. Bayeux, Musée de la Tapisserie (photo: Giraudon/Art Resource, NY)

Figure 8. Guy Seizes Harold at Ponthieu. Bayeux, Musée de la Tapisserie (photo: Marburg/Art Resource, NY)

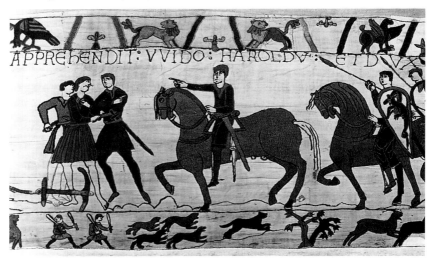

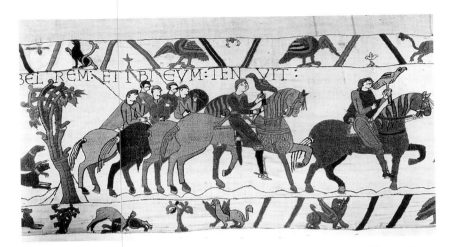

Figure 9. Harold Taken to Beaurain. Bayeux, Musée de la Tapisserie (photo: Giraudon/Art Resource, NY)

Figure 10. Harold and Guy Converse at Beaurain. Bayeux, Musée de la Tapisserie (photo: Giraudon/Art Resource, NY)

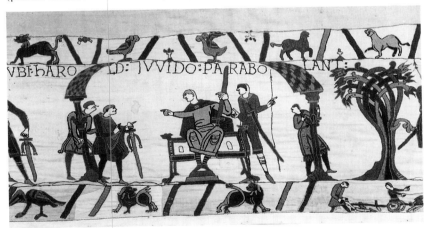

was held prisoner at Beaurain (ET DVXIT EVM AD BELREM ET IBI EVM TENVIT),[102] Harold and his men ride great steeds, carry their hawks, and are followed by dogs as if on a hunt rather than being led to incarceration in the count's castle (Fig. 9). Although Harold is no longer armed with lance and shield, his intrusion into another noble's land across the Channel can be construed as no less arrogant and aggressive. Having asserted hunting rights at Bosham, the Anglo-Saxon earl is clearly trespassing at Ponthieu, and is thereby characterized as an outsider to feudal privileges within territory held in fief to the Norman duke. As David Bernstein observed, Harold was first depicted as a hunter setting forth from England and immediately upon arriving in France, "the hunter himself is captured."[103]

The sequence at Ponthieu ends with a scene in which Harold and Guy are discussing an unnamed topic in the castle at Beaurain (Fig. 10). It is a moment that has gone unrecorded by the historians but one that functions in the Bayeux Tapestry to fix the viewer's attention on the several registers of Harold's relationship to Guy. As the Anglo-Saxon earl crosses the threshold of the great vaulted hall, he is a powerless outsider, a petitioner for his freedom. Although he still bears arms, his sword is pointed downward in a gesture of submission as he faces Guy, whose upright sword and commanding gesture signal his power over Harold's fate. Contradicting the more usual medieval tendency to fill spaces more densely, the empty space between the two figures stretches into a wide break, creating a dramatic gap within the enclosing architectural canopy. That Harold remains an outsider is further signaled by relegating the first four letters of his inscribed name to the outside of the building. As Guy's colloquy with Harold is interrupted by a man pulling at his elbow, signaling the arrival of a messenger from the duke, the two protagonists move even farther apart both physically and ideologically. The hostile, alienating mood of this scene stresses Harold's role as an interloper into a world of feudal bonds and loyalty that he will soon betray.

The whole sequence of events at Ponthieu was probably intended to remind the knowledgeable viewer that the first count was captured at Mortemer in 1051, held prisoner by the Normans at Bayeux, and, after

his release, became William's vassal.[104] Within the Norman scheme, Harold will follow this pattern; in a proleptic sense the scene can be read as a prelude to the initiation of the earl of Wessex as William's vassal. If Guy functions as a link between Harold and William, the castle at Beaurain can be perceived as a porous place of transition, open at both ends, with Harold entering at one end and William's messenger pressing in at the other. As suggested by the spatial tensions created by the figures pulling apart within Beaurain Castle, Harold's imminent vassalage will be built literally on quicksand and will break apart. The Bayeux Tapestry's visualization of the wayward beginning of Harold's journey to Normandy thus signals the doomed character of the whole enterprise, tending to confirm Eadmer's report of the king's warning and the viewer's sense of unease in the presence of an ongoing ambiguity of moral direction. If Guy's role in the larger discourse is to serve as a link between Harold and William, it can be seen to weaken and fail at the outset in the large gap that dominates the conference at Beaurain. Harold's failure to cross the threshold at this moment fixes his moral center for the remainder of the narrative. His loyalty remains rooted in the old Anglo-Saxon pre-feudal alliances with England and his king.

FABLES

Fable constitutes an important medieval literary genre and in that sense could have been discussed earlier along with epic and panegyric. However, the fabulous components of the Bayeux Tapestry do not function entirely in the same way, nor do they bear analogous relationships to the narrative as a whole. Like the silent voices, shifting places, and scenic episodes, the animal fables that populate the borders constitute narrative strategies that implicate the viewer in the creation of discursive meaning.

For the most part, the upper and lower borders of the Bayeux Tapestry are filled with pairs of birds and animals, forming a zoological frame of about 450 beasts.[105] What has captured the attention of modern interpreters, however, are the scenes illustrating at least nine fables of Ae-

sop.[106] Contrasting with the relentless, unbroken surge of events that constitute the main visual narrative, the fables are characteristically concentrated in single, isolated, brief episodes, each separately framed. The Aesopian tales are dispersed randomly along the length of the Tapestry, mainly but not entirely in the lower border. Their random distribution and repetition suggest an intentional alignment with episodes or characters in the central narrative.[107] Interestingly, the heaviest concentration of fables occurs in the lower border at the beginning of Harold's journey to Normandy. The Fox and Crow, Wolf and Lamb, Bitch and her Litter, Wolf and Crane, and Wolf-King, Mouse and Frog, Goat and Wolf follow in quick succession, from the moment the earl leaves Bosham until he is captured at Ponthieu.[108] All the stories deal with trickery, deceit, betrayal, and greed, without exception exemplified by the wrongful appropriation of territory or food.

On several different levels, the Bayeux Tapestry's fables construct a discursive realm intended to be perceived as a significant "other," critically differentiated from the main narrative. The irregular diagonal lines framing each episode form jagged, disruptive patterns that tend to deflect the viewer's gaze from the continuous progression of the dominant plot line.[109] Clearly distanced from the monumentally scaled and expansive genres of literary history, epic, and panegyric framing the story of the Norman Conquest, fable is one of the smallest of "small" literary forms.[110] Its gross anatomy requires a narrative that is characteristically brief, so concise that the distinction between means and end disappears.[111] Compression of events creates an abridgment of time that removes the stories from the regime of history. No causal relation to the past complicates a dominant present. Entirely alien to the complex motives and narrative indeterminacies of the central *récit,* the Aesopian tales are stereotypical and unambiguously open.[112] Characteristically revealed through the fictitious conversations of dumb animals, the characters generate a representation of singular and uncomplicated motivations that move to predictable ends.[113]

In the kingdom of animals that inhabit the Bayeux Tapestry's fables, the world of nature turns out to be the world of human nature. When

animals are given speech, their instinctive desires and acts acquire moral, social, and political value.[114] Because animals do not ordinarily speak, the regime of the fable is automatically defined as fiction. But clothing a beast's speech within an alien discursive mode does not alter its essential nature. If the fox and wolf are permitted to speak with their own voices, they have only one thing to say.[115] The animals in fables tell some hard truths, that is, nonfictions.[116] In the twelfth-century view of Conrad of Hirsau, "Their invented stories . . . correspond to the truth."[117]

In the Bayeux Tapestry the fabulist's strategy in giving animals speech operates in an especially powerful way, working against the grain of the human silences in the main narrative. As Berel Lang observes,

> The "fact" that animals do not speak outside of fables foreshadows the many other facts in larger fictions that also have not "happened," the fable is only more candid than other literary forms in admitting the dependence of invention on what is already known and known to be true, that is, to be fact.[118]

By invoking intertextual connections created in the juxtaposition of fable and epic history, the viewer's "invention" of speech for the mute protagonists acquires further legitimacy in its claim to the truth. The fabulist's assertion of the humanly familiar creates a set of operational identities recognizable to the reader. Conversely, the Bayeux Tapestry's assumption of such familiarity with the genre identifies the viewer as belonging to an elite court society in which an oral tradition for such texts would be accessible. When the "animal-in-the-text" becomes the strategy that enables the discovery of humans in the text, this process becomes a critical part of the story. As Lang has argued, it *is* the story.[119] Because animals do not have ideas, the reader is free to treat animals as ideas, and the moral of the story unfolds as part of its action.[120] Within the abbreviated economy of the fable's structure, as idea and action merge, the two are visible to the viewer in a single eye-scan. In the world of the fable, a part of the meaning that we find is constituted by the act of searching for it.[121]

In one of the most popular medieval versions of Aesop's fables,

Avianus added short commentaries to the text, thus habituating the readers and hearers of such tales to interpreting the surface story in terms of an abstract moral precept.[122] Small scale and seemingly naive simplicity disguise the seriousness and force of their arguments.[123] Just as the pretense of humility frequently masks ambition in the fables' stock of moral aphorisms, quotations of and reference to fables appealed to a shared world of moral beliefs. They could be used as arguments about politics, in the widest sense of agreement about social life and individual action – in short, as an invocation of ideological values. Just as trickery and deceit form the standard moral vocabulary of the fable, subterfuge serves as a major strategy in inducing the viewer to become actively complicit in the Bayeux Tapestry's narrative project on a larger scale. Things are not what they seem, and it falls to the viewer to discover the "truth." Just as a *fabula* can be defined as a rationalized or interpreted segment of history, its discourse can map out or define the reader's role in the main narrative.[124]

In their primal narrative essence, fables belong to the realm of what Aristotle called *mythos,* the force that plots out human events into a humanly comprehensible order.[125] Differentiated from descriptive "history," the veracity of fiction in the mythic fable inheres in its being something told, heard, and repeated. As Barbara Herrnstein Smith observes, however, these "sayings" seem "in fact never to have been said at all but rather to have arisen *in toto* from the culture or verbal community as a sort of eternal verbal response to an eternal state of affairs."[126] As a compendium of collective signs, myth possesses the "authority of the ritually stabilized," having become a sum of the narrational habituations of living culture through performance.[127] Because their meanings are indefinite enough to cover almost all human, natural, and historical exigencies, fables, along with proverbs, embody timeless wisdom or universal truth. Hence the readiness with which they lend themselves to metaphoric or parabolic application.[128] As we observed in the strategy of silencing dialogue in the Bayeux Tapestry, the quotation of fables manages to say something without assuming the responsibility for having said it. The narrator-designer disclaims authorship of the utterance

but does not dissociate himself from either its general "truth" or its applicability to the particular situation at hand.[129]

Not only because it is given pride of place as the first in the Bayeux Tapestry's series of fables but also because it is the only tale to be represented in three different places, the story of the Fox and the Crow commands our special attention.[130] Just beneath the stairs leading to the sea from the banquet in Harold's manor house at Bosham (Figs. 6 and 11), we see the crow perched on a tree branch, losing a piece of cheese to a fox who has tricked him by flattery into opening his mouth, by challenging him to sing, to be something he is not.[131] In its initial pictorialization, the cheese is falling in mid-air, still in contention between two rivals. When we next see the fabled pair, as Harold accompanies William on an expedition to Brittany, the fox is firmly in possession of the cheese (Figs. 12 and 25). The last version is aligned in the upper margin with Harold's return to England (Figs. 13 and 32) – and we have returned to the beginning of the fable where the crow still holds the cheese in his beak in a classic configuration encapsulating the entire narrative. The cheese now seems more difficult to seize, as spatial distance and barriers now separate the fox from his victim.

Before we discuss the fable's connections to the main narrative, let us examine the narrative embedded in the fable itself. The situation is stated simply and directly in the juxtaposition of the fox looking at the crow with the cheese in his beak, so that the fox's physical proximity and desire for the cheese motivate his discourse to the crow. Like the speeches in the main narrative, the dialogue is silent and must be supplied by the viewer. It is the spoken discourse that reveals the creation of a counterdesire in the crow to sing that will enable the fox to satisfy his own desire for the cheese. The pivotal move from physical event to interior motivation is made both by the characters and by the viewer. The story or plot is embedded in the difference or gap that exists between their respective perceptions. Because the fabled discourse centers on the unforeseen transfer or control or possession, the whole narrative hinges on the reader's perception and the crow's misperception of the fox's deceptive scheme. In the Bayeux Tapestry's reversed order of telling, the pro-

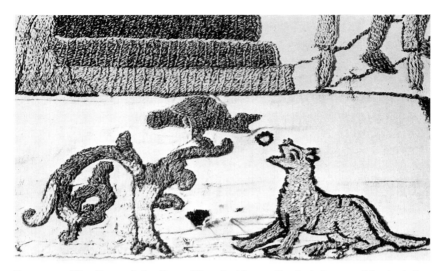

Figure 11. The Fox and the Crow (Detail of Lower Border). Bayeux, Musée de la Tapisserie (photo: Latomus)

jected outcome of the plot is revealed in the first two illustrations, before the physical situation leading to the conflicting desires for the cheese has been established. The viewer can then conclude that on the English side of the Channel the crow has the cheese; in Normandy, possession shifts to the fox. The disruptive force causing the conflicting desires for the cheese thus appears to be aligned with Harold's departure from England. The moment he sets foot toward Normandy, the prize makes its way into the mouth of the hungry fox. As J. Bard McNulty has argued, the cheese represents the crown and succession to the English throne.[132]

Unlike narrative indeterminacies that create spaces for the viewer's involvement in the main register of action, the moral embedded in fable is not an interpretation. There is no room left for doubt or speculation, for there is no plausible alternative to the one given.[133] Just as the animal characters themselves cannot reflect within the fable on who or what they are, the reader cannot distinguish the literal act from the moral conclusion implied by it or reflect on alternate possibilities. Indeed, the

Figure 12. The Fox and the Crow (Detail of Lower Border). Bayeux, Musée de la Tapisserie (photo: Latomus)

Figure 13. The Fox and the Crow (Detail of Upper Border). Bayeux, Musée de la Tapisserie (photo: Latomus)

morals of fables are not "moral" in the sense that they involve ethical obligations.[134] As we saw with the Fox and Crow, one character's desire is thwarted by another character who opposes and defeats him by his own desire. As Lang argues, it is not in itself immoral to want more than you have, nor to lose what you already have as the result of an attempt to get more.[135] As desire and self-interest are the motives for the action in the fable, they also offer clues to its resolution. Because the crow's craving for praise and ambition for the highest position among birds causes him to forget for the moment his desire for the cheese, he ends up with neither. The moral, like the joke, is *on* him, not *by* him.[136] In attempting to be something more than he is, to have his cake and eat it too, the crow ends up with less. We are thus dealing with delusive aspirations and unsuitable desires.[137]

Within the world of animals, neutrality prevails in a zero-sum game. The fox can gain only through the crow's loss. Because it was stolen or found by the crow in the first place, the cheese is not part of the "natural" equation. The moral of the fable lies outside its own discourse, to be drawn by the reader within another, human framework.[138] Thus, for example, neutrality disappears in the realm of epic, where animals are either friends or enemies.[139] As the fable relates to the larger text of the Bayeux Tapestry, the morality of choice is built upon and defined by the language of feudal obligations and privileges, by the notion of *dreit* (or "right"),[140] implying an order that allocates to each creature whatever is appropriate to it, an established order against which it is wrong to rebel by overweening desire. The Fox and Crow fable thus makes the point that the pride of those overly eager for high praise is appropriately served by the lying flattery of others.[141]

The still-point upon which morality turns within an economy of feudal values is, of course, the recognition and operation of order and its limitations. The fable makes itself a boundary between the real and the illusory. It defines a threshold between desire and its imagined object, and thus displays the dangers of seeking to erase this threshold. In the moral reading of the fable, it is the reader's perception of where and how the animals of the fable situate themselves with respect to this boundary

that constitutes the reader's own position within the order of things. As the reader must stand precisely upon this boundary, the fable becomes the locus of interpretation.[142]

The marginal location of the fables in the borders of the Bayeux Tapestry visualizes and reifies the liminality of their situations. Fable has nothing to say about the feudally ordered or corrupted world in its own right, but finds its proper center in the endlessly varied intersections of order and disorder on the margins. Fable itself is always at a crossroads. Its vision is bipolar, moving back and forth between the worlds of animals and men. Just as the animal fable adheres to the borders of large genres and major texts, it assumes a limited place in the Bayeux Tapestry from which it can assess the conflict of human desires and counter-desires from a uniquely privileged perspective.[143]

Returning to the string of fables marking Harold's journey to Normandy, we can now explore their overall impact on the viewer's perception. On a purely formal and visual level, they can be seen to disrupt the order of symmetrically paired birds and beasts that form the prevailing border pattern from beginning to end.[144] They introduce an entropy that not only draws the viewer's attention but also signals the very nature of their significance. By destabilizing an established order, they can be seen to function on a metaphorical level to represent an interruption in the orderly succession of the English crown prior to 1066 as well as a subversive undermining of the feudal order set in place after the Conquest. As McNulty observed, similar metaphorical disruptions in the border pattern occur when symmetrically placed birds are knocked off balance in the margins of battle scenes.[145]

The potentially subversive power of the fables lies in the indeterminacy and ambiguity of their discourse. As is suggested by the pervasive disagreements among modern interpreters, the border fables constitute just as much an ideological battleground as the main narrative. The viewer is pulled into their discourse, first on the simple level of reading fable as moral. Then, as he or she is forced to choose between conflicting ideologies, the viewer must seek alignment either with the old insular but loose and generally closed power structure of Anglo-Saxon England or

with the new Norman feudal order of globally scaled and absolute binding loyalties between a lord and his vassals.

In the conventionalized world of victim and predator, conflicting desires create a microcosm of power relationships. The first fable of the Fox and Crow significantly breaks the pattern of the weak unfairly pitted against the strong as legitimators and wielders of power by centering the plot on two predators related only by their desire for the same object. However, the crow is diverted by a conflicting desire for higher status and prestige into a system that values beauty and song, whereas the fox is single-minded and practical, subverting the alien values of his rival to his advantage. Linked to the main narrative, the contest between the fox and crow encapsulates the rivalry between Harold and William for the English crown. When viewed within the feudal system of values represented by the Norman duke, William becomes the crow victimized by Harold's cunning and duplicity.[146] Not only is the ambitious English earl a fox, his craft is then seen in a succession of animal roles, disguising and at the same time revealing his true nature as a deceptive predator, reinforcing his otherwise unexplained role as hunter in the main narrative. Indeed, the first illustration of this fable is aligned below the figure of Harold setting out with his hawk and dogs. From this perspective, the whole sequence of fables can be seen as a warning to the viewer that Harold's fair appearances are deceptive.

From the Anglo-Saxon side, Harold can be perceived as the crow, a foolish dupe who is tricked by the cunning William (fox) into playing a new game without being told the rules. In this way, the fables seem to demonstrate the consequences of Harold's failure to heed Edward's counsel of prudence given in Eadmer's English version of the story.[147] As McNulty points out, whereas the cheese is not yet in the possession of either contender before Harold leaves England, the prize will be seized by the fox when William leads his captive-guest on an expedition that will in turn lead to Bayeux and the fateful oath in which Harold will unknowingly relinquish his claim to the throne.[148] Once Harold returns to England, free from the immediate and dangerous power of William, the cheese is shown in the mouth of the crow, but by this time the point

has been driven home that the crown is no longer securely in English control.[149]

The positioning of identical versions of the next fable of the Wolf and Crane at the outset of Harold's voyage (Figs. 6 and 14) and then directly above the landing place on his return (Fig. 32) can be seen to cast Harold in a similar role as victim. In the fable the crane extracts a bone stuck in the wolf's throat, but fails to receive the promised reward. As the predator explains, "You have had your head in the mouth of a wolf and have survived. That is your reward!" As Bernstein argues, this fable is equally porous to conflicting interpretation. Whereas the Canterbury historian Eadmer emphasized Harold's folly for placing himself in William's clutches, the Norman historians stress Harold's ingratitude to the duke for rescuing him from Count Guy.[150] But it must be remembered that Harold's debt to William was negotiable only within the framework of the new Norman feudal regime and had no validity in England, where it could not take precedence over the earl's obedience to his king. Along similar lines, in the simple confrontation between the strong and the weak that occurs in the fable of the Wolf and the Lamb, the ruthless and illegitimate seizure of the lamb's watering hole can be seen as the kind of flagrant abuse of power that seems to have more relevance to the fate of the English after the Norman Conquest than to any purported tyrannies committed by Harold during his brief rule.

In the case of the Pregnant Bitch who refused to relinquish a borrowed refuge after her litter was raised (Fig. 15), Harold's use of guile can be seen to cause the use of force by William.[151] Not only the moral turning point of the broken promise but also the provisional nature of a territorial claim seem to shift the collective force of the fable's argument to William's side. Marie de France's later moralization of this tale to show how a good man can be driven out of his lawful inheritance was in fact an argument advanced by William in his successful effort to raise troops for the invasion.[152] In the Bayeux Tapestry, the second illustration of the fable is aligned with William leading his troops into battle at Hastings.

Norman voices seem to dominate the fables at the end of the series, closing the arguments for William's cause. In the last fable in which vi-

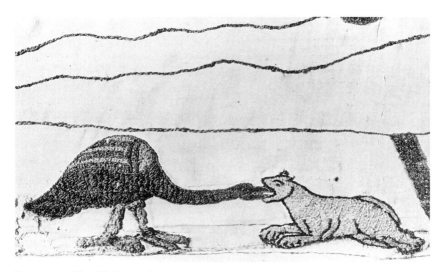

Figure 14. The Wolf and the Crane (Detail of Lower Border). Bayeux, Musée de la Tapisserie (photo: Latomus)

Figure 15. Bitch with Her Litter (Detail of Lower Border). Bayeux, Musée de la Tapisserie (photo: Latomus)

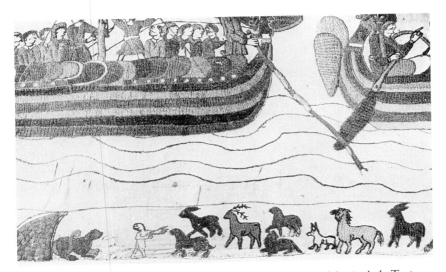

Figure 16. The Wolf King (Detail of Lower Border). Bayeux, Musée de la Tapisserie (photo: Latomus)

Figure 17. The Goat Who Sang (Detail of Upper Border). Bayeux, Musée de la Tapisserie (photo: Latomus)

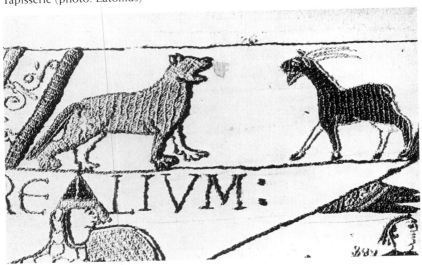

olence and fraud reign as paths to power (Fig. 16), the Wolf King makes the most obvious and direct reference to what can be seen as Harold's wrongful, illegitimate succession. As the illustration appears beneath the earl's ship making its way to Normandy (Fig. 6), the viewer must draw the inevitable inference that Harold is carrying a message from Edward promising William the crown. When the good Lion King, who has no heir, urges his subjects to choose a new king, they elect a wolf, from whom they extract an oath never to harm the other animals, but when the wolf becomes hungry for meat, he breaks all his promises. The fortuitous elements of an heirless kingdom, the election of a new king by royal counselors and the swearing of an oath in this fable conspire toward an unmistakable identification with Harold as the villain.[153]

In the last two fables we discuss, the viewer is pulled into seeing how the feudal system works without being offered an alternative. The Goat Who Sang first appears beneath the episode in which Guy captures Harold (Figs. 7 and 17) and then again when William is shown with his forces enlisted from both within and outside Normandy to support his cause. A goat caught by a wolf persuades his captor to let him sing a mass before he is killed and eaten. When the wolf agrees, the goat sings so loudly that men come hurrying to his rescue. Their response can be read as an unambiguous reference to the kinds of feudal ties that enabled William to rescue Harold from Guy's ransom demands, just as it demonstrates William's feudal power to enlist massive support from neighboring lords and vassals for the invasion of England. The series of fables ends with a related display of feudal rights and privileges, in this case royal exclusionary rights to hunt in his vassals' demesne. The fable of the lion hunting with his chosen companions constitutes a flat assertion of a victor's right to control the spoils.[154] But, more important, it defines Harold's role as hunter at the beginning of the main narrative as a potential poacher and usurper of royal privilege. The last fable openly and proleptically refers to the new regime that will prevail in England after the Conquest, so that Harold's transgression will be perceived by contemporary court audiences as egregious and intolerable.

The discourse of the Bayeux Tapestry centers on change, not simply

the convulsive disruption brought by the military conquest, but a slower, more gradual process of cultural and political transformation from Anglo-Saxon to Anglo-Norman. The post-Conquest model of power formation has been characterized as what Lévi-Strauss called a *bricolage*,[155] a recognizably new entity created from existing elements used, reshaped, and reused, moving from the distribution and redistribution of land and resources to a tinkering with all levels of language and culture. Notwithstanding the determination of the conquering lords to keep "the conquered people" (*gente subiecta*) in a state of dependence, coercion also involved an "illusion of choice," in which Norman and Anglo-Saxon alike were subject to constant tests of ability and loyalty. In a very real sense, the Bayeux Tapestry confronted the contemporary post-Conquest viewer with just such a test.

The string of fables seems to leave options open at the beginning of the sequence, but then closes the English options off at the end, so that the biased but unsuspecting viewer has the illusion of making a choice, although no alternative is actually offered. The transgressive subtexts thus function as a deceptive but effective strategy to win English audiences over to Norman rule. Like the fables themselves, these minidramas of conflicting desire operate in a seemingly direct but duplicitous way, targeting the viewer with lingering loyalties or sympathies with the old regime and then drawing him or her into a realization of the inevitability if not the rightness of the Conquest. Subversive in favor of the Norman cause, it is a strategy of propaganda leading to the conversion of shifting loyalties in the years of transition following 1066. As we shall see, the same strategy of a gradual but inevitable closure of ambiguity dominates the end of the main narrative.

CHAPTER THREE

NARRATIVE STRUCTURES: THE UNFOLDING OF DISCOURSE IN EVENT CLUSTERS

OTWITHSTANDING ITS EPISODIC AND SOME-times disjunct unfolding of the narrative, the Bayeux Tapestry was clearly designed as a totality. Although the work is constructed of eight separate pieces of uneven length,[1] the sutures do not occur between scenes or episodes but between words of the inscriptions. As Michel Parisse points out, the artistic production was not a traditional tapestry hung on a wall to keep out the cold but a story meant to be read as a continuous *récit*.[2] Whereas the interlocking implications of each event serve to link them over the wide span of the whole, the narrative organization is based on relays of smaller units, event clusters or "microsequences," that make up the fine grain of its texture. In Barthes' terms, actions tend to cohere into nominal events or template schemata to which the reader-viewer can internally respond with descriptive headings, such as "journey" or "encounter," that will ultimately function as a network of ideas that bind the narrative together.[3]

Medieval plots tend to display a loosely knit sequential structure of events strung serially along a line of action.[4] Because each cluster has a degree of unity that can be perceived as a reasonably coherent and independent short narrative, certain symmetrical effects can be achieved through repetition, reversal, or inversion, when the same action occurs under different circumstances. The isotropic groupings of episodes build their own tensions and resolutions, creating gaps that give rise to a sense of provisional closure and isolation.[5] Repetition creates a sense of antic-

74

ipation as each iteration contains new information. When the designer neglects to fulfill the audience's expectations by altering or refusing to repeat a pattern, tension is introduced and the reader-viewer becomes uncomfortable and anxious.[6] Within this kind of serial or modular structure, the repeated resolution of episodic tensions offers the medieval audience an experience of multiple climaxes.[7]

The story's design as a series of scenes is a purely rhetorical strategy, which invites viewers to "see for themselves." Appealing to the visual and dramatic imagination of the reader-viewer, the invitation is clearly illusionistic in purpose and effect. Just as scenic narration continues to dominate fiction today, in the Bayeux Tapestry we find ourselves in the grip of scripted gestures and the illusion they generate. As Michel Parisse observes, its succession of clearly marked tableaux becomes most accessible to us in terms of film – *mise-en-scène* and montage.[8] The "film" is thus organized in relatively long sequences, a sequence comprising several scenes or "shots" unfolding in time, but sometimes in different places. For each change of sequence, whether a rupture of time or displacement to another site, a visual signifier (stylized tree or building) marks the "cut," or ellipse.[9] Interestingly, the Bayeux Tapestry uses a technique similar to the "fast cutaway" of twentieth-century films that reveals an analogous lack of concern with showing how characters get from one place to another.[10] In contrast with the logic of connection in the fast-changing world of contemporary film, such gaps are perceived not only as the passage of time but also as a necessary apparatus of "screen punctuation" for the medieval viewer. The syntagmatic separation of event-clusters also creates narrative interstices or pauses similar to cinematic "fades" that permit the viewer to absorb the impact of the semantic sequence.[11] Actual cuts in time, however, such as the four months separating Harold's coronation and the appearance of the comet, or the two months between William's ordering of the fleet and its embarkation, are elided without mimetic or metaphorical markers.[12] The viewer of the Bayeux Tapestry is offered no clue that its events, actually unfolding over two-and-a-half years, have been compressed into a single experience of present time.

In the visual narrative of the Bayeux Tapestry, the fundamental and pervasive illusion of space becomes dominant. As we have already seen, the concept of "scene," in itself an essentially pictorial idea, is defined in two ways – as place or setting and as a moment in time. Similarly, dialogue, which is inherently temporal, is relevant only "in location."[13] A sequence of episodes can be structured only by juxtaposition or parataxis rather than by temporal progression, so that a purely spatial narrative is only superficially temporal and more a matter of changing places.[14] The functional moment is "now," not "then," allowing the exploration of a continuously widening present. The Bayeux Tapestry's most effective exploitation of spatial form in narrative can be seen in its frequent reversals of episodes, subverting the chronology to create an effect.[15] The structural reversal of episodes creates a feeling of expanded synchrony, "of history seen from a vertical or omniscient perspective, transmuting history into the timeless world of myth."[16] As Barthes observed, each point in a reversed narrative radiates in several directions at the same time, working its way through several relays before it reaches its meaning. The cluster of reversed scenes is thus "claimed" by the whole narrative, as another kind of time, totally in the present, and comes to prevail in the temporal distortion of such a reversal.[17] In film the effect is created by techniques of montage that intercut shots of several actions initiated in different locations, converging on a single moment and place.

Although the loosely knit sequential structure of the Bayeux Tapestry's narrative is made coherent and thus unified by an overarching goal projected at the beginning of the text and ultimately reached at the end, the objective is often as obscure to the reader as to the protagonists.[18] As we have already seen, the two narrative modes of "story" and "chronicle" are powerfully merged. The essentially linear structure of chronicle is interlocked with the "circularity" of story, involving unity of action as well as a problem and its solution.[19] Much of the Bayeux Tapestry's dramatic force draws upon the powerful tensions that build between story and chronicle, between causality and temporality. What sometimes strikes the modern spectator as a lack of narrative cohesion can be explained by culturally constructed notions of causality that prevailed in

the Middle Ages, the medieval conviction that every sequence of events constitutes a "story," and that all events have causality, meaning, and finality.[20] Just as the audience becomes actively complicit in the Bayeux Tapestry's story by supplying its missing speeches, the simple juxtaposition of events provides the powerful effect of opening their parataxis to ongoing interpretations of causality and motivation.[21] Causality tends to appear within episodes rather than to connect them. It is the reader-viewer who must assume or infer causal connections. The text's refusal to provide an interpretive syntax places the reader-viewer in a position similar to that of the figures in the narrative.[22]

The naive reader who does not know how the story ends is pulled along by interest, sympathy, and curiosity, whereas the knowledgeable viewer of the Bayeux Tapestry experiences the discourse in a stream of transience, anticipation, and retrospection.[23] Comprehension, however, is not simple foreknowledge or perception but an individual act of seeing things together in a kind of synoptic vision. Grasping temporal succession in the Bayeux Tapestry necessitates thinking of it in both directions at once. Within the medieval regime of storytelling, where circularity of meaning dominates cognition, action and events are connected by a network of overlapping descriptions that refer to the story as a whole. As Louis Mink observes, only in retrospect are plans miscarried, ideas seminal, and battles decisive.[24]

In this sense, the most compelling tension that propels the visual narrative in the Bayeux Tapestry operates between its story structure, which is hierarchical and vertical, and its chronicle structure, which is sequential and horizontal or juxtapositional.[25] It is a tension that subsumes causality and motivation within a different kind of narration, as overarching vertical relationships make a radical intrusion into the world of "story." Subjects or protagonists no longer control the course of action. Significant gaps or dissimilarities prevail between the intended results of their actions and the actual outcome.[26] As in the fables, the *récit* is taken over by the conflicting desires whose collision course is defined by a structure, or forces, or system, outside the story. The larger narrative structure – created by parataxis, interlacing, reversal, slippage, and

merger – reveals the ideological engine that drives the whole discourse. Taken in seriatim, conflicting desires reveal what the Bayeux Tapestry is about – the problematics of power. An impasse is created that makes the Norman invasion an inevitability. Harold and William will establish feudal ties that will conflict with Harold's obligation to his king. The overall conflict between the old Anglo-Saxon order of royal power and the new Norman order of feudal power can be resolved only by one subsuming the other. In the end, the two ideological systems merge, fulfilling William's intention from the beginning. Thus, as we attempt to analyze the larger narrative structures in the Bayeux Tapestry, we must at the same time confront the ideological cargo carried by those structures.

HAROLD IN NORMANDY

In a sense, the three scenic episodes taking Harold from the king's hall at Westminster to Guy's castle at Beaurain can be seen as a prelude to the first major sequence of clustered events centered on Harold in Normandy: (1) the journey from Ponthieu into the duchy, (2) Harold's first meeting with William at Rouen, (3) the Brittany campaign, and (4) Harold's investiture and oath.

The Journey from Ponthieu to Normandy

The frustratingly slow and convoluted transition taking Harold from Beaurain to the ducal palace at Rouen[27] comprises a cluster of episodes in which the repetition and reversal of messengers moving back and forth vividly transmit the idea of delay. In order to see the moving links that join Harold and Guy to William,[28] the viewer's glance takes in enough to embrace the whole sequence, bracketed by trees. In film, a similar effect can be created by the very different means of the "establishing shot," a long shot introducing a scene to establish the relationship of details to be shown in subsequent nearer shots.[29] The complexity of negotiations and differing protocols involved in traversing territorial boundaries in France, from one feudal domain to another, are

clearly differenced from the looser, open, and more direct relations in England between the king and his earls, signaled by the move from Westminster to Wessex.

Much has been made of the reversal of episodes in this cluster, visually signaled not only by the inscriptions but also by shifts in the direction of the action. We first see the arrival of William's messengers at Beaurain (VBI NVNTII WILLELMI DVCIS VENERVNT AD WIDONEM), followed by two messengers (NVNTII WILLELMI) galloping toward Ponthieu (Fig. 18). The catalytic action propelling the embassy demanding Harold's release springs proleptically from two scenes forward (HIC VENIT NVNTIVS AD WILGELMVM DVCEM), in which the earl's messenger, identified as an Anglo-Saxon by his long hair and mustache, gestures toward William with open hands (Fig. 19). Although we might assume that the English identity of Harold's messenger suggests that the designer based the episode on Eadmer's account,[30] the scene can be interpreted more loosely to stress Harold's debt to William for his release. As the duke extends his index finger toward Harold's messenger, he initiates a strong reversal of narrative direction to the left, toward Guy's castle. In contrast, William's Norman castle (Figs. 19–20) becomes a fulcrum or center from which the action moves away, first toward the left and then toward the right, thus stressing the duke's literal power to control the "turn" of events. The sequence then concludes with Guy leading Harold to William (HIC WIDO DVXIT HAROLDVM AD WILGELMVM NORMANNORVM DVCEM), bringing the movement to a temporary halt as the entourage from Ponthieu is greeted by William and his armed guard (Fig. 20).

Contrary to assertions that the reversal of direction in this sequence was intended as a representation of two different but simultaneous events, the narrative inversion should be read as a "flashback" that not only permits Guy to remain at the center of the story but also creates an opposing center in the ducal castle in Normandy. As William commands Harold's release, the reversal creates an impressive demonstration of the duke's power to bend men to his will within the feudal hierarchy.[31] In terms of genre, the narrative segments of departure and arrival, actual

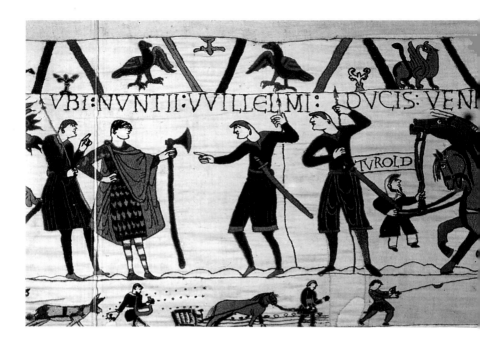

movements in space and time, visually display a curious mirror-image quality characteristic of the epic *chanson de geste*, further weighting their impact on the viewer.[32]

All attention is riveted on Harold as he approaches William's fortress at Rouen (Fig. 20). Although the earl of Wessex still holds his hawk, his role as hunter-predator is compromised as he becomes the visual target of pointing fingers and lowered lances. One weapon seems to pull down the "O" of his inscribed name. His ambiguous role as aggressor and victim is again stressed. The borders below this sequence are filled with hunting scenes reiterating the juxtaposition of predator and victim. In the border beneath the two messengers sent by William to command Harold's release from Guy is the representation of a man with sword and shield approaching a tethered bear. Rather than readying for an attack, the armed man is probably attempting to free a dangerous beast, thus

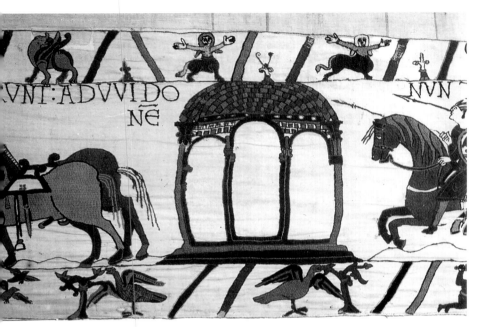

Figure 18. William's Messengers Come to Guy. Bayeux, Musée de la Tapisserie (photo: Giraudon/Art Resource, NY)

providing a more apt reading of the vignette in the context of its alignment with the main narrative. Another, even more engaging marginal vignette reveals a naked man, with raised arms and erect penis, pursuing a defenseless naked woman (Figs. 20–21). Given the congruence of directed action between Harold above and the naked rapist below, the border image is probably intended to index Harold's own otherwise hidden character and motivation as a *raptor*, signaled by the continued presence of his hawk. Erasing any doubt or ambiguity concerning the meaning of this liminal scene, a dragon, the heraldic emblem of Wessex that will later appear at Hastings, also threatens the woman and then turns away in the direction of the duke's castle, his fiery tongue still spitting menacing flames, directed toward a hapless goat.

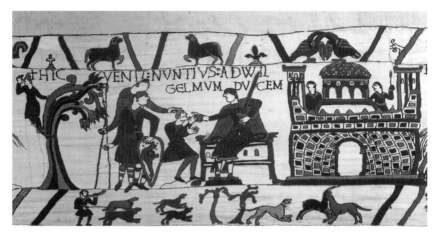

Figure 19. Guy's Messengers Come to William. Bayeux, Musée de la Tapisserie (photo: Giraudon/Art Resource, NY)

Figure 20. Guy Takes Harold to William. Bayeux, Musée de la Tapisserie (photo: Marburg/Art Resource, NY)

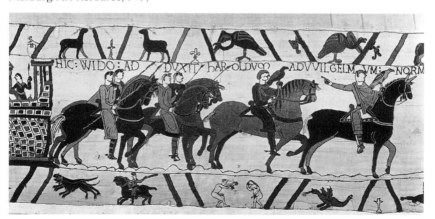

Figure 21. Naked Man and Woman (Detail of Lower Border). Bayeux, Musée de la Tapisserie (photo: Latomus)

Harold and William at Rouen

As if in acknowledgment of William's greater power and control over Harold, the next sequence (Figs. 22–23) begins by displaying a significant emblematic shift in which the hawk is now held by the duke beneath his inscribed name. Harold, now empty-handed and powerless, points uncertainly to his identifying inscription, as his hunting dogs under the control of a new master bound eagerly toward Rouen. Their approach to William's palace (HIC DVX WILGELM CVM HAROLDO VENIT AD PALATIVM SVVM) opens the next cluster of scenic episodes, dominated by a silent colloquy between William and Harold. In contrast to Edward's palace at Westminster, Rouen was already a great fortified stone castle in 1064, of which we see a great hall, watchtower, and gateway.[33] Unlike the porous walls of Guy's castle in Ponthieu, the Norman stronghold at Rouen provides an airtight enclosure, bereft of inscriptions, as if

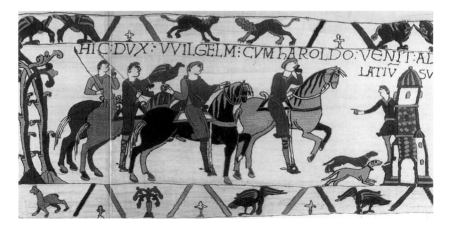

Figure 22. William and Harold Arrive at Rouen. Bayeux, Musée de la Tapisserie (photo: Giraudon/Art Resource, NY)

Figure 23. William and Harold Converse in the Palace. Bayeux, Musée de la Tapisserie (photo: Giraudon/Art Resource, NY)

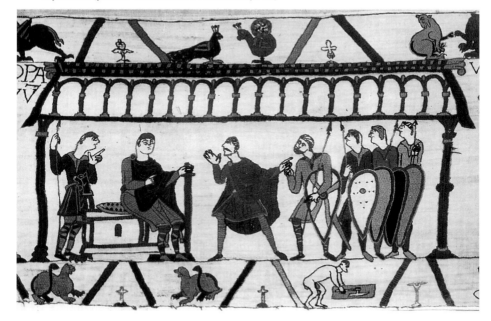

to ensure the security of the verbal exchange within. Despite the visible presence of witnesses, surviving contemporary documents fail to record the content of the mute dialogue. Enthroned at the left, holding his sword downward to signal his peaceful acknowledgment of Harold's message, William points to the earl as he speaks. Harold stands before him in an aggressive open stance gesturing in two directions at once, extending his open right hand to the duke and at the same time pointing with his left, as the first of a group of armed vassals grasps his gesturing hand. What could be the subject of this animated discussion? Because the scene actually forms an extension of the duke's rescue or ransom, we might be tempted to hear Harold offering to join William's expedition to Brittany as a gesture of his gratitude. Above the speakers are two confronted male peacocks. The one above Harold spreads his tail feathers in an impressive display, suggesting that the earl is perhaps boasting of his military prowess, offering a marginal subtext that can be linked to his gesture toward and acknowledgment of the armed vassals standing at the right. Moreover, the ceremonial meeting is strategically located between the first demonstration of William's feudal power over Guy and the duke's defeat of his recalcitrant ally Conan in Brittany.

Although profiles recur with great frequency throughout the Bayeux Tapestry,[34] the juxtaposition of William's schematized three-quarter face against Harold's profile suggests a polarity that can be read as a distinction between ruler and ruled, and perhaps between good and evil.[35] Contrasting with the duke's latent or potential glance directed toward the observer. Harold's profile is detached from the viewer and belongs to a body in action. The transitional turn of the head might also be perceived as a gesture of deception as he makes his presence and motives partly hidden from view and hence less accessible to us. Because character is a text requiring interpretation, often made difficult, as in this case, by a multiplicity of conflicting signs, other characters in the narrative become active readers of the protagonists. The earl's character is clearly being read by William and his men, whose gazes are all fastened on Harold's "performance" before the duke. But the audience must still rely on its own interpretation, even a wishful misreading at this point.[36]

Harold's conflicted stance, with his head turned in profile to the left, offers a set of striking gestures that prefigure his twisting pose when he swears the oath at Bayeux (Fig. 31). It has been remarked repeatedly that the designer of the Bayeux Tapestry contradicts the account given by William of Poitiers, who places Harold's oath before rather than after the Breton campaign. Could the suggestive and dramatically compelling scene we have before us have been intended as the first installment of Harold's declaration of loyalty to William? Or is it meant simply to work proleptically to anticipate the oath? In either case, given the designer's propensity to frame as well as to interlock episodic strings, we might be inclined to see the Breton campaign as bracketed by two declarations of Harold's fealty, first at Rouen and then at Bayeux.

The Ælfgyva Interlude

The mysterious exchange between William and Harold is immediately followed by an equally enigmatic scene inscribed "Here a cleric and Ælfgyva" (VBI CLERICVS ET ÆLFGYVA) (Fig. 24). Since Ælfgyva is a frequently documented Anglo-Saxon name, the lady has been variously identified as Harold's sister proposed for betrothal to William or a Norman noble,[37] Abbess Ædgifu of Leominster,[38] Ælfgifu of Northampton, the Anglo-Saxon common-law wife or concubine of King Cnut,[39] or William's daughter offered in marriage to Harold.[40] Uniquely and perhaps significantly lacking a verb describing the action or relationship between the two figures, we can only surmise that it would have been obvious to a contemporary audience from the now obscure clues given by the gestures, the name "Ælfgyva," and the distinctive character of the architectural props. Because the woman is veiled, we can assume that she is either married, widowed, or a nun. As she faces the man with both hands open and raised, she seems to be registering acceptance or submission rather than surprise.[41] The cleric is tonsured but not wearing priestly vestments, so that we can safely discard any possibility that the scene has anything to do directly with a betrothal or marriage. As Mc-

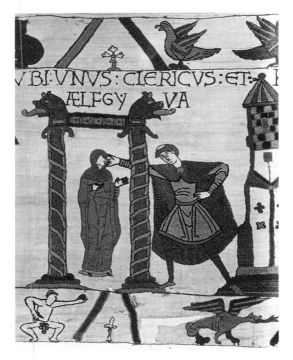

Figure 24. Ælfgyva and a Cleric. Bayeux, Musée de la Tapisserie (photo: Marburg/ Art Resource, NY)

Nulty suggests, the aggressive face-fondling gesture is charged with erotic meaning, mirrored and made more explicit in the margin by the small naked man displaying his large genitals.[42] Indeed, the cleric's arm is thrust behind the column enclosing the veiled woman, suggesting the kind of secret or clandestine encounter that could be interpreted as adultery or *fornicatio*, in which vows of fidelity and/or celibacy are being broken.[43] In light of Duke William's recent legislation against clerical incontinence, the implication would not have been lost on a contemporary Norman audience.[44] If the reader-viewer can make an inference based on visual analogies of gesture and body stance between this pair and the

colloquy that takes place in the great hall at Rouen, Harold might be read as a breaker of promises. Depending upon the viewer's sympathies, Harold can be seen as either betraying Edward by allying himself with the Norman duke or as a future traitor to William.

The sexual indiscretion between Ælfgyva and the cleric transpires at the threshold or within a structure that is strikingly differentiated from any other architectural form in the Bayeux Tapestry, so that it can be read as clearly not part of William's palace in Normandy. The spirals winding around the columns capped by huge dragons' heads mark the place as Anglo-Scandinavian or Anglo-Saxon, consistent with the woman's Anglo-Saxon name. Moreover, unlike all the other figures in the Bayeux Tapestry, Ælfgyva does not stand on a ground line but hovers above it, perhaps suggesting that her appearance is an interpolation to be read as not only in another place but also in another time (VBI, as opposed to HIC). In filmic terms, the enigmatic interlude can be seen as constituting a "flashback," introduced by an overt mark of transition similar to a slow dissolve – here, by an archaizing architectural frame that "goes back."[45]

Whoever Ælfgyva was, as a medieval woman she is defined by her re-lation to men – whose daughter she is, to whom she is married, sleeps with, or is raped by, and of whom she is the mother or ancestor.[46] Thus it is possible, as McNulty argues, that Ælfgyva and the cleric are in-tended to visualize the subject of William and Harold's discourse, in which they agree that the Norwegians and Danes had no legitimate claim to the English throne through Sven, since he was the illegitimate offspring borne to Cnut's wife Ælfgyfu of Northampton and a priest some thirty years before 1064.[47] More central to the present problem of succession is another "Ælfgyva," Cnut's second wife and queen, also known as Emma, daughter of Duke Robert I of Normandy and mother of Edward the Confessor, through whom William made his claim to the English throne by blood kinship.[48] Because Emma of Normandy changed her name to Ælfgifu when she married Æthelred,[49] the ambi-guity of the flashback can be seen to evoke the two "Ælfgyvas" as a way of alluding to the rivalry between two aggressive and ambitious women

claiming that their sons should become king of England.[50] In this way, the epithet "Ælfgyva" takes on a characteristically medieval multivalence that can refer simultaneously to both an obstacle as well as a guarantee to William's dynastic claim.

Because the brief episode intervenes between the scene of Harold conversing with William in the palace and then riding out against Count Conan of Brittany, it seems to relate in some indirect way to Harold's character, William's claim to the English throne, and the coming invasion. In the margin beneath William's armed vassals is a naked man planing a wooden plank with an ax of the sort shown later in the building of ships for the Norman fleet; just ahead, as William and Harold set off on the expedition to Brittany, the border reveals the crow's cheese in the possession of the fox. At this point the historical interpretation of the Bayeux Tapestry coincides with the assertions of modern historians that the Breton adventure was among the last in a long series of feudal wars in which William built up and tested the armies that were to lead him to great victories across the Channel.[51]

The Brittany Campaign

As William's military expedition in Brittany begins, both the narrative as well as the itinerary take a slight detour to the famous pilgrimage shrine of Mont-Saint-Michel (Fig. 25), then under the duke's protection (HIC WILLEM DVX ET EXERCITVS EIVS VENERVNT AD MONTE MICHAELIS). Perched on a high promontory off the coast, the abbey church breaks into the upper border, where it is displayed like a protective aegis hovering above William's advancing troops. Although the image is seemingly irrelevant to the main business at hand, attention might have been drawn to Mont-Saint-Michael for its connection with the Tapestry's patron, Odo of Bayeux, whose foundation of Saint-Vigor, set up by monks from the abbey shrine, lay just outside the cathedral city.[52] Equally important, however, is Mont-Saint-Michel's link to Edward the Confessor, who had granted to the abbey St. Michael's Mount in Cornwall and oth-

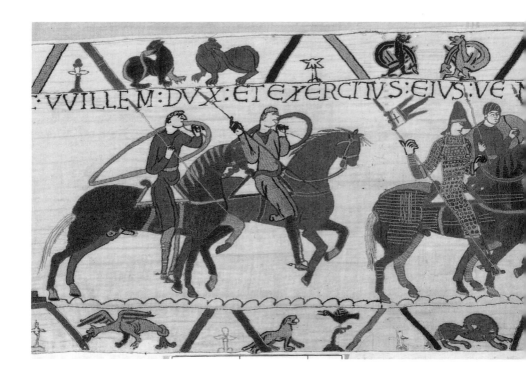

er property in England.[53] The famous pilgrimage can thus be seen as a sacred talismanic link between Normandy and England to which both William and Harold pay homage.

Although not mentioned in any extant Norman source, Harold's rescue of soldiers from the quicksand as William's troops ford the River Couesnon (Fig. 26) casts him in the role of a larger-than-life epic hero in an ostentatious display of courage and loyalty to his new lord (HIC HAROLD DVX TRAHEBAT EOS DE ARENA). Eels swim in the border below not only to intensify the sense of danger threatened by the quicksand but also to create a pause by moving in the opposite direction, so that the viewer can absorb the impact of Harold's action before going on. For the first time since leaving England, the earl of Wessex is again accorded the title *"dux,"* making him William's equal in rank.

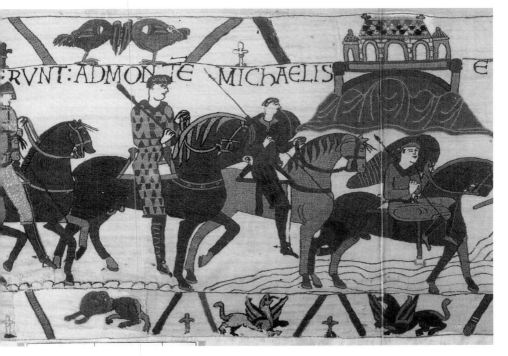

Figure 25. William Leads His Army to Mont-Saint-Michel. Bayeux, Musée de la Tapisserie (photo: Giraudon/Art Resource, NY)

Following a brief spatial break, the Normans gallop off to attack the citadel at Dol from which Conan, the duke of Brittany, escapes down a rope, seeking refuge at Rennes (Fig. 27). Although the event is reported in no other source, the Bayeux Tapestry shows William's army swinging south from Dol deep into Brittany and then penetrating even further in pursuit of the rebellious duke to Dinan before returning to Normandy.[54] The campaign is then brought to a triumphant end by Conan's surrender of the fortress at Dinan (Fig. 28). The importance of this expanded version of the Breton campaign could hardly have been lost on a post-Conquest audience. The discrepancies between William of Poitiers' account and that in the Bayeux Tapestry amount to a gross distortion,

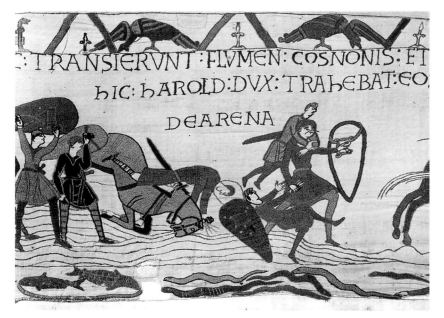

Figure 26. Harold Rescues William's Men from Quicksand. Bayeux, Musée de la Tapisserie (photo: Giraudon/Art Resource, NY)

probably intended to promote the Conqueror's reputation as an unbending warlord and to stand as a warning that he will brook no rebellion from his new English subjects.[55] Just as there is no written record confirming that the Normans ever appeared before the walls of Rennes, according to the *Gesta,* Conan was never inside Dol but actually besieged it. When William arrived, Conan withdrew without a battle and found refuge with Geoffrey of Anjou, well out of Norman reach.[56] The Bayeux Tapestry's brilliant dramatic moments of Conan's humiliation and defeat (ET CONAN FUGA VERTIT REDNES) are probably pure narrative invention (Figs. 27–28). The Breton duke escapes from Dol by sliding down a rope and then surrenders Dinan by extending the castle's keys on the tip of his lance, transferring them to the tip of William's own weapon (ET CONAN CLAVES PORREXIT).[57]

The campaign that settled the unrest in Brittany in 1064 completed the process by which William established himself as the undisputed master of northwestern France. In a long series of successful feudal wars, the duke of Normandy built up and tested the armies that were to lead him to great victories across the Channel.[58] Partly as a result of the Breton expedition, there was a large pro-Norman faction that made up the most numerous of the contingents of non-Norman volunteers who accompanied the duke to England in 1066.[59] On a number of different levels, the long sequence of episodes in the Bayeux Tapestry underlines the significance of the Brittany campaign as a dress rehearsal for the coming Norman invasion of England.

Harold's Investiture and Oath

The climax of Harold's journey to Normandy centers on two ritual moments when the earl formally becomes William's man. Literally slotted into a narrow interval bracketed between the surrender of Dinan and William's arrival at Bayeux (Fig. 29), the duke bestows arms on Harold (DEDIT HAROLDO ARMA). Unlike the episodes that lead up to this moment, the event is a symbolic one in the sense that some of its meanings can be recovered only by reference to a system of arbitrary conventions.[60] Its momentous significance is belied by its brevity, for, as Werckmeister pointed out, the words *"dedit arma"* denote a contemporary description of the act of knighting.[61] The two figures stand close together in full armor, as William places a helmet on the earl's head and grasps his upper right arm. Although Harold is obviously being rewarded for his part in the Brittany campaign, the gesture is not simply the bestowal of gifts mentioned by the Norman chroniclers.[62] We are witnessing a ceremonial investiture that gave Harold feudal status.[63] Because the designer of the Bayeux Tapestry shifted the chronology of William's bestowal of arms to a moment after the battle, the gesture cannot be construed as practical, but as ceremonial.[64] The scene marks a further and deeper stage of Harold's obligation to William.[65] At the same time, the omission of the ceremonial handclasp (*immixtio manum*), along

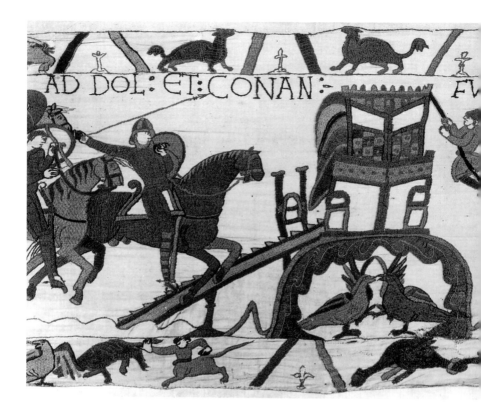

with the reversal in the prescribed order of oath and investiture, consti-
tute striking, visible irregularities in feudal protocol that could easily be
read to suggest an inherent flaw in Harold's new relationship to
William.[66]

Although no historical source claims that William conferred knight-
hood upon Harold, the designer of the Bayeux Tapestry seems to have
been fully aware that the earl's obligation to William was a feudal one,[67]
as made evident by Wace's later, twelfth-century epic poem, which was
in turn probably inspired by the Tapestry's imagery.[68] To support such a
claim, Werckmeister astutely observes an apparently intentional subor-
dination of Harold's name to that of the duke in the inscription.[69] Al-

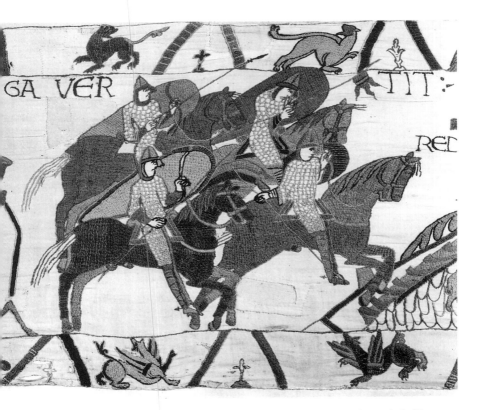

Figure 27. Conan Escapes from Dol toward Rennes. Bayeux, Musée de la Tapis-
serie (photo: Giraudon/Art Resource, NY)

though the practice of Anglo-Saxon lords and kings giving their men
arms was known in the late tenth and early eleventh century,[70] the
Bayeux Tapestry episode had a deep significance for the post-Conquest
perception of Old English society, for it implied that the great earl, the
leading subject of the English realm, was not a knight prior to this mo-
ment.[71] Only when William arms him is Harold declared to be *chevalier
sans peur et sans reproche.*[72] Again, we see the Tapestry's design intended to
be perceived within a post-Conquest framework of feudal ideology.

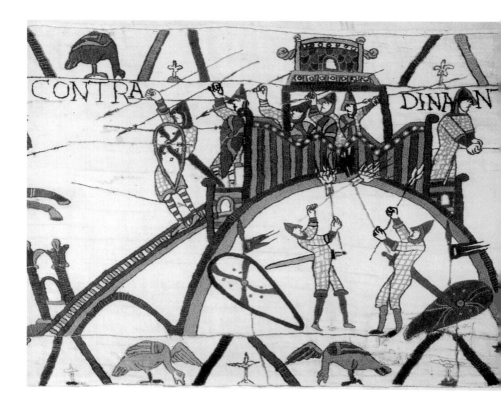

A further signifier of feudal allegiance is Harold's conspicuous display of the pennon, which breaks into the inscription and flies over the last two letters of his name. As Dodwell and Werckmeister have argued, the banner can be read as a symbol of feudal vassalage.[73] This would suggest that Harold is receiving not only knighthood from William but also the investiture of his own landed possessions in Wessex to be held in fief, presumably following the duke's succession to the English throne. At the time – that is, in 1064 – such an act seems to have had no legal basis on either side of the Channel, but again this is the significance of the investiture given by William of Poitiers in the years directly following the Conquest.[74]

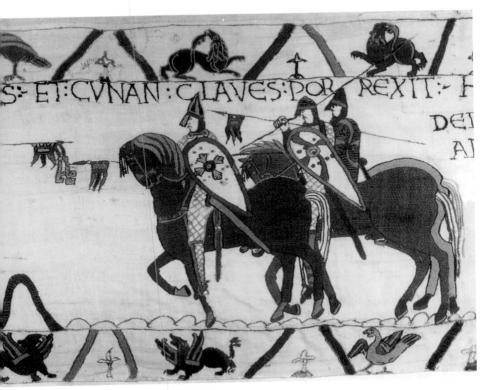

Figure 28. Conan Surrenders at Dinan. Bayeux, Musée de la Tapisserie (photo: Giraudon/Art Resource, NY)

The stasis of the ceremony creates another narrative pause, enabling the viewer to assess the impact of the whole string of events constituting the Breton campaign, so that the close juxtaposition of the two armed figures conveys a sense of closure. At the same time, Harold extends his arm holding the pennon in a gesture that signals the return of the ducal lord and his new vassal to Normandy. The two closely interlocked armed figures serve as a visualized point of narrative interlacing, where the closure of one sequence (Fig. 29) overlaps the opening of the next (Fig. 30), as Harold is pulled into William's procession to Bayeux

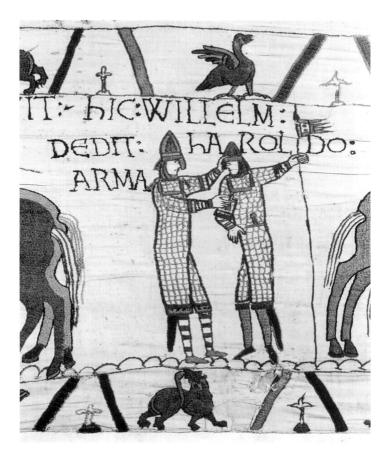

Figure 29. William Gives Arms to Harold. Bayeux, Musée de la Tapisserie (photo: Giraudon/Art Resource, NY)

(HIC WILLELM VENIT BAGIAS). Although William of Poitiers specifies that Harold swore his oath at Bonneville-sur-Touques,[75] and Orderic Vitalis later locates the event at Rouen,[76] the Bayeux Tapestry uniquely situates the episode at Bayeux, a calculated move that confers a measure of feudal control upon Odo of Bayeux, who will fall heir to Harold's patrimony in Wessex following the Conquest.[77] Stressing the idea of feudal

demesne, Odo's castle at Bayeux is visualized as a motte tower approached by a high ramp, similar to the series of fortifications just seen in Brittany at Dol, Rennes, and Dinan.[78] William's peaceful occupation of the castle underlines Odo's feudal relationship to his half-brother insofar as his territory is held in fief to the duke.

The serial intensification of Harold's obligation to William reaches its peak in the scene of oath-swearing at Bayeux (Fig. 31). As the first climax of the large narrative, the momentous oath on relics does much more than heighten and epitomize what has gone before. Although it has been read as the "seal on the document which has already been written,"[79] the event shifts the discourse into a new register of political ideology. Dramatic ambiguity as well as chronological displacement and lack of closure alert the viewer to its significant weight within the narrative. As C. R. Dodwell observed, "This part of the Bayeux Tapestry . . . is by no means a simple chronicle of events, but an explanation at various levels of Harold's obligation and indebtedness to William, so that when Harold accepts the crown, the full depth and breadth of his treachery can be gauged by the medieval spectator."[80]

Contrasting with other scenes in which royal and hunting regalia, along with weapons and armor, were clearly subordinated to the actions and gestures of the protagonists, Harold's oath-taking becomes an object-centered event in the sense that the two large reliquaries are inseparable from his gestures as the targeted focus of the scene. The objects themselves are clearly not the point of the narrative, but they function as a device for gathering meaning.[81] As eloquent objects within the material semantics of the Middle Ages, relics were particularly powerful. Because their power depended entirely on their authenticity and uniqueness,[82] the Bayeux relics are pointedly displayed in a shrine resting on two poles, indicating that they had been brought from another place expressly for the oath-taking.[83] The visible demonstration of the relics' portability serves not only to authenticate their sacred power, already stated in the inscription ("SACRAMENTVM"), but also perhaps to remind post-Conquest court audiences that William wore the Bayeux relics around his neck while fighting at Hastings.[84] The meaning of such

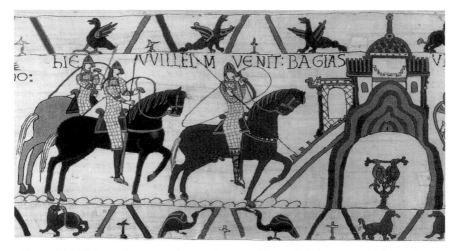

Figure 30. William Arrives at Bayeux. Bayeux, Musée de la Tapisserie (photo: Giraudon/Art Resource, NY)

focal objects is never intrinsic but derived from the narrative context. As Pizarro argues, historiographic narratives constitute an unstable field in which objects can be moved, handed around, and manipulated.[85] Moreover, the gesture or action that brings the object into the story rarely involves normal use but turns instead on unusual treatment or mis-use. In the case of the Bayeux Tapestry, such oaths on relics constitute a familiar ingredient of the *chanson* tradition that serves as one of its generic paradigms.[86] Depending upon the viewer's political bias, however, Harold's oath can be read as false, as perjury, and thus as a gross abuse of relics.

In contrast with Guy of Amiens, who states explicitly that Harold's oaths were secret,[87] the Bayeux Tapestry represents the transaction not as a private agreement but as a solemn ceremony, witnessed by the duke's men pointing to Harold's name in the inscription.[88] Both William of Poitiers and Guy of Amiens characterize the oath as a feudal contract,[89] by which Harold swore (1) to be the *vicarius* of the duke at Edward's court, (2) to use all his influence and wealth to confirm William in pos-

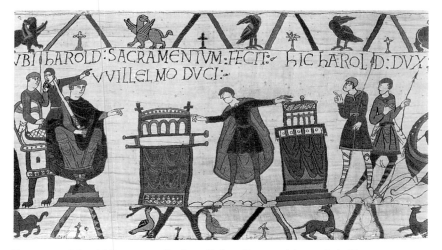

Figure 31. Harold Swears an Oath on Relics. Bayeux, Musée de la Tapisserie (photo: Giraudon/Art Resource, NY)

session of the kingdom after Edward's death, (3) to place a garrison of the duke's knights in Dover Castle at his own expense, and (4) to maintain garrisons in other parts of England at the duke's will, in return for which Harold received his own territories in Wessex in fief to the duke.[90] Whereas in the most detailed account William of Poitiers asserts that, "according to the entirely truthful relation of certain most notable men of utter integrity who were present at the time," Harold freely added these clauses to the oath, Eadmer later claimed that the earl was acting under duress.[91] As Werckmeister convincingly argues, however, the Norman sources clearly describe an oath of fealty, which entails another order of obligation that can be considered binding but not feudal in character.[92] As in the Bayeux Tapestry, however, the exact nature of what Harold's oath actually involved is similarly evaded in the brief description by William of Jumièges: "Harold . . . swore fealty concerning the kingdom with many oaths."[93]

Harold's oath of fealty proleptically signals a momentous shift in William's status from feudal overlord to autocratic ruler. Once William was crowned king of England, his power would demand not feudal homage but ceremonial expressions of fealty, as attested by the obligatory oaths unilaterally acknowledging the king's sovereignty at Salisbury in 1066.[94] Although feudal vassalage became predominant in England after the Conquest, the first Anglo-Norman kings demanded fealty over feudal bonds as an acknowledgment of royal supremacy over conditional territorial power.[95] Thus, if the Bayeux Tapestry was perceived as a triumphal celebration of William's ascent to kingship, nothing short of an oath of fealty would constitute an adequate recognition of the duke's claim to the throne.

Notwithstanding the fact that William was not yet king at the moment of Harold's oath, his future royal authority could not be founded on a feudal contract such as that embodied in the previous investiture with arms. It is at this moment, however, that Harold's loyalties become conflicted between William and Edward, between Normandy and England. The oath of fealty just sworn to the duke as future king of England observes a traditional Anglo-Saxon protocol of absolute and indissoluble allegiance expressed by the hold-oath of the *witan*. Thus, although such an oath could override the feudal obligation of a vassal to his lord, it could not annul a prior oath of fealty to a king.[96] Notwithstanding his oath to William, Harold still owed his fealty to King Edward.

Harold's conflicted loyalties at this moment can be seen as the force that drives the visual discourse of the Bayeux Tapestry. He is represented as a man literally pulled in opposing directions as his outstretched arms touch the two reliquaries. Because oaths were almost invariably sworn on a single shrine,[97] the doubling of the reliquaries at Bayeux can most plausibly be read on a metaphorical level to signal Harold's conflicting fealty to two kings. In contrast to the preceding and subsequent scenes in which speeches form the main action, the oath takes place outdoors on the shores of Normandy. As Harold places his hand on the second reliquary, he half turns toward the Channel to return home (Fig. 32). From the Norman point of view, the second shrine could be seen as a

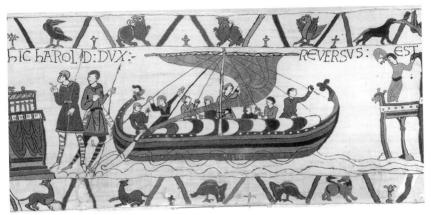

Figure 32. Harold Returns to England. Bayeux, Musée de la Tapisserie (photo: Giraudon/Art Resource, NY)

proleptic reference to the bones of Edward the Confessor, as it merges the form of the dead king's funeral bier bearing his soon-to-be-consecrated body to its burial destination within the columnar arcades of Westminster Abbey (Fig. 34). As if to align the second shrine and Harold's sacred oath upon it with England, a second inscription begins directly above the altar on the right, "HIC HAROLD DVX REVERSVS EST AD ANGLICAM TERRAM."[98] Interestingly, Harold's name is no longer subordinate to William's in the inscription; instead, he gets "top billing" twice.

Locating Harold's oath in an open space on the shore facing England further emphasizes the direction in which William's future kingdom lies. The tapestry designer's chronological displacement of this scene in contradiction of the Norman accounts to a position following and indeed at the very end of the Brittany campaign now seems calculated to locate Harold on liminal ground, caught in a moment of crucial indeterminacy. The two men at the left express their reading of the earl's character and situation in their own indecisive movements. They gesture in opposite directions but at the same time prod the letters of Harold's in-

scribed name toward the right, in the direction of the returning ship. As the earl is pulled toward his brief royal destiny across the Channel, the viewer can read the wide interval between the two protagonists as an unraveling of the feudal bond that drew them so close together in the investiture ceremony – as a pulling apart of allegiances – ironically, at the moment when Harold's ultimate loyalty to his future king is being sworn. As if to signal the destructive layer of the rivalry undermining the spectacle of allegiance, two small birds have been promoted from the ranks of hundreds of confronted and contorted inhabitants of the borders to claim a significant place in the main narrative. Perched upon a single pedestal within a semicircular frame beneath the motte-tower at Bayeux, they make rival claims to what looks to be a double-headed scepter by grasping it in their beaks as they turn in opposite directions.

HAROLD'S RETURN TO ENGLAND

The next string of events carries the narrative into its substantive or causal center in the earl's final meeting with Edward, the king's death and burial, and Harold's "coronation." In retrospect, the overall structure of the Bayeux Tapestry's narrative can now be conceived as comprising three unequal parts: the first long sequence culminating in Harold's oath, a short section dealing with his return and rulership, followed by a third and very long series of episodes representing the Norman invasion and the Battle of Hastings. In the first episode of the middle part (Fig. 32), the small lookout situated between the words "REVERSVS" and "EST" signals not only Harold's return to England but also a number of other "turns" in the plot. The isolation of "REVERSVS" stresses the idea that, although the earl has returned, he is not the same. Now burdened by divided loyalties he has been transformed by his journey.

In contrast to his close proximity to Edward in the initial episode (Fig. 1), the earl of Wessex now stands outside the palace (Fig. 33), physically isolated, psychologically removed, and politically alienated. Devoid of honor and dignity, he lowers his head into his shoulders, his neck and arms outstretched, as he recounts what happened in Normandy.[99] Now,

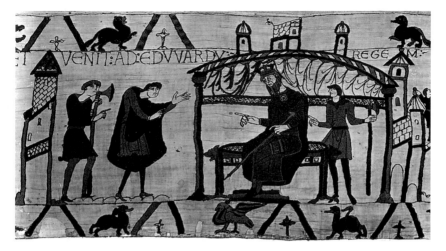

Figure 33. Harold Reports to King Edward. Bayeux, Musée de la Tapisserie (photo: Marburg/Art Resource, NY)

more than ever, Harold is represented as a transgressive figure driven by desire, not a master but a servant, not inside but outside, not where he wants to be, and not having what he wants.[100] The viewer is again confronted by the discursive dilemma of dialogic silence; however, Harold's schematic but powerful gestures create an effective opening into the emotional dynamics of the exchange. As the king raises a finger of admonition against Harold's seemingly ineffectual efforts at explanation, the audience is tempted to interpret the scene in terms of the Anglo-Saxon tradition recorded by Eadmer, in which Edward is reported to have said, "Did I not tell you that I know William, and that your going might bring calamity upon his kingdom?"[101] Whereas in this context Harold would be perceived as the foolhardy dupe of the Norman duke, he might also be read differently, as a traitor. Within a cultural code that makes effective use of widespread symbolic associations of gesture and parallelism of allusion, Harold's hunched and twisted stance can be perceived as a visible sign of his moral perversion.[102] Just as Shakespeare's

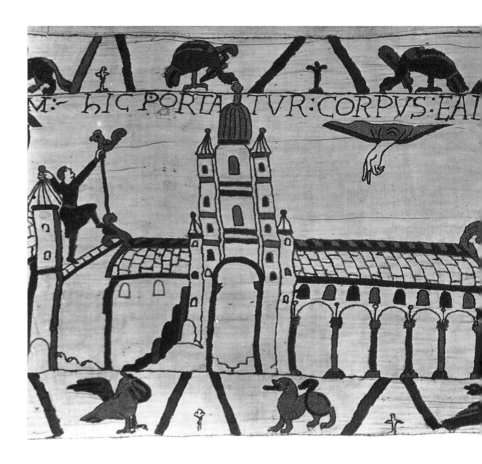

Richard III was given an invented hump as an outward manifestation of his inner evil character, an earlier story of Charlemagne's treacherous hunchbacked son Pippin, who conspired to usurp his father's power, could have provided a paradigm for the Bayeux Tapestry designer's grotesque characterization of Harold.[103]

In the scene we have just witnessed, a man stands behind the king, touching Edward's elbow and extending a long-handled Anglo-Saxon ceremonial battle-ax beneath the inscription "REGEM." He makes an ef-

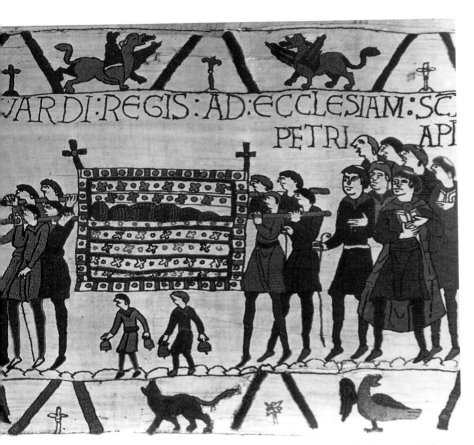

Figure 34. Edward's Burial at Westminster. Bayeux, Musée de la Tapisserie (photo: Marburg/Art Resource, NY)

fective transition to the next episode (represented in reversed order at the left), of the king's burial (Fig. 34) by seeming to remind Edward of his impending death and hence of the urgency of the exchange. At the same time, with his left (*sinister*) hand he gestures toward a workman setting up a weathercock on the roof of the just completed church of Westminster Abbey, as if to signal the changes that will be brought about by Edward's demise. The newly completed structure awaiting the burial of

the royal body becomes the singular focus of divine presence, uniquely invoked in this otherwise purely secular work by the hand of God. Once introduced, however, God operates at the edge of the medieval viewer's consciousness as a transcendent character who will not be visible again but nevertheless will be present throughout the rest of the narrative.[104] Consequently, when William decides upon a course of invasion, he is initiating a "trial by battle" in which the righteous will prevail. Within the implied vertical reality of the narrative, God will not allow the innocent to be defeated or the guilty to triumph.[105]

As Bernstein and others have pointed out, the Bayeux Tapestry's visual representation of the deathbed scene (Fig. 35) corresponds so closely to the contemporary account in the *Life of Ædward*, his last speech can also be plausibly attributed to the mute embroidered figure of the expiring king:

> When Edward was sick unto death, his men stood and wept bitterly. . . . Then he addressed his last words to the queen who was sitting at his feet, "May God be gracious to this my wife . . . ," and stretching forth his hand to his administrator, her brother Harold, he said, "I commend this woman and all the kingdom to your protection."[106]

In the Bayeux Tapestry, Edward reaches out and touches Harold with his fingertips in a confirming gesture.[107] Behind him, Harold's sister, the weeping Queen Edith, points to her brother with her right hand, stressing his indirect blood tie to the king. Whereas the *Vita Ædwardi* uses the ambiguous expression "protector" of the kingdom, the *Anglo-Saxon Chronicle* clearly states that Harold was designated successor to the throne: "Earl Harold succeeded in the realm of England, just as the king had granted it to him and as he had been chosen [by the leading men of the realm]."[108]

On the vital question of Edward's last-minute nomination of Harold as his successor, both the English and Norman sources agree that it took place, but only the English texts stress the legitimacy and procedural regularity in the transmission of power.[109] In England, even when there were eligible heirs, the throne was not passed on in a strict order of pri-

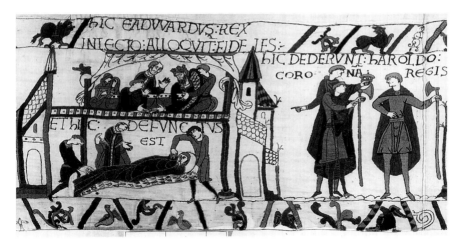

Figure 35. Death of King Edward; Harold is Offered the Crown. Bayeux, Musée de la Tapisserie (photo: Giraudon/Art Resource, NY)

mogeniture. The reigning king could designate a successor who would then be "recognized" by the nobles. In the next episode, Harold does not "seize" the kingdom at the Confessor's death, as alleged by the Norman sources,[110] but is "elected" by the nobles, a circumstance made clear not only by the gestural offering of the crown, but also by the inscription: "DEDERVNT HAROLDO CORONA REGIS."[111] However, as Cowdrey points out, all three figures hold the royal regalia in their left hands, perhaps suggesting Harold's subversion of William's "right" to the throne.[112] Interestingly, an ancient Norman tradition also recognized the deathbed designation as a legitimate mechanism for succession.[113] In practice, however, the legacy to rule was a matter not of "election" or even of recognition, but of the will and the military power to enforce that will by the new ruler. Harold's claim as Edward's successor was open to further challenge by William, as a rival heir who was related through blood ties to the Confessor's mother, Queen Emma. In Norman eyes, William's claim was all the more powerful as a male heir produced by female-related lines.[114]

As pointed out by Bernstein[115] and others, the Bayeux Tapestry's strategy of reversing the chronological sequence of events shifts the death scene onto the central axis of a larger cluster from which two events result – the demise of one king and the succession of the next. The causal connection between Edward's deathbed wishes and Harold's acceptance of the crown is conveyed not only by the paratactic juxtaposition of the scenes, but also by the backward-pointing gesture of the man who hands over the crown and whose head breaks into the inscribed word "CORONA."[116] From an opposing political perspective, the close parataxis would have suggested an indecent haste following Edward's death, motivated by Harold's fear of opposition to what would appear to be a premeditated move.[117] Nonetheless, the temporal implications of the Bayeux Tapestry's visual narrative are grounded in the fact that on the day following Edward's death, he was buried and Harold was chosen and crowned in his place.[118]

In retrospect, the viewer now realizes the significance of the inscription above the deathbed scene. Elevated to a prominent display position in the upper border, it reads "HIC AEDWARDVS REX IN LECTO ALLOQUIT FIDELES." Among the "faithful" surrounding the king is Harold, who was bound to Edward by the same kind of fealty oath he had sworn to William in Normandy. As David Bates points out, the old Carolingian term *fideles*, unusual elsewhere, was used in Normandy to describe a vassal.[119] If Edward's dead body carried on the bier can be seen to resemble the portable shrine at Bayeux, the viewer can now conjecture what the second reliquary emblematized – not simply England, but the royal, if not sacred person of Edward, whose remains were to become the abbey's major "relic." Although the Anglo-Saxon interpretation tends to dominate this sequence, an option remains open to the viewer to read Harold either as traitor to William or as faithful subject to Edward.

In the momentous scene in which the royal power of England is transferred to the new king (Fig. 36), Harold does not crown himself in the unmistakable gesture of a usurper, as he is characterized in the contemporary Anglo-Saxon *Life of Ædward*, but is represented instead as a legit-

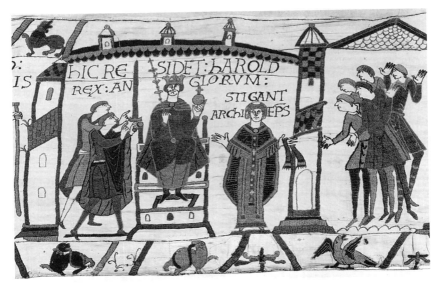

Figure 36. Harold Reigns. Bayeux, Musée de la Tapisserie (photo: Giraudon/Art Resource, NY)

imate heir "elected" by the barons.[120] In purely visual terms, the terse, tightly knit structure of the episode in which Harold is offered the crown constitutes a reversal of the loose, disjunctive string of figures with which the sequence opened (Fig. 33). The two ritual battle-axes that mark the disparate ends of the first scene are now moved close together to create a ceremonial frame for the king-elect. Although Harold's frontal body stance, with profile head turned to the left and arm stretched to the right, is reminiscent of his earlier conflicted appearances, the context established by the serially constructed narrative permits the viewer to see Harold in a new role, single-mindedly centered on his kingship. Indeed, the various declensions of "REX" repeated in the string of five inscriptions accompanying this sequence further suggest the idea of a regular and legitimate order of succession. In a similar vein, the repetition and re-

alignment of the two battle-axes provide a linkage between Harold's report to the king and Edward's last-minute deathbed change of heart in designating the earl of Wessex instead of William as his heir.

The provisional closure implicit in Harold's being offered the crown anticipates the next climactic moment (Fig. 36), in which we see the new king enthroned in full regalia (HIC RESIDET HAROLD REX ANGLORVM). In contrast to everything that has gone before, the narrative comes to a full "freeze-frame" stop. Represented in an iconic state of "majesty" as both the object and subject of universal attention,[121] Harold's frontal gaze includes the viewer within a semicircle of acclaiming subjects that moves into an imaginary space extending in front of his throne, embracing the court audience standing within a great hall gazing at the Tapestry. Although the Bayeux Tapestry does not actually show the ceremony of coronation and anointing, the ritual display of throne, crown, scepter, orb, and sword constitutes an unequivocal expression of royal investiture. The image can be read as the transmission of power from one king to the next through the transmission of objects. The display of objects becomes equivalent to a speech act in the sense that the regalia become statements claiming power within a recognizable ideology of kingship.

At this point, the discourse stressing the legitimacy of Harold's rule might be seen to close off the alternative Norman view of him as a usurper, but the designer keeps the viewer's options open by interpolating the figure of Stigand, the excommunicated archbishop of Canterbury, whose alleged role in Harold's coronation gave the Normans grounds for disputing the validity of the ceremony.[122] Counselor to King Edward and supported by the Anglo-Saxon aristocracy, Stigand first took the side of King Harold but then rallied to William after Hastings. Deposed in 1070 by an English council and replaced by Lanfranc, Stigand was imprisoned and died at Winchester in 1072.[123] Since, according to the twelfth-century account by Florence of Worcester (*Chronicon* I.224), the first English source that gives details of the ceremony, it was archbishop Ældred of York who officiated, the intrusive frontal figure of Stigand, ostentatiously displaying the *pallium* signifying his spurious claim to high ecclesiastical office, seems calculated to undermine the otherwise per-

suasive legitimacy of Harold's kingship. As we shall see, however, the Bayeux Tapestry's propaganda mission was equally focused on legitimizing the English power of its patron, Odo of Bayeux, earl of Kent.

Among all the powerful Anglo-Saxons who survived the Conquest, Stigand could clearly be perceived as a significant rival if not a threat to Odo's position of wealth and influence in England. Basing his source of power on close relationships with four English kings from Cnut to William, Stigand was clearly among the wealthiest landholders in the kingdom both before and after the Conquest.[124] However, his elevation to the see of Canterbury, while the incumbent Robert of Jumièges was still alive and in exile in Normandy, was held to be uncanonical. In contrast to Odo, Norman knight and half-brother to the king, Stigand's power derived exclusively from his ecclesiastical office, leaving him vulnerable to attack. In the words of his modern biographer, "It appears that Stigand's real sin after the Conquest was that he was too rich, too powerful, and too well-connected to the surviving Anglo-Saxon aristocracy for William's comfort and was deposed along with them for reasons as much political as spiritual."[125]

Instead of conferring a sacred and sacramental status upon Harold's coronation, the confrontational presence of a second "usurper" in the Bayeux Tapestry's visualization of the event casts doubt upon its legitimacy, throwing the narrative moment off balance.[126] The resulting rupture of the viewer's confidence in the succession is further destabilized by the even more powerful appearance of Halley's comet in the next frame (Fig. 37). Throughout the Middle Ages, comets were believed to be mysterious harbingers of momentous events, as expressed, for example, in the *Chronicle of Melrose*:

> A comet is a star which is not always visible, but which appears frequently upon the death of a king, or on the destruction of a kingdom. When it appears with a crown of shining rays, it portends the decease of a king; but if it has streaming hair, and throws it off, as it were, then it betokens the ruin of the country.[127]

Although there was no precision in its "portending," the comet's effect was conceived to prefigure some kind of cataclysmic disturbance. With-

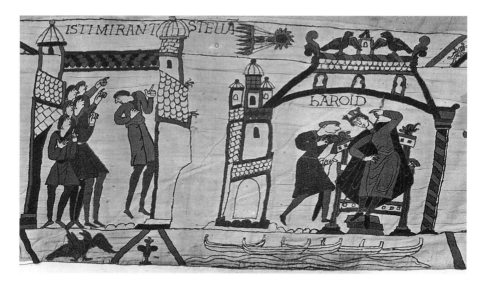

Figure 37. Halley's Comet. Bayeux, Musée de la Tapisserie (photo: Marburg/Art Resource, NY)

in the context of such beliefs, human events were perceived as analogous to comets,[128] so that the juxtaposition of this spectacular astronomical phenomenon with Harold's coronation becomes invested with potent significance. The attention of the acclaiming nobles is diverted and now riveted upon the portentous vision streaking across the night sky. With his body slumped forward and thrown askew, Harold can already be seen as proleptically unseated from his throne, as a ghostly armada of empty Norman ships sail past in the lower border.

Harold bends toward a figure approaching him from the left. Again, the viewer must supply the missing dialogue to the mute exchange. Here we might well see a conflation of messages that converge to disrupt the order of Harold's kingship. Along with Dodwell, the viewer might arguably assume that the discussion concerns the future invasion foretold by the omen.[129] At the same time, the man speaking to Harold might be recognized as the messenger sent by William, who, according to

William of Poitiers,[130] is threatening invasion if the Norman claim to the crown is not honored.[131] The scene clearly constitutes a reprise of the opening episode of the Bayeux Tapestry's narrative, in which another king, Edward, is dispatching rather than receiving a messenger. The designer's strategy of repeating scenes in new contexts invests Harold's last appearance as king with a special urgency, as the messenger rushes forward in the same direction as the comet and brings a sense of closure to this short sequence, conventionally marked by a tree at the right. In contrast to the unbroken and insistent reiterations of "REX" in the five preceding inscriptions, the regal epithet suddenly disappears, eclipsed by the comet, bringing to a close the short middle section of the Bayeux Tapestry's epic narrative.

At this juncture, having mapped Harold's fortunes beyond their midway mark, the viewer is still uncertain whether the earl of Wessex, now king, is a tragic hero ill-fated by the uncontrollable forces of destiny or whether he is a contemptible villain ultimately destroyed by a major flaw of moral character.[132] Whichever way the viewer's sympathies now lean, the image of Harold's precarious teetering on the throne epitomizes the instability of his role in the whole narrative. From beginning to end, the Bayeux Tapestry centers on the rise and fall of a single figure, whose character, status, and motives remain ambiguous. As he moves back and forth from place to place, engaging in critical dialogic exchanges with a number of figures more powerful than he, Harold's conflicted turns and twists create an image of constant instability and catalytic movement that becomes the center of the visual discourse.

THE NORMAN CONQUEST AND ODO OF BAYEUX

T HE LAST AND LONGEST PART OF THE BAYEUX Tapestry's epic-scaled narrative is dominated by William's invasion and conquest of England. Having shed much of the ambiguity and indeterminacy that complicated the first two sections, the story is now set upon a clear-cut course. Following the coronation of Harold, the Norman expedition to England has as its goal the duke's claim to the kingdom, presumably promised him by the dead king Edward. The Battle of Hastings culminates in a decisive conquest sealed by the death of King Harold. As a magnificent piece of propaganda, the Bayeux Tapestry's narrative now becomes a story transparently shaped to a purpose, but it is the designer's brilliant strategy to delay revealing that purpose until this moment, more than halfway through the discourse.

Up to this point, the viewer has witnessed the unfolding of events delineating the destinies of three kings: Edward, who dies; William, who expects to succeed him; and Harold, who actually (albeit briefly) becomes ruler of England after the Confessor's death. Now the chess game continues with two contending kings on the board. From this point on, however, the game strategy will be dominated by another piece, the white bishop in the person of Odo of Bayeux, who will play a critical role in checkmating Harold, the black king. Absent until now, the tapestry's patron, without displacing William, will become the external center that binds together the loose ends of the episodic narrative structure by giving it a more precisely defined political and ideological di-

rection, a raison d'être, for Odo will derive far more than a measure of William's reflected glory as a result of his participation in the adventure. Whereas William will gain Harold's crown, the bishop of Bayeux will fall heir to all that the earl of Wessex possessed before he became king – he will become the earl of Kent, next to the king the richest and most powerful man in Norman England. Within this new framework, the game will be just as much a contest for feudal power between Odo and Harold as a battle between two rulers.

Using the technique of episodic reiteration within a series of shifting narrative contexts, the last long section is introduced by a reprise of Harold's ship landing in Normandy (HIC NAVIS ANGLICA VENIT IN TERRAM WILLELMI DVCIS) (Fig. 38).[1] While the new king remains on his shaky throne across the Channel, his messenger delivers a reply to William's ultimatum threatening armed seizure of the realm. As the news of Harold's resolve reaches the duke, the decision is made to take the crown by force in a scene that conflates into a single deliberation a number of great councils held to consider the question of invasion (Fig. 39).[2] In a dialogic moment unique within the Bayeux Tapestry's narrative, the inscription informs the viewer what is being said ("Here Duke William commands a fleet to be built"). However, the visualization of the scene constitutes an emphatic contradiction of the inscribed text, for it is the tonsured Odo, not William, whose gesture sweeps past the shoulder of a carpenter with a planing ax, to initiate a long and elaborately detailed sequence of images representing each stage of the construction and preparation.[3] Forcefully eliding William of Poitiers' extended account of William's councils in which arguments both for and against invasion were heard, the Tapestry designer expanded Odo's role well beyond his feudal service to the duke in providing wise counsel; the bishop of Bayeux usurps his half-brother's decisive command. In contrast to what we see before us, the Norman historians assert that, among the inner circle of new magnates who had shared William's rise to power, it was William fitzOsbern rather than Odo who persuaded them that the adventure was feasible.[4] Here the designer is clearly rewriting history to elevate his patron's position, as he is literally raised to a spatial position

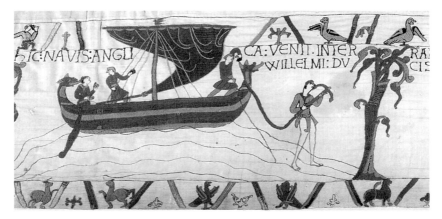

Figure 38. English Ship Sent to William. Bayeux, Musée de la Tapisserie (photo: Giraudon/Art Resource, NY)

Figure 39. William Orders the Building of the Fleet. Bayeux, Musée de la Tapisserie (photo: Marburg/Art Resource, NY)

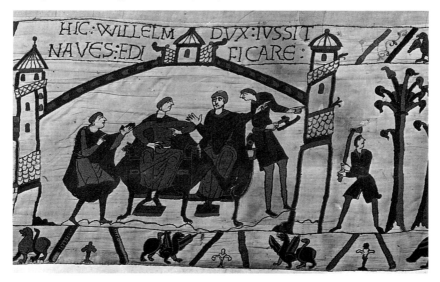

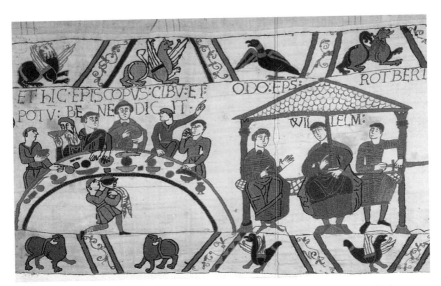

Figure 40. Odo's Banquet at Hastings; William with Odo and Robert of Mortain. Bayeux, Musée de la Tapisserie (photo: Giraudon/Art Resource, NY)

slightly higher than that of the duke. More important, the new fictionalized account invests Odo with a measure of power and influence in relation to his half-brother that significantly differs from Harold's relationship to Edward. As a worthy vassal, the bishop of Bayeux is thus deserving of the great rewards awaiting him after the Conquest.

Whereas Odo would have been readily recognized by contemporary viewers, his identity is textually unannounced in his initial appearance and is only gradually revealed in the inscriptions after the Norman force has successfully crossed the Channel and set up headquarters at Hastings, where a fortification is built. Here Odo is seen presiding at an elaborate banquet (Fig. 40). This time it is William who remains nameless, and his half-brother is now designated "EPISCOPVS." Although it is in his clerical role that he dominates the scene by blessing the meal, with the word "BENEDICIT" extending over the four figures to his right and left, the interpolation of the fictional episode was probably not intended pri-

marily to evoke the idea of piety and prayer.[5] Instead, the Norman celebration prompts the viewer's memory of the banquet at Bosham, preceded by the earl's prayer before the manor's church at the beginning of the narrative in which Harold displayed the prerogatives of his territorial power as the earl of Wessex. The repetition of the banquet scene enacted with a new cast of actors, in a new time and place, directs the spectator to recognize Odo's future role as the earl of Kent, quite literally stepping into Harold's shoes as presiding lord at table in the English territory that will become the domain of his earldom. As the semicircular table embraces and includes the spectator among the guests, the image makes an all-important link between past and present, legitimating Odo's role as the post-Conquest lord of the great hall in which the Tapestry is being displayed.

As if to signal the role that will earn the bishop his post-Conquest reward, the diner at Odo's left interrupts the blessing to point to the inscription above the next scene, where we encounter the patron's name inscribed for the first time, "ODO EPISCOPVS" (Fig. 40). However, it is not his clerical office, but his feudal service during the military campaign that takes center stage in the narrative's drive toward conquest. Flanked by his half-brothers Odo and Robert of Mortain, William holds a council of war. The "family portrait" displays not only the ties of blood kinship that bind Odo to William, but also the duke's apparent approval of the bishop-knight's *consilium*.

The close juxtaposition of the two scenes of the banquet and war council allows only a momentary glimpse of Odo in a fully frontal and centrally dominant position. He then resumes an auxiliary position at William's right as his most powerful vassal, proleptically foreshadowing the earl of Kent's post-Conquest role as a power second only to the new Norman king.[6] In contrast to the English tradition under Edward, whereby the great magnates were connected to the king at best by marriage, Odo, like the Norman counts before the Conquest, was a blood relation of the duke.[7] The pairing of William's two half-brothers in this dynastic portrait seems calculated to display the special privileges and feudal bonds guaranteed by kinship. Sometime about 1060, the duke trans-

ferred Mortain from a rebellious distant cousin to his conspicuously loyal half-brother Robert.[8] As count of Mortain, he held a frontier lordship of great strategic importance, bordering on Brittany and Bellême.[9] Similarly, the merger of political and fraternal ties binding Odo to William went back even further, to 1049, when the duke awarded his half-brother the bishopric of Bayeux, when he was well under the canonical age of 30, as part of a strategy to reassert ducal authority over lower Normandy.[10] The image thus serves to fortify an important dynastic claim to extend the same kind of power in England. After the Conquest, the lands Odo received made him by far the wealthiest of the Norman tenants-in-chief, his only close rival being his own brother Robert.[11]

Odo's last appearance in the Bayeux Tapestry (Fig. 41) is also pure invention on the part of the designer, as he projects the bishop into a pivotal role at the climax of the Battle of Hastings. Whereas William of Poitiers gives the victory to the single-handed action of the duke, the Conqueror now shares the turning point with Odo.[12] With the Normans in disarray, it was William who appeared in their midst, giving the battle a new turn:

> "Look at me well. I am still alive and by the grace of God I shall yet prove victor. What is this madness that makes you flee . . . ? You are throwing away victory and lasting glory, rushing into ruin and incurring abiding disgrace."[13]

Along with William, we see Odo in full armor on horseback, wielding the same clublike symbol of command (*baculus*) as that held by William.[14] Usurping actions ascribed to the duke alone, the warrior-bishop "thrusts himself in front of those in flight," and "restores their courage" by urging them forward (HIC ODO EPISCOPVS BACVLVM TENENS CONFORTAT PVEROS). At this crucial moment, Odo and William can be seen to form a bracketing pair of profile figures, Odo pressing forward and William turning back as he lifts the visor of his helmet to dispel the rumor that he has been killed. Odo now performs the second of two primary services of vassal to his feudal lord, *auxilium* in battle. Just as Harold had aided the duke during the Brittany campaign in the first section of

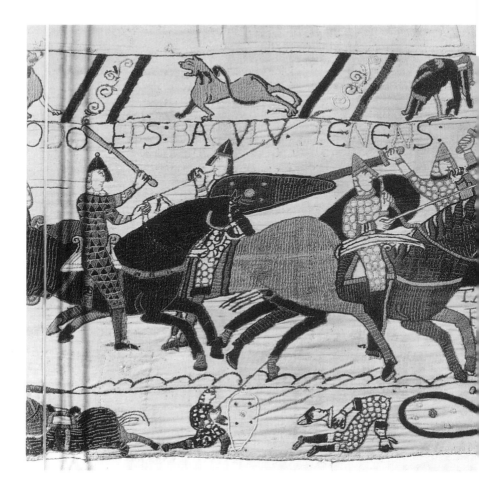

the narrative, that role is now claimed by Odo. As Dodwell pointed out, Odo can be compared to *Roland*'s Turpin, "simply a feudal baron with benefit of clergy."[15] The persona of the warrior-bishop constructed for Odo in the Bayeux Tapestry finds compelling affirmation in his episcopal seal: on the obverse a traditional bishop stands with crosier, whereas the reverse displays an equestrian knight in helmet and armor, holding a sword or baton.[16] The rare design of the two-sided equestrian seal

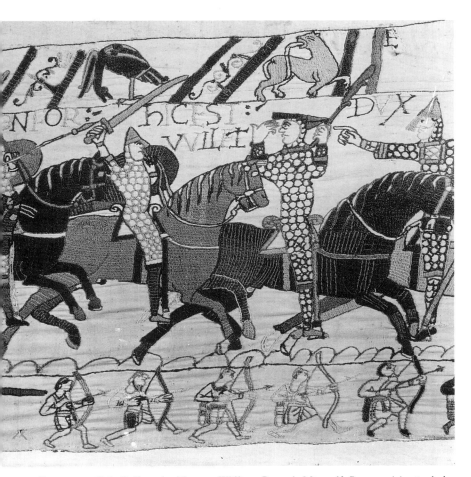

Figure 41. Odo Rallies the Troops; William Reveals Himself. Bayeux, Musée de la Tapisserie (photo: Giraudon/Art Resource, NY)

was an innovation begun by William immediately after the Conquest. Its conspicuous appropriation by the new bishop-earl of Wessex gives eloquent testimony to the consuming secular ambition that took Odo from Normandy to England and made him earl of Kent and William's vice-regent.[17]

Although the Bayeux Tapestry clearly magnified Odo's role in the Norman invasion, he is reported to have taken part in its planning and to have donated ships; he certainly accompanied the troops across the Channel to Pevensey (Fig. 2), a site prominently marked for notice by inscription in the Tapestry (HIC WILLEM DVX IN MAGNO NAVIGIO MARE TRANSIVIT ET VENIT AD PEVENESAE).[18] After Hastings, Odo was rewarded with the earldom of Kent, as well as with responsibility for defending the ports along the southeastern coast. Three persons singled out by name in the Bayeux Tapestry — Turold, Wadard, and Vital — all became Odo's tenants.[19] Founded on the ruin of the Godwinson family, Odo's English lands far exceeded those of any other Norman's holdings, making him the clear heir to Harold's power before he became king.[20] At the time the Bayeux Tapestry was commissioned, Odo was engaged in pacifying the potentially rebellious area around Canterbury. As earl of Kent and, in William's absence, vice-regent of all England, Odo left behind a legacy of hatred and resentment against what were repeatedly characterized by contemporary writers as his insatiable ambition, greed, and callous brutality.[21] In the fullest and most evenhanded account of his character, the twelfth-century Norman historian Orderic Vitalis wrote:

> What shall I say of Odo, bishop of Bayeux, who was an earl palatine dreaded by Englishmen everywhere, and able to dispense justice like a second king? He had authority greater than all earls and magnates in the kingdom, and gained much ancient treasure, as well as holding Kent. . . . In this man, it seems to me, vices were mingled with virtues, but he was given more to worldly affairs than to spiritual contemplation.[22]

Indeed it was the perceived conflict between his secular and clerical claims to rank and power that seems to have generated his eventual downfall and exile in 1082. According to the later chronicler William of Malmesbury, the Norman archbishop Lanfranc of Canterbury was the sole instigator of the challenge that sent Odo to prison. In the midst of the ongoing land disputes in Kent, Lanfranc insisted on distinguishing Odo's status as the king's brother and earl of Kent from his ecclesiastical

office as bishop of Bayeux,[23] a functional distinction clearly alien to the ideology espoused by the Norman prince-bishops of the eleventh century. Although it could be argued that his intense preoccupation with "worldly affairs" was the inevitable result of the feudal system, which forced baronial status upon him in the first place, Odo obviously gloried in its spectacular power, privilege, and wealth.[24]

Much has been made of the unique and fortuitous intrusion of the relics of Bayeux into the visual discourse of Odo's Tapestry (Fig. 31). As the sacred objects upon which Harold allegedly swore his false oath, they pull the bishop of Bayeux into the ranks of the earl's victims, lending further weight to Odo's role in the Conquest. In the first documented record of the Bayeux Tapestry, dating from 1476, we learn that it was displayed each year in the nave of Bayeux Cathedral during the feast and octave of the relics.[25] It has even been suggested that Odo commissioned the work for the dedication of the cathedral in 1077.[26] Although the connection with the cathedral and the relics of Bayeux undoubtedly accounts for its remarkable preservation, the format and the purely secular character of the Bayeux Tapestry tend to argue strongly against the Norman cathedral as its original destination. Far more likely is the supposition that Odo had the work made expressly for English audiences in secular settings and then took it to Bayeux when he was exiled and imprisoned in 1082. Probably made sometime between 1077 and 1082 when Odo was at the height of his power in England, albeit under threat from Lanfranc,[27] the Bayeux Tapestry rewrites the bishop's role at Hastings in terms that flaunt his power with a blatant kind of arrogance. Consonant with his Turpin-like virtues as the perfectly faithful vassal,[28] his claim to power rested in the last analysis solely on his blood relationship to William, in a narrative that subordinated religion to the expediency of secular power politics.

As propaganda for Odo's power in England, it was important to establish not only his role in the invasion but his role as successor to the earldom of Kent in the zero-sum game of feudal conflict. In the Bayeux Tapestry, Harold's death (Fig. 42) is expanded spatially and dramatically into three cyclical episodes gathered together toward the end of the

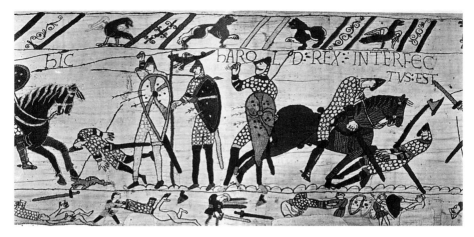

Figure 42. Death of Harold. Bayeux, Musée de la Tapisserie (photo: Marburg/Art Resource, NY)

narrative. Here the inscription is aggressively penetrated by the thrusts of Norman lances and arrows (HIC / HARO/L/D REX INTERFECTVS EST),[29] creating an "invasion" that threatens to destroy the king's name. In an otherwise puzzling but significant prelude to Harold's death at Hastings, the dragon-standard of Wessex is first displayed by an Anglo-Saxon soldier standing before the king and facing attack by a Norman cavalryman. In the next moment the dragon-standard has fallen to the ground in a reversal of the cyclical action, bringing the momentum to a dramatic pause before we see Harold struck by an arrow. Although both Wace and William of Malmesbury describe Harold standing by the standard, neither source refers to the red and gold dragon emblem of Wessex.[30] Indeed, its presence at this moment in the Bayeux Tapestry makes little historical sense, since Harold is no longer earl but king of all England.

Within the context of Odo's claim to power in southeast England, however, the symbolism of the emblematic fall of Wessex signals its territorial availability to a new Norman overlord. As Bernstein points out, the dragon is being crushed under the Norman horse's hoof in an ancient

topos of defeat.[31] In most conventional dragon myths, a conflict develops around the opposition of two combatants, hero and dragon, and is ineluctably resolved in the dragon's death.[32] In its most expressive and immediately accessible Anglo-Saxon form, the dragon-fight in *Beowulf*, the dragon poses a threat to the whole of ordered society. As a reward for destroying the adversarial symbol of human greed, the hero receives treasure either from the dragon's hoard or from a grateful king, and is given dominion over part of the kingdom. This kind of layered meaning can be seen to extend even more directly to Odo, who had earlier built a new abbey just outside Bayeux dedicated to the popular local dragon-slaying St. Vigor.[33] On another level, as Harold's death unfolds in a serial cluster of three consecutive moments, his death is preceded by his "loss" of Wessex as well as the kingdom, in a paratactic implication of causality.

Much has been written concerning the next episode, in which Harold is blinded by an arrow. Coming as the tragic climax of a long sequence of dramatic gestures in which we see figures pointing to eyes, the viewer is invited to consider how blindness and insight have been played off as a binary opposition throughout the narrative.[34] The viewer is constantly being urged to "see" Harold by figures pointing at him in almost every scene in which he appears, but his enigmatic character keeps slipping from our grasp. Whereas Harold is being observed by others, including the viewer, he himself is portrayed as lost on the way to Normandy, ostensibly "blind" to the presence of Halley's comet, and eventually blinded before his death. One of the most telling instances where the design thematizes "seeing" as insight is when the watchman in the tower signals the word "reversus" on Harold's return to England (Fig. 32), inviting the viewer to consider how the earl has been transformed (*reversus*) by his voyage to Normandy. Later in the narrative, in the midst of the battle the action stops as William asks whether Vital has seen Harold's army, in response to which he reports that he sees the kings' forces advancing. Finally, it is William whom we are invited by Odo to see as the duke lifts his visor, revealing his face to the troops (Fig. 41). The centrality of vision and seeing reminds the viewer of the au-

thenticating value of "witnessing" events, reinforcing the notion of "truth" in the Bayeux Tapestry's ritual reenactment of events in images. Above all, the centrality of seeing valorizes the viewer's present experience as "eyewitness" to the visualized events.

Although Harold's loss of sight could have been seen as tantamount to simultaneously declaring and punishing his sin of faithlessness or perjury,[35] it is more likely that the viewer is being asked to witness Harold suffering a legal Norman punishment inflicted on rebels and poachers in England after the Conquest. The hunter who set off for Normandy with his hawk and dogs at the outset of the Bayeux Tapestry's narrative transgressed the laws of an alien land and suffered the consequences. In the end, Harold's failure to desist from hunting "off limits," that is, to live within the rules of a new ideological system, was punished as the ultimate trespass. In the so-called Articles of William the Conqueror, sentences of blinding and castration were given wide application.[36] In his obituary on William, the Anglo-Saxon chronicler singles out this particularly brutal and demeaning punishment in connection with poaching in the king's forests:

> He made great protection for the game
> And imposed laws for the same
> That those who slew hart or hind
> Should be made blind.[37]

In Harold's prolonged last agony at Hastings, he is subjected to yet a third "death" by castration, euphemistically represented by a Norman soldier striking the king's thigh with his sword. At the same time that the gesture can be read as a punishment for "trespassers," castration provides an absolute "closure" to Harold's reign and to any possibility of a future claim upon Odo's earldom by Godwinson progeny. With the foreclosure of similar territorial claims in mind, a representation of the deaths of Harold's two brothers, Leofwine and Gyrth, both earls holding vast estates in Buckinghamshire, Surrey, and Oxfordshire, occurs earlier in the Tapestry's account of the Battle of Hastings (Fig. 43).[38]

With the triple "death" of Harold, the English then turn and flee (ET

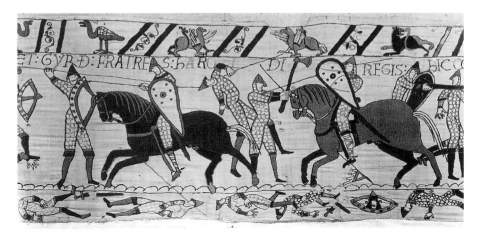

Figure 43. Harold's Brothers, Leofwine and Gyrth, Killed in Battle. Bayeux, Musée de la Tapisserie (photo: Giraudon/Art Resource, NY)

FUGA VERTERVNT ANGLI). As it now survives, perhaps incomplete,[39] the final image (Fig. 44) left in the viewer's memory is neither a pile of dead Anglo-Saxon warriors nor a triumphant icon of William crowned in London, but an irregular line of small figures, now bereft of armor and weapons, quitting the countryside in southeastern England, vacating its land for the new Norman overlords. According to the *Carmen de Hastingae*, it was Eustace of Boulogne who led the pursuit of the fleeing English at the end of the battle.[40] Although he does not play this role in the Bayeux Tapestry, his presence at Hastings, raising the papal banner into the upper margin at the turning point of the battle (Fig. 41), singles him out, along with Odo, as deserving rich rewards after 1066. It has been suggested that Eustace was the principal commander of William's army.[41] Because the chronicles are full of contradictions, his role in the Conquest is difficult to determine, but Eustace became one of the largest noble landholders in England.[42] Indeed, his primary motivation in joining William's expedition was to gain land, wealth, and power.[43] Unlike the other conquistadors, Eustace had previous ties to England that may

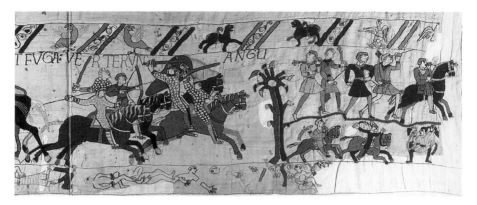

Figure 44. The English Flee from Battle. Bayeux, Musée de la Tapisserie (photo: Giraudon/Art Resource, NY)

have shaped expectations of what lands William should grant him in re-ward for his services. In addition to furthering our understanding of the strong links between post-Conquest landholding and the Bayeux Tap-estry's curious rewriting of history, the fortuitous introduction of Eustace of Boulogne might help us narrow the dating of the work to the years when the count of Boulogne was restored to good standing in 1077, af-ter his rebellion against the king[44] and before Odo of Bayeux had fallen from favor in 1082.

The narrative ends with a Norman victory, but there is dishonor in stripping the English dead as well as in the mutilation of Harold. As Cowdrey remarks, the last section of the Bayeux Tapestry tells the sto-ry of a hard-fought battle whose outcome was not foreordained by prov-idence or fate, but by an unexpected tactical turn when Odo intervened and the Norman cavalry rallied.[45] A recent analysis of the battle argues that the outcome was determined by the success or failure of leadership. The turning point may have been reached earlier with the deaths of Harold's brothers, Earls Gyrth and Leofwine (see Fig. 43), who were killed in front of the Saxon army just as the advance was getting under way, so that the whole Saxon counterattack might have collapsed from

this sudden loss of command. As Stephen Murillo observes, the place-
ment of their deaths in the Bayeux Tapestry confirms such an interpre-
tation, coming immediately after the Norman attack, before William ral-
lies his troops, and well before the climactic moments of Harold's
death.[46] Nonetheless, it was Harold's death that made the Norman vic-
tory at Hastings decisive:

> As long as King Harold stood under his banner, both in the sense of re-
> maining alive and in the sense of refusing to run, the Saxon army stood
> with him. . . . But a large proportion of the entire Saxon leadership class
> perished, including any possible effective heirs. . . . Yet the decimation of
> the Saxon leadership was also partly the result of Harold's decision to
> stand firm and of William's relentless determination. . . . Both leaders in
> the end decided to risk all on one throw of the dice.[47]

The work was designed with two almost mutually exclusive goals in
mind: the Bayeux Tapestry both legitimizes Norman rule in England,
particularly Odo's earldom in Kent, and at the same time retains the dig-
nity and honor of an English king, however discredited, slain in battle.[48]
In this way, morale and loyalty could be promoted among the broad
spectrum of Anglo-Saxon society upon whom the new rulers of England
depended.[49]

In its present state, the narrative "text" of the Bayeux Tapestry seems un-
finished, ending literally on a jagged edge of unfulfilled expectations.
Whether its "incompleteness" results from accidental damage or artistic
intention, the viewer is nevertheless left at a moment of indeterminacy.
Notwithstanding the finality of William's victory over the English flee-
ing from the battlefield at Hastings in 1066, the post-Conquest narra-
tive remains essentially unfinished. Its ongoing action propels the con-
temporary spectator from past events and present perception into an
unpredictable future.

Based on Baudri's description of an imaginary tapestry in the encomi-
um written for the Conqueror's daughter, Parisse hypothesizes that the
Bayeux Tapestry concluded with a series of scenes in which the English

take flight, chased by the Norman cavalry. Night falls and the English find refuge in their flight, accompanied by moving descriptions of the suffering and anguish of the people. William offers peace and is joyously received in London as king. In the last scene the king wears his crown, thus providing the necessary final image of William's coronation in ceremonial legitimation of his victory.[50] Given the apparent integrity of the narrative and the tendentious argument of the historical record that concludes with the elevation of the Norman duke as king of England, Richard Brilliant would also see the Tapestry "end with William at Westminster, thereby completing the entire program in the very place in which it began, but with a new, Norman occupant of the English throne."[51] Such a resolution would also seem satisfying within the context of the Tapestry's salient structuring of the narrative as a sequence of places invested with feudal power and territorial claim. As a final but by no means minor consideration, along with Hayden White we might see a narrative closure of this kind as a structural necessity to ensure an order of meaning in a chronological framework of events that they do not possess as mere sequence.[52] History, as opposed to annals or chronicles, structures the reality of events into a "discourse of desire," by making the real into an object, goal, and end, by confirming the formal coherence of the story with narrative closure.[53]

The Bayeux Tapestry functions as the material, visible embodiment of an ideology, a network of values defining feudalism and absolute monarchy. Within this realm of signs and social practices, the viewer becomes part of their representation, as he or she is called upon to produce rather than perceive meaning. As the viewing subject becomes part of the picture, the work privileges its own ideal spectator and in turn confers a sense of social and political dominance upon the comprehending beholder.[54] Whereas Baudri's imaginary tapestry was obliged to provide an appropriate "place" of power for the triumphant William, the designer of the Bayeux Tapestry would have been required to create places of power for Odo and the new Norman aristocracy as well as for their newly conquered subjects — that is, the kind of spaces just vacated by the English fleeing into the countryside — into what will already have become,

by the time of the Tapestry's making and viewing, the earldom of Kent. Thus it could be argued that the viewer's impulse to "perform" the text would be more readily accommodated by the Bayeux Tapestry's present open-ended, "unfinished" state than by the kind of confrontational image of absolute power proposed by Parisse and Brilliant.[55]

Within the medieval conventions upon which the visual narrative in the Bayeux Tapestry is structured, its form is inherently fragmentary, a discontinuity of continuing presentness. It can end, but it cannot be concluded or resolved.[56] Rather than providing structural fulfillment, its narrative ending is abrupt and unprepared. Despite the ongoing presence of an insistent textuality in the inscriptions, the designer aimed not at the production of a fixed text, but at the creation of a narrative that lives and endures in flux from performance to performance within a quasi-oral tradition. Given its pervasive, but characteristically medieval indeterminacy, the Bayeux Tapestry does not tell a story; it merely provides the spectator with a set of recognizable signs that engender a provisional reconstruction of the story. Its images do not reproduce the spectator's direct experience of a theatrical spectacle, but instead approximate a narrative summary, a sequence of skeletal diagrams, incorporating the acts of visual imagination that the spectator inwardly performs as he or she sees and hears the dramatic recital of the actions in the presence of embroidered images.[57]

Like all medieval texts, the Bayeux Tapestry was most likely appropriated and absorbed as an experience without closure.[58] As in the plot structure of Icelandic saga, "The story . . . is not a thing finished and done with, it is a series of pictures rising in the mind, succeeding, displacing, and correcting one another."[59] The identity of the text is constantly challenged and even undermined by the subversive or centrifugal possibilities of multiple interpretation built into the consciously underdetermined visual discourse of the Bayeux Tapestry by its designer. The "performed text" represented a periodic enactment of the most basic values and innermost codes of a new medieval culture of Norman feudalism, an affirmation of that which was ideologically manifest elsewhere as "what everybody knows."[60] In terms of the rhetorical strategies pursued in

reading and picturing texts, the acting out in speech, gesture, or concrete action gave meaning to the present. As illustrations mime the discourse of the text, they engage in an experiential playing out or miming of logocentric ideals. Premised on the medieval recognition of a radical discontinuity of time between sense and reference, between surface and deep structure, the Bayeux Tapestry's imaged discourse constitutes a deliberate attempt to conflate past and present, here and there, speaker, audience, and characters, in a transparency of meaning that can be felt to exist beyond the text, beyond words.

NOTES

INTRODUCTION

1. R. A. Brown, *Norman Conquest*, p. xv.
2. See Douglas, "Edward the Confessor," pp. 526–45.
3. On the structure and function of this cultural process in earlier eleventh-century Europe, see Geary, *Phantoms of Remembrance*, pp. 7–9.
4. See Pocock, "Origins of the Study of the Past," p. 217.
5. See McNulty, *Narrative Art*, p. 13; Wilson, *Bayeux Tapestry*, p. 212.
6. Barthes, "Introduction," p. 264.
7. See Culler, *Pursuit of Signs*, pp. 37–9; Barthes, "Introduction," pp. 269–72; Bal and Bryson, "Semiotics and Art History," pp. 184–5.
8. Iser, *Act of Reading*, p. 21.
9. Quoted by Thompkins, *Reader-Response Criticism*, p. xiv.
10. Iser, *Act of Reading*, p. 24.
11. The theoretical analysis that follows is based upon Turner, "Social Dramas," pp. 150–9.
12. Turner, "Social Dramas," p. 156.
13. On rhetoric and its bearing upon historiography, see LaCapra, *History and Criticism*, pp. 36–43.
14. See Patterson, *Negotiating the Past*, pp. 64–6.
15. See O'Brien, "Michel Foucault's History of Culture," p. 35.
16. Foucault, *Archaeology of Knowledge*, pp. 48–9.
17. Greimas, *Sémiotique structurale*; idem, "Les actants," pp. 161–76.
18. Martin, *Recent Theories*, p. 104.
19. B. H. Smith, "Narrative Versions," p. 228.
20. Barthes, "Introduction," pp. 260–1.
21. See Culler, *Pursuit of Signs*, pp. 170–1; B. H. Smith, "Narrative Versions," p. 224.

22. Bal and Bryson, "Semiotics and Art History," pp. 206–207; see Bakhtin, *The Dialogic Imagination*.
23. Bal and Bryson, "Semiotics and Art History," pp. 178–80; Culler, *Framing the Sign*, p. xiv.
24. For extended arguments on the place of production, see Brooks and Walker, "Authority and Interpretation," pp. 10, 13, 17–18; Bernstein, *Mystery*, pp. 37–50.
25. See Bates, "Character and Career," p. 2; Bernstein, *Mystery*, p. 32; S. A. Brown, "Bayeux Tapestry: Why Eustace?" p. 23.
26. See Loyn, *Norman Conquest*, p. 108.
27. Loyn, *Norman Conquest*, p. 102; Barlow, *Feudal Kingdom*, p. 85.
28. Barlow, *Feudal Kingdom*, p. 117.
29. Gransden, "Propaganda," pp. 363–4.
30. See Bertrand, *La Tapisserie*, p. 313; Grape, *Bayeux Tapestry*, p. 78.
31. Bernstein, *Mystery*, pp. 105, 212, n. 46. The great tower at Chepstow (100 × 40 feet) was clearly large enough to accommodate the Bayeux Tapestry's 232-foot length; J. C. Perks, *Chepstow Castle*, 2nd ed. (London, 1967).
32. Bernstein, *Mystery*, p. 107, cites a plausible parallel in the tenth-century Byzantine Joshua Roll.
33. See ibid., pp. 104–107, fig. 65; Brilliant, "Bayeux Tapestry," p. 99.
34. See Cowdrey, "Towards an Interpretation," pp. 64–8; Grape, *Bayeux Tapestry*, p. 80. On the itinerant Anglo-Norman courts, see Hollister, *Monarchy*, p. 24.
35. See Zumthor, *Toward a Medieval Poetics*, pp. 45–6; see also Nichols, "Philology," pp. 1–10.
36. Fiske, *Understanding Popular Culture*; see also Sponsler, "Culture of the Spectator," pp. 28–9.
37. Kermode, "Secrets," p. 88.
38. Ibid., p. 92.

CHAPTER 1

1. See Clanchy, *From Memory to Written Record*, pp. 6–7.
2. See Lepelley, "Contribution," pp. 313–21; Brooks and Walker, "Authority and Interpretation," p. 10; Wilson, *Bayeux Tapestry*, pp. 203–204.
3. Clanchy, *From Memory to Written Record*, pp. 18–19, 27; M. Bloch, *Feudal Society*, pp. 75–81.
4. Clanchy, *From Memory to Written Record*, pp. 224–52.
5. Ibid., p. 206.
6. Ibid., p. 186.

7. See B. H. Smith, *On the Margins*, p. 7.
8. Augustine, *De Magistro* 4.8.165.
9. See Gellrich, *Discourse and Dominion*, pp. 8–10.
10. John of Salisbury, *Metalogicon* I.13, p. 32: "Littere autem, id est figure, primo vocum indices sunt . . . et frequenter absentium dicta sine voce loquuntur."
11. Parisse, *La Tapisserie*, p. 79.
12. Ibid., p. 53; Brilliant, "Bayeux Tapestry," pp. 102, 113.
13. See Clanchy, *From Memory to Written Record*, pp. 284–5; Brilliant, "Bayeux Tapestry," p. 109.
14. See Chatman, "What Novels Can Do," p. 128.
15. For the theoretical basis of this and what follows, see Chatman, *Story and Discourse*, pp. 146–223; see also Bordwell, *Narration in the Fiction Film*; Branigan, *Narrative Comprehension*.
16. Favreau, *Études d'épigraphie médiévale*, p. 205.
17. As pointed out by Brilliant, "Bayeux Tapestry," pp. 108–109.
18. Quoted by Parisse, *La Tapisserie*, p. 37.
19. See B. H. Smith, *On the Margins*, p. 7.
20. See Sturges, *Medieval Interpretation*, pp. 17–18; B. H. Smith, *On the Margins*, p. 51.
21. See Chatman, *Story and Discourse*, p. 64.
22. See S. A. Brown, "Bayeux Tapestry: History of Propaganda?" pp. 24–5. For a comparative discussion of narrative conventions in contemporary works, see Brilliant, "Bayeux Tapestry," pp. 103–105.
23. See Kelly, "Interpretation of Genres," pp. 108–109, 112, 122.
24. Culler, *Structuralist Poetics*, p. 147.
25. See Rosmarin, *Power of Genre*, pp. 39–41; Fishelov, *Metaphors of Genre*, p. 10.
26. See Ong, "Orality," p. 1.
27. Vitz, *Medieval Narrative*, p. 113.
28. Ibid., p. 111.
29. Morse, *Truth and Convention*, p. 5.
30. Fentress and Wickham, *Social Memory*, pp. 161–3; Zumthor, *Toward a Medieval Poetics*, p. 50.
31. Morse, *Truth and Convention*, p. 6.
32. Ibid., pp. 3, 6.
33. Ibid., p. 89.
34. S. A. Brown, "Bayeux Tapestry and the *Song of Roland*," p. 340.
35. Gransden, *Historical Writing*, pp. 29–31; Taylor, *Use of Medieval Chronicles*, pp. 3–5.
36. S. A. Brown, "Bayeux Tapestry and the *Song of Roland*," p. 342.
37. Gransden, *Historical Writing*, p. 40.

38. Ibid., p. 94.
39. See M. Bloch, *Feudal Society*, pp. 88–92.
40. See Morse, *Truth and Convention*, pp. 231–3.
41. Quoted from *Accessus ad auctores* by Minnis and Scott, *Medieval Literary Theory*, p. 43.
42. Isidore of Seville, *Etymologiae* I.44.5: ". . . for what was seen was recounted without lies (quae enim videntur, sine mendacio proferuntur)." See Beer, *Narrative Conventions*, pp. 10, 23.
43. See Kellner, "As Real as It Gets," p. 50.
44. Isidore of Seville, *Etymologiae* I.40–44. Isidore then distinguishes *historia* from *fabula* as the narration of things that have actually taken place as opposed to fictional happenings. See Partner, *Serious Entertainments*, p. 195.
45. See Morse, *Truth and Convention*, pp. 6, 86. As Zumthor, *Toward a Medieval Poetics*, p. 12, observed, history does not mean veracity. Historicity is the attribute of that which asks or desires to be believed.
46. Morse, *Truth and Convention*, pp. 80, 82.
47. Nichols, *Romanesque Signs*, p. xiii; Morse, *Truth and Convention*, pp. 5, 17.
48. Morse, *Truth and Convention*, p. 17.
49. Ibid., p. 87.
50. Ibid., pp. 2–3.
51. These events and their Norman sources are discussed in detail by S. A. Brown, "Bayeux Tapestry, History or Propaganda?" pp. 16–25.
52. William of Poitiers, *Gesta Guillelmi* I.22; see Davis, "William of Poitiers," pp. 71–100. See Beer, *Narrative Conventions*, pp. 14–15, 30; Morse, *Truth and Convention*, p. 98.
53. Spiegel, "History," pp. 81–3.
54. Spiegel, "History," pp. 81–2; Morse, *Truth and Convention*, p. 98, who notes that the ostensibly superior accuracy of prose had become an accepted *topos* for the Middle Ages.
55. Matthew of Westminster, *The Flowers of History*, II, p. 418.
56. See Brandt, *Shape of Medieval History*, pp. 71, 76.
57. See Jameson, *Political Unconscious*, pp. 23–41; also Patterson, *Negotiating the Past*, p. 50.
58. See Brandt, *Shape of Medieval History*, pp. 79–80.
59. Zumthor, *Toward a Medieval Poetics*, p. 16.
60. Brandt, *Shape of Medieval History*, pp. 88–90, 109.
61. See Brandt, *Shape of Medieval History*, pp. 130, 138.
62. See Morse, *Truth and Convention*, p. 106.

63. Zumthor, *Toward a Medieval Poetics*, p. 90.
64. Ibid., pp. 379–80.
65. Ibid., p. 38.
66. Nichols, *Romanesque Signs*, pp. xiii, 148.
67. Ibid., p. xiii; Zumthor, *Toward a Medieval Poetics*, p. 382; see also M. Bloch, *Feudal Society*, pp. 92–5.
68. See supra, p. 6.
69. Zumthor, *Toward a Medieval Poetics*, p. 5.
70. Van Houts, "Latin Poetry," p. 39; cf. *Carmen de Hastingae*, pp. xxi–xxii, xxvii–xxviii.
71. Van Houts, "Latin Poetry," p. 56.
72. *Carmen de Hastingae*, vv. 34–7 and p. xxxvi.
73. Dodwell, "Bayeux Tapestry," pp. 549–60; S. A. Brown, "Bayeux Tapestry and the *Song of Roland*," pp. 339–48.
74. Wace, *Le Roman de Rou*, lines 13, 149–55; William of Malmesbury, *Gesta Regum Anglorum*, p. 302; see Van Houts, "Latin Poetry," pp. 39, 56.
75. S. A. Brown, "Bayeux Tapestry and the *Song of Roland*," p. 347; Dodwell, "Bayeux Tapestry," p. 560. Also see Douglas, "*Song of Roland*," pp. 99–102.
76. Jauss, *Toward an Aesthetic of Reception*, p. 100.
77. Ibid., pp. 83–7.
78. Zumthor, *Toward a Medieval Poetics*, pp. 129–30.
79. Dodwell, "Bayeux Tapestry," p. 554.
80. See S. A. Brown, "Bayeux Tapestry and the *Song of Roland*," p. 343; Jauss, *Toward an Aesthetic of Reception*, p. 5.
81. Nichols, *Romanesque Signs*, pp. 149, 164.
82. Dodwell, "Bayeux Tapestry," p. 557.
83. Ibid., p. 553; S. A. Brown, "Bayeux Tapestry and the *Song of Roland*," pp. 341–2.
84. Dodwell, "The Bayeux Tapestry," p. 558.
85. Erich Auerbach, *Typologische Motive in der mittelalterlichen Literatur* (Cologne, 1964), p. 61, quoted by Zumthor, *Toward a Medieval Poetics*, p. 13.
86. Zumthor, *Toward a Medieval Poetics*, p. 65.
87. Ibid., pp. 66–7.
88. See infra, pp. 125–8.
89. For an analysis of the use of fictional strategies in Ranke's historical writing, see Hans Robert Jauss, *Question and Answer: Forms of Dialogic Understanding* (Minneapolis: University of Minnesota Press, 1989), pp. 28–9, 34–8.
90. *Encomium Emmae*; see also Morse, *Truth and Convention*, pp. 127–30.

91. *Encomium Emmae,* p. 5; see Morse, *Truth and Convention,* p. 139.
92. See Körner, *Battle of Hastings,* p. 68.
93. Ibid., p. 51.
94. John, *"Encomium,"* pp. 61–2.
95. Cnut swears an oath to Emma that he would never set up a son by any other wife to rule after him.
96. Körner, *Battle of Hastings,* p. 57.
97. *Encomium Emmae,* pp. 49–51.
98. See Searle, "Emma the Conqueror," pp. 281–3.
99. John, *"Encomium,"* p. 80.
100. Ibid., p. 94.
101. *The Battle of Maldon,* ed. D. G. Scragg (Manchester, 1981); *The Battle of Maldon,* ed. Janet Cooper (London, 1993); Hans Erik Andersen, *The Battle of Maldon: Meaning, Dating and Historicity of an Old English Poem;* see Wilson, *Bayeux Tapestry,* p. 203, who discussed the poem's paradigmatic relationship to the Bayeux Tapestry.
102. Brown and Herren, *"Adelae Comitissae,"* p. 72; cf. Brookes and Walker, "Authority and Interpretation," p. 26.
103. Brown and Herren, *"Adelae Comitissae,"* p. 73.
104. Ibid., p. 58, who quote vv. 233–4: "Porro recenseres titulorum scripta legendo / In velo veras historiasque novas."
105. Brown and Herren, *"Adelae Comitissae,"* p. 61.

CHAPTER 2

1. See Brandt, *Shape of Medieval History,* pp. 98–9, 103.
2. Parks, "Textualization of Orality," pp. 53–4.
3. Morse, *Truth and Convention,* pp. 64–6; Beer, *Narrative Conventions,* p. 41; Sturges, *Medieval Interpretation,* p. 5.
4. Morse, *Truth and Convention,* p. 56.
5. Ibid., p. 73.
6. Quintilian, *Institutio Oratio* 2.1.10, 2.4. 1–4, 4.2.116–20.
7. See Morse, *Truth and Convention,* p. 60.
8. Ibid., p. 113.
9. T. A. Heslop, Review of Wilson, *Bayeux Tapestry,* in *Burlington Magazine* 128 (1986), p. 147.
10. See Sturges, *Medieval Interpretation,* pp. 2–5.
11. Ibid., p. 180.

12. Zumthor, *Toward a Medieval Poetics*, p. 6.
13. See R. A. Brown, *Normans*, pp. 67–8; Douglas, *William the Conqueror*, p. 172; Loyn, *Norman Conquest*, pp. 19–20, 61–7.
14. See R. A. Brown, *Normans*, pp. 68–9.
15. Quoted by R. A. Brown, *Norman Conquest*, p. 22.
16. Brooks and Walker, "Authority and Interpretation," pp. 10–11; Bernstein, *Mystery*, pp. 115–16.
17. Eadmer, *Historia Novorum*, trans. Bosanquet, p. 6.
18. Wace, *His Chronicle*, pp. 76–8.
19. See Nichols, *Romanesque Signs*, p. 194.
20. For a discussion and analysis of the poststructuralist shift to a more open, non-functional notion of character in the work of Barthes and Todorov, see Chatman, *Story and Discourse*, pp. 111–34.
21. Barthes, *S/Z*, pp. 190–1.
22. Chatman, *Story and Discourse*, p. 130.
23. See Zumthor, *Toward a Medieval Poetics*, pp. 361–2.
24. See Sponsler, "Culture of the Spectator," p. 16.
25. See Halperin, "Ideology of Silence," p. 466.
26. Sponsler, "Culture of the Spectator," p. 20; cf. Max Horkheim and Theodor Adorno, "The Culture Industry: Enlightenment as Mass Deception," in *The Dialectic of Enlightenment* (New York, 1977), pp. 120–67.
27. Nichols, *Romanesque Signs*, p. 149.
28. See Pizarro, *Rhetoric of the Scene*, p. 105.
29. Beer, *Narrative Convention*, pp. 40–3, argues a similar case for Villehardouin's insertion of direct speech to amplify the account of the conquest of Constantinople given in the *Gesta Francorum*.
30. Morse, *Truth and Convention*, pp. 56–91.
31. Bernstein, *Mystery*, pp. 163–4.
32. See Jameson, "Metacommentary," pp. 10, 17.
33. See Patterson, *Negotiating the Past*, pp. 58–9.
34. B. H. Smith, *On the Margins*, pp. 15–16.
35. See ibid., pp. 30–1.
36. See ibid., pp. 101–102.
37. See Bordwell, *Narration in the Fiction Film*, p. 20.
38. Brilliant, "Bayeux Tapestry," pp. 113, 118.
39. See Leach, *Rhetoric of Space*, pp. 320–1.
40. See Brilliant, "Bayeux Tapestry," p. 107.
41. Douglas, *William the Conqueror*, pp. 188–9.

42. Renn, "Burhgeat and Gonfanon," pp. 189–90.
43. Ibid., pp. 191–2. See infra, pp. 129–30 on Eustace.
44. Loyn, *Norman Conquest*, pp. 116–17.
45. Ibid., pp. 101–104. On Norman feudal practices before 1066, see Barlow, *Feudal Kingdom*, pp. 104–105.
46. Loyn, *Norman Conquest*, p. 121.
47. Brandon and Short, *South East*, p. 29. See also Williams, "Land and Power," pp. 171–87; Golding, "Robert of Mortain," p. 119.
48. Morse, *Truth and Convention*, p. 109; Nichols, *Romanesque Signs*, pp. 151–2.
49. See Chatman, "What Novels Can Do," pp. 123–6.
50. See Leach, *Rhetoric of Space*, p. 79.
51. Ibid., p. 281.
52. Loyn, *Norman Conquest*, pp. 56–8.
53. See Douglas, *William the Conqueror*, p. 175.
54. Chibnall, "Orderic Vitalis," p. 47, who cites the well-known statement of Orderic II.218; also R. A. Brown, *Normans*, pp. 84–5, 100; R. A. Brown, *Castles*, pp. 10, 84.
55. Leach, *Rhetoric of Space*, pp. 311–12.
56. See R. A. Brown, *Normans*, p. 202.
57. Chibnall, "Orderic Vitalis," p. 47.
58. See R. A. Brown, *Castles*, p. 218.
59. See Renn, "Burhgeat and Gonfanon," pp. 177–86.
60. See infra, pp. 100–01. [p. 90]
61. Chibnall, "Orderic Vitalis," p. 56.
62. See R. A. Brown, *Castles*, pp. 222–3; idem, *Normans*, pp. 36–7, 73–4.
63. See Searle, *Predatory Kinship*, pp. 239, 243.
64. See Heinemann, "Network," pp. 178–92; also Brilliant, "Bayeux Tapestry," p. 105.
65. See Leach, *Rhetoric of Space*, pp. 117, 137–8.
66. As Bates, *Normandy*, p. 148, points out, the use of the title "duke" was uncommon even in Normandy before 1066; Richard II was the first Norman ruler to style himself *dux*.
67. Yapp, "Animals," p. 30. Distinguished by its shorter wings, the bird can be identified as a goshawk rather than a falcon.
68. Zumthor, *Toward a Medieval Poetics*, p. 17.
69. Barlow, *Norman Conquest*, p. 11.
70. See J. Campbell, *Anglo-Saxons*, fig. 201; R. A. Brown, *Castles*, pp. 217–18. For fuller references, see K. H. Macdermott, *Bosham Church* (Chichester, 1926);

Victoria County History, Sussex, IV (London, 1953), pp. 181ff.; Joan Taylor, *Anglo-Saxon Architecture*, I (Cambridge, 1965), pp. 81–4.

71. See R. L. S. Bruce-Mitford, *The Sutton-Hoo Ship-Burial* (London, 1968), pp. 29–31.
72. On the architecture of Bosham, see R. A. Brown, *Castles*, pp. 218–19.
73. Wace, *His Chronicle*, trans. Taylor, p. 78.
74. Domesday Book I.310 or DB I.18b, cited by Williams, "Land and Power," p. 185.
75. Williams, "Land and Power," pp. 185–7; Brandon and Short, *South East*, p. 21.
76. S. A. Brown, "Bayeux Tapestry: History or Propaganda?" p. 17.
77. See Heinemann, "Network," p. 192.
78. Evans, "Episodes," pp. 126, 130–3; Haidu, "Episode," p. 60, defines "episode" as a syntactical unit of narrative structure, subsidiary to a principle of textual coherence located not in the referential function of a category such as "character," but on the semantic level.
79. As pointed out by Brooks and Walker, "Authority and interpretation," p. 20.
80. See Pizarro, *Rhetoric of the Scene*, p. 64.
81. On the semiotic status of the episode, see Wittig, *Stylistic and Narrative Structures*, p. 136; Haidu, "Episode," p. 60.
82. See Vitz, *Medieval Narrative*, p. 101.
83. Kellogg, "Varieties of Tradition," pp. 124–5.
84. Foley, "Implications," pp. 39–40, who cites Om Prakash Joshi, *Painted Folklore and Folklore Patterns of India* (Delhi, 1976); John D. Smith, *The Epic of Pabuji: A Study, Transcription and Translation* (Cambridge, 1991), pp. 14–70.
85. Pizarro, *Rhetoric of the Scene*, p. 32.
86. Vitz, *Medieval Narrative*, p. 119.
87. Pizarro, *Rhetoric of the Scene*, p. 13.
88. Ibid., p. 14.
89. Pächt, *Rise of Pictorial Narrative*, pp. 71–2.
90. Scheub, "Body and Image," p. 345.
91. Ibid., pp. 365–6.
92. Pizarro, *Rhetoric of the Scene*, p. 140.
93. See Chatman, "What Novels Can Do," pp. 132–3.
94. Pizarro, *Rhetoric of the Scene*, p. 141; for a succinct account of the narratological concepts of story and discourse, see Gerald Prince, "Narratology," in *The Johns Hopkins Guide to Literary Theory and Criticism*, ed. Michael Groden and Martin Kreisworth (Baltimore, 1994), pp. 524–7.
95. Chatman, "What Novels Can Do," p. 130.

96. See M. W. Campbell, "Hypothèses," p. 243.

97. As pointed out by Douglas, "Edward the Confessor," p. 541.

98. William of Poitiers, *Gesta Guillelmi* 41–2, pp. 100–106. As Bertrand points out in *La Tapisserie*, p. 61, on another level, Guy might be perceived as exercising his maritime right of *wareck*, whereby all ships belong to the lord of the shores on which they land.

99. See Bertrand, *La Tapisserie*, p. 79.

100. See Strickland, "Slaughter," pp. 44, 56.

101. Douglas, *William the Conqueror*, p. 176.

102. William of Poitiers, *Gesta Guillelmi*, pp. 100–102; Douglas, *William the Conqueror*, p. 176.

103. Bernstein, *Mystery*, pp. 124–5.

104. See Bates, *Normandy*, p. 77.

105. See Hicks, "Borders," pp. 251–65; Yapp, "Animals," pp. 15–73; Abraham and Letienne, "Les Bordures," pp. 483–518.

106. As identified by Chefneux, "Les Fables," pp. 1–35, 153–94, who argues that the model was the English *Romulus* of Alfred, the same source used for the *fabliaux* of Marie de France. Herman, in *Les Fables*, identified an improbable forty-two fables based on his hypothesis that the designer was copying the scenes directly from an illustrated Phaedrus collection of Aesopian fables.

107. See Hicks, "Borders," pp. 252–3.

108. Many of the connections of these fables with the main narrative have been analyzed by Bernstein, *Mystery*, pp. 128–135; Cowdrey, "Towards an Interpretation," pp. 55–6; Terkla, "Cut on the Norman Bias," pp. 269–74.

109. See Bernstein, *Mystery*, pp. 125–6; Terkel, "Cut on the Norman Bias," pp. 266, 268. However, their assertions that these patterns were intended to have been recognized as Norman chevrons is less plausible.

110. Needler, "Animal Fable," p. 428.

111. Lang, *Anatomy*, pp. 200–201.

112. Ibid., p. 202.

113. Lang, *Anatomy*, pp. 202–203.

114. Needler, "Animal Fable," pp. 423–4, 432.

115. See ibid., p. 431.

116. Lang, *Anatomy*, p. 211.

117. Quoted by Minnis and Scott, *Medieval Literary Theory*, p. 47.

118. Lang, *Anatomy*, p. 211.

119. Ibid., p. 204.

120. Ibid., p. 206.

121. Needler, "Animal Fable," p. 434.

122. See Morse, *Truth and Convention*, p. 40.
123. Ibid., p. 42.
124. See Ryan, "Embedded Narratives," p. 322.
125. Ricoeur, *Time and Narrative*, I, p. 36.
126. B. H. Smith, *On the Margins*, p. 69.
127. See Berthoff, "Fiction," pp. 276, 278, 282.
128. B. H. Smith, *On the Margins*, pp. 70–1.
129. Ibid., p. 73.
130. For a semiotic analysis of this fable, see Ryan, "Embedded Narratives, pp. 319–40.
131. See Terkla, "Cut on the Norman Bias," p. 269.
132. McNulty, *Narrative Art*, p. 28.
133. See Lang, *Anatomy*, p. 205.
134. Ibid., pp. 206–207.
135. Ibid., p. 207.
136. Ibid., p. 211.
137. Needler, "Animal Fable," p. 432.
138. Lang, *Anatomy*, p. 213.
139. Needler, "Animal Fable," p. 427.
140. On the medieval animal fable as a "mirror of feudal ethos," see Jauss, *Untersuchungen*, pp. 45–55; Hans Ulrich Gumbrecht, *Marie de France, Äsop* (Munich, 1973), p. 47; Henderson, "Medieval Beasts," pp. 40–1.
141. Needler, "Animal Fable," p. 428, 436.
142. Ibid., p. 435.
143. Ibid., p. 438.
144. See McNulty, *Narrative Art*, pp. 26–7.
145. Ibid., p. 26.
146. Cowdrey, "Towards an Interpretation," pp. 55–6; Terkel, "Cut on the Norman Bias," p. 270.
147. Bernstein, *Mystery*, p. 129.
148. McNulty, *Narrative Art*, p. 28.
149. Ibid., pp. 27–9.
150. Bernstein, *Mystery*, p. 132.
151. Ibid., pp. 130–1.
152. As pointed out by McNulty, *Narrative Art*, pp. 29–30.
153. See ibid., pp. 31–2.
154. See ibid., p. 34.
155. Claude Lévi-Strauss, *La pensée sauvage* (Paris: Plon, 1962), pp. 26–47; See Searle, *Predatory Kinship*, pp. 237–49.

CHAPTER 3

1. Bertrand, *La Tapisserie*, pp. 24–5.
2. Parisse, *La Tapisserie*, p. 50.
3. See Barthes, "Introduction," pp. 253–6; also Bordwell, *Narrative in the Fiction Film*, pp. 34–6.
4. Ryding, *Structure in Medieval Narrative*, pp. 33, 43–4; Evans, "Episodes," p. 126.
5. Evans, "Episodes," p. 127; Haidu, "Episode," p. 660.
6. See Scheub, "Body and Image," pp. 345–6.
7. See Evans, "Episodes," 127, who cites David Lodge's pun on the expectations of a court audience that presumably included women; also Haidu, "Episode," pp. 659–60, who comments on the analysis of serialism in myth by Claude Lévi-Strauss, *L'Origine des manières de table* (Paris: Plon, 1968), pp. 9–11, 88–91, 95–106, 156–7; see also Mel Bochner, "The Serial Attitude," *Art Forum* 6 (1967), p. 2.
8. See Parisse, *La Tapisserie*, pp. 53–4.
9. In film, the "cut" between shots refers to the transition between two shots linked together by a simple fade, giving the impression during projection that the first shot is suddenly and instantaneously displaced by the second. "Ellipsis" refers to a narrative discontinuity, between story and discourse. See Chatman, *Story and Discourse*, p. 71.
10. See ibid., p. 52.
11. See Sturges, *Medieval Interpretation*, p. 176.
12. As noted by Parisse, *La Tapisserie*, p. 60.
13. See Kestner, "Secondary Illusion," pp. 100, 107.
14. See Mickelsen, "Types of Spatial Structure," p. 75.
15. See Smitten, "Spatial Form," pp. 13, 17–19.
16. See Vitz, *Medieval Narrative*, p. 120.
17. Barthes, "Introduction," pp. 267–8.
18. Evans, "Episodes," p. 126.
19. See Vitz, *Medieval Narrative*, pp. 107–108.
20. See Vitz, *Medieval Narrative*, pp. 112, 176–7.
21. Bloomfield, *Essays and Explorations*, p. 101.
22. See Sturges, *Medieval Interpretation*, p. 190.
23. See Mink, "History and Fiction," pp. 546–7.
24. Ibid., pp. 553–7.
25. See Vitz, *Medieval Narrative*, p. 115.
26. See ibid., p. 181.
27. According to William of Poitiers, *Gesta Guillelmi* I.41, Guy delivered Harold to

William at the border castle of Eu, and from there he was taken to Rouen. Judging from the splendor of the architectural representation, the Bayeux Tapestry designer elided the first destination to compress the narrative. See S. A. Brown, "Bayeux Tapestry: History or Propaganda?" p. 17.

28. Parisse, *La Tapisserie*, p. 75.
29. Chatman, "What Novels Can Do," p. 129.
30. See Wissolik, "Duke William's Messengers," pp. 102–107, who further argues that Eadmer's account independently asserts that William sent two sets of envoys to Guy, but clearly a single set of messengers are represented twice in cyclical action.
31. See Bernstein, *Mystery*, p. 19.
32. See Heinemann, "Network," p. 187.
33. R. A. Brown, *Castles*, pp. 220–2.
34. See Grape, *Bayeux Tapestry*, pp. 74–6.
35. See Schapiro, *Words and Pictures*, pp. 43–5. As Garnier, *Le Langage*, I, pp. 142–6, observes, the profile position generally can be read as a sign of inferiority.
36. See Sturges, *Medieval Interpretation*, p. 186.
37. Wissolik, "Saxon Statement," pp. 87–91.
38. M. W. Campbell, "Aefgyva," pp. 127–45.
39. McNulty, "Lady Aelfgyva," pp. 659–68.
40. Bertrand, *La Tapisserie de Bayeux*, pp. 62, 87; see also Searle, "Women and Legitimisation," p. 162.
41. See Frugoni, "L'Iconografia," pp. 950–1.
42. McNulty, "Lady Aefgyva," p. 665, who cites Garnier, *Le Langage*, II, pp. 120–6.
43. See Karras, "Latin Vocabulary," pp. 4–5.
44. See Cowdrey, "Towards an Interpretation," p. 54, n. 19, who cites the synod of Lisieux, canons 2–3; L. Deslisle, "Canons du Concile tenu à Lisieux en 1064," *Journal des savants* (1901), pp. 516–21.
45. See Chatman, *Story and Discourse*, p. 64.
46. See Vitz, *Medieval Narrative*, p. 105.
47. McNulty, "Lady Aefgyva," pp. 666–7.
48. See Loyn, *Norman Conquest*, pp. 50–1, 138; Searle, *Predatory Kinship*, pp. 138–9; Williams, "Problems," pp. 160–1.
49. Stafford, "Portrayal," p. 144.
50. See M. W. Campbell, "Queen Emma," pp. 66–79; Stafford, "Sons and Mothers," pp. 93–4.
51. See Loyn, *Norman Conquest*, p. 42.
52. See Grape, *Bayeux Tapestry*, p. 58; J. J. G. Alexander, *Norman Illumination at Mont-Saint-Michel 966–1100* (Oxford: Clarendon Press, 1970), p. 13. See also

Bertrand, "Le Mont-Saint-Michel," pp. 137–40. On the architectural representation of the church, see R. A. Brown, *Castles*, pp. 216–17.

53. For the text of the charter of 1033–34, see R. A. Brown, *Norman Conquest*, p. 139.

54. For a discussion of the architectural representations of the castles of Dol, Rennes, and Dinan, see R. A. Brown, *Castles*, pp. 222–3.

55. See S. A. Brown, "Bayeux Tapestry and the *Song of Roland*," p. 342; Grape, *Bayeux Tapestry*, p. 58. On the significance of the Breton war of 1064 in William's overall political strategy, see Douglas, *William the Conqueror*, pp. 178–9.

56. See S. A. Brown, "Bayeux Tapestry: History or Propaganda?" p. 18; Wilson, *Bayeux Tapestry*, p. 10; Grape, *Bayeux Tapestry*, p. 57.

57. Wilson, *Bayeux Tapestry*, p. 10; Bernstein, *Mystery*, p. 41. Both trace the pictorial sources for Conan's escape down a rope to an illustration in the Ælfric Paraphrase (British Library MS Cotton Claudius B.IV), fol. 141v.

58. Loyn, *Norman Conquest*, p. 42; also Hollister, *Monarchy*, p. 20.

59. See R. A. Brown, *Normans*, p. 128.

60. B. H. Smith, *On the Margins*, pp. 96–7.

61. Werckmeister, "Political Ideology," p. 568; Brooks, "Arms," pp. 92–3.

62. William of Poitiers, *Gesta Guillelmi* I.42, p. 104.

63. Wilson, *Bayeux Tapestry*, p. 180.

64. See Parisse, *La Tapisserie*, p. 139; Werckmeister, "Political Ideology," p. 567.

65. As pointed out by Brooks and Walker, "Authority and Interpretation," p. 4.

66. See R. A. Brown, *Normans*, p. 74.

67. Werckmeister, "Political Ideology," p. 570.

68. Wace, *Roman de Rou*, II, p. 205, vv. 8595–6.

69. Werckmeister, "Political Ideology," p. 569.

70. See Brooks, "Arms," p. 93.

71. R. A. Brown, *Normans*, p. 84.

72. Cowdrey, "Towards an Interpretation, p. 54.

73. Dodwell, "Bayeux Tapestry," p. 554, Werckmeister, "Political Ideology," pp. 569–70.

74. William of Poitiers, *Gesta Guillelmi*, p. 104 n. 2; Werckmeister, "Political Ideology," p. 570.

75. William of Poitiers, *Gesta Guillelmi*, quoted by R. A. Brown, *Norman Conquest*, p. 23. Bonneville-sur-Touques was a favorite ducal residence not far from Lisieux, where William of Poitiers was archdeacon.

76. Orderic Vitalis, *Historia Ecclesiastica* II, 134–7.

77. See Brooks and Walker, "Authority and Interpretation," p. 8.
78. See R. A. Brown, *Castles*, p. 223.
79. Dodwell, "Bayeux Tapestry," p. 554.
80. Ibid.
81. See Pizarro, *Rhetoric of the Scene*, pp. 174–83.
82. Ibid., pp. 190, 201.
83. See Bernstein, *Mystery*, pp. 168–9.
84. William of Poitiers, *Gesta Guillelmi* II.14, pp. 180–2 ("the relics whose favor Harold had alienated from himself by violating the faith he had pledged by swearing on them"), as pointed out by S. A. Brown, "Bayeux Tapestry and the *Song of Roland*," p. 346; see also R. A. Brown, *Normans*, p. 141.
85. Pizarro, *Rhetoric of the Scene*, p. 205.
86. See Dodwell, "Bayeux Tapestry," p. 554.
87. *Carmen de Hastingae*, p. 71; see Werckmeister, "Political Ideology," pp. 564–5.
88. Grape, *Bayeux Tapestry*, p. 117.
89. William of Poitiers, *Gesta Guillelmi* I.42, in R. A. Brown *Norman Conquest*, p. 23; *Carmen de Hastingae*, p. 16, vv. 233–4, 239–42, 245–6. See Loyn, *Norman Conquest*, p. 58.
90. See Loyn, *Norman Conquest*, p. 58.
91. Eadmer, *Historia Novorum*, trans. Bosanquet, p. 8.
92. Werckmeister, "Political Ideology," pp. 571–9.
93. William of Jumièges, *Gesta Normannorum* VII, 13, pp. 160–1. In the same vein, William of Poitiers, *Gesta Guillelmi*, pp. 103–105, states that "Harold publicly swore fealty to [William] by the sacred rite of Christians." See R. A. Brown, *Norman Conquest*, pp. 23–4.
94. H. A. Cronne, "The Salisbury Oath," *History* 19 (1934), p. 251; see Loyn, *Norman Conquest*, pp. 129–30; Barlow, *Feudal Kingdom*, p. 109.
95. Werckmeister, "Political Ideology," p. 575. On feudalism and monarchy, see R. A. Brown, *Normans*, pp. 206, 209.
96. See M. Bloch, *Feudal Society*, p. 124.
97. See Grape, *Bayeux Tapestry*, p. 72, n. 326.
98. On the overlapping of the new inscription with the oath scene, see Bernstein, *Mystery*, p. 117.
99. See Parisse, *La Tapisserie*, p. 63.
100. See Vitz, *Medieval Narrative*, pp. 86–9; Jameson, *Political Unconscious* pp. 66–8.
101. Eadmer, *Historia Novorum*, p. 8; see Parisse, *La Tapisserie*, p. 46; Brooks and Walker, "Authority and Interpretation," pp. 10–11.
102. See Pizarro, *Rhetoric of the Scene*, pp. 130–1.

103. See ibid., p. 131; Morse, *Truth and Convention*, p. 104; Cowdrey, "Towards an Interpretation," p. 56.

104. See Vitz, *Medieval Narrative*, p. 3.

105. See Sturges, *Medieval Interpretation*, p. 181.

106. *Vita Ædwardi*, pp. xli–xlix.

107. Brooks and Walker, "Authority and Interpretation," p. 12.

108. *Anglo-Saxon Chronicle*, II, p. 142.

109. Bernstein, *Mystery*, p. 120. There is no doubt, however, that Harold correctly represents the custom of England, whereby succession came to depend on the testamentary disposition of the previous king; see Williams, "Problems," pp. 166–7.

110. William of Jumièges, *Gesta Normannorum*, in *English Historical Documents*, II, p. 215; William of Poitiers, *Gesta Guillelmi*, pp. 146–7.

111. See Bernstein, *Mystery*, p. 122; R. A. Brown, *Normans*, p. 133–7.

112. Cowdrey, "Towards an Interpretation," pp. 57–8.

113. See Searle, *Predatory Kinship*, pp. 143–8.

114. See ibid., p. 247.

115. Bernstein, *Mystery*, p. 212.

116. See Brooks and Walker, "Authority and Interpretation," p. 21; McNulty, *Narrative Art*, pp. 70–1.

117. See Douglas, *William the Conqueror*, p. 182.

118. See Barlow, *Feudal Kingdom*, pp. 75–6.

119. Bates, *Normandy*, p. 124.

120. See Bernstein, *Mystery*, pp. 122–3.

121. Garnier, *Le Langage*, I, p. 142.

122. William of Poitiers, *Gesta Guillelmi*, p. 146; See Barlow, *Feudal Kingdom*, p. 32; also Nelson, "Rites of the Conqueror," pp. 127–8.

123. See Parisse, *La Tapisserie*, p. 107.

124. M. F. Smith, "Archbishop Stigand," pp. 197–219.

125. M. F. Smith, "Archbishop Stigand," p. 218.

126. See Grape, *Bayeux Tapestry*, pp. 55–7.

127. *Chronica de mailros*, ed. Joseph Stevenson (Edinburgh, 1835), p. 70, quoted by Brandt, *Shape of Medieval History*, p. 53.

128. See Brandt, *Shape of Medieval History*, p. 73.

129. Dodwell, "Bayeux Tapestry," p. 559.

130. William of Poitiers, *Gesta Guillellmi* II.41.

131. See S. A. Brown, "Bayeux Tapestry: History or Propaganda?" p. 23.

132. See Bernstein, *Mystery*, p. 123.

CHAPTER 4

1. Contrary to S. A. Brown, "Bayeux Tapestry: History or Propaganda?" p. 23, who asserts that this scene refers to William of Poitiers' account of how Harold sent spies to Normandy and that one of them was brought before William.
2. See R. A. Brown, *Normans*, p. 126.
3. See Bernstein, *Mystery*, pp. 136–7; S. A. Brown, "Bayeux Tapestry: History or Propaganda?" p. 22; Cowdrey, "Towards an Interpretation," pp. 50–1.
4. William of Poitiers, *Gesta Guillelmi*, p. 149; Orderic Vitalis, *Historia Ecclesiastica*, II, p. 122; Wace, *Roman de Rou*, II, pp. 270–5; see Douglas, *William the Conqueror*, p. 184.
5. Cf. Brooks and Walker, "Authority and Interpretation," pp. 14–17; Bernstein, *Mystery*, pp. 137–40; S. A. Brown, "Bayeux Tapestry: History or Propaganda," p. 21.
6. See Loyn, *Norman Conquest*, pp. 123–4.
7. See C. P. Lewis, "Early Earls," pp. 210, 222; also Searle, *Predatory Kinship*, pp. 233–4.
8. See C. P. Lewis, "Early Earls," p. 210; David C. Douglas, "The Earliest Norman Counts," *English Historical Review* 61 (1946), p. 141.
9. Golding, "Robert of Mortain," pp. 119–21.
10. Bernstein, *Mystery*, p. 31.
11. Golding, "Robert of Mortain," pp. 119, 124; idem, *Conquest and Colonization*, p. 75. Robert probably did not acquire his large estates in Cornwall and Yorkshire until after 1075. See Bates, "Character of Career," p. 2; idem, "Notes," pp. 28–9.
12. See Bernstein, *Mystery*, p. 141; McNulty, *Narrative Art*, pp. 63–4.
13. Quoted by Bernstein, *Mystery*, p. 141; also see R. A. Brown, *Normans*, p. 147.
14. Bates, "Character and Career," p. 6.
15. Dodwell, "Bayeux Tapestry," pp. 549, 557.
16. See Heslop, "English Seals," pp. 10–11; Bernstein, *Mystery*, p. 142.
17. Dodwell, "Bayeux Tapestry," pp. 549–50.
18. William of Poitiers, *Gesta Guillelmi*, p. 183; Wace, *Le Roman de Rou de Wace*, I, v. 6186; see Bernstein, *Mystery*, p. 32.
19. See Brooks and Walker, "Authority and Interpretation," p. 8; Cowdrey, "Towards an Interpretation," p. 50.
20. See Bates, "Character and Career," p. 10.
21. See ibid., pp. 2–5.
22. Orderic Vitalis, *Historia Ecclesiastica* IV, 264–6, quoted by Bernstein, *Mystery*, p. 35.

23. William of Malmesbury, *Gesta Regum*, II, pp. 360–1.
24. See Bates, "Character and Career," pp. 16–17; Bernstein, *Mystery*, pp. 35–6.
25. Simone Bertrand, "History of the Tapestry," in *The Bayeux Tapestry*, ed. Sir Frank Stenton, 2nd ed. (London: Phaidon, 1965), p. 88.
26. Brooks and Walker, "Authority and Interpretation," pp. 8–9.
27. In contrast to Werckmeister, "Political Ideology," pp. 579–89, and S. A. Brown, "Bayeux Tapestry: History or Propaganda?" who dates the Bayeux Tapestry to 1082–87, when Odo was imprisoned by William, I substantially agree with the dating proposed by Brooks and Walker, "Authority and Interpretation," p. 10, to 1067–82, when Odo was earl of Kent and vice-regent at the height of his political favor and power in England. The dates might be narrowed further to 1077–82; see infra, p. 130.
28. Dodwell, "Bayeux Tapestry," pp. 557–8; also Werckmeister, "Political Ideology," p. 585.
29. See Brooks and Walker, "Authority and Interpretation," pp. 23–33.
30. William of Malmesbury, *De Gestis Regum* II.302; Wace, *Roman de Rou*, I, vv. 8805–6; see also R. A. Brown, *Normans*, p. 141; Brooks and Walker, "Authority and Interpretation," pp. 32–3.
31. Bernstein, "Blinding," p. 41; idem, *Mystery*, p. 31; Renn, "Burhgeat and Gonfanon," p. 187.
32. See Evans, "Semiotics," pp. 94, 96, 100.
33. Bernstein, *Mystery*, p. 31; Orderic Vitalis, *Historia Ecclesiastica* IV, 117.
34. Brilliant, "Bayeux Tapestry," pp. 101–102, suggests the possibility of their programmatic significance without indicating what it might be.
35. Bernstein, *Mystery*, pp. 54–6.
36. Bernstein, "Blinding," pp. 56–7; *English Historical Documents*, I, p. 423; II, p. 400.
37. 'E' Chronicles, 1086 (7), *English Historical Documents*, II, p. 164, quoted by Bernstein, "Blinding," p. 57.
38. See Wilson, *Bayeux Tapestry*, p. 14.
39. See ibid., p. 9; Bernstein, *Mystery*, p. 15; Grape, *Bayeux Tapestry*, p. 23.
40. *Carmen de Hastingae*, vv. 561–6, cited by Tanner, "Expansion," p. 271.
41. S. A. Brown, "Bayeux Tapestry: Why Eustace?" pp. 8–12, 12–17.
42. Tanner, "Expansion," pp. 270–1. On the conflicting characterizations of Eustace, see S. A. Brown, "Bayeux Tapestry: Why Eustace?" p. 18. At one point the *Gesta Guillelmi* describes him as the worst of cowards, who fled after the battle had been fought and won.
43. Tanner, "Expansion," p. 273; Williams, *English*, pp. 15–16.
44. Bernstein, *Mystery*, p. 38; see S. A. Brown, "Bayeux Tapestry: History or Propaganda?" pp. 25–6.

45. Cowdrey, "Towards an Interpretation," pp. 61–2.
46. Murillo, "Hastings," p. 224.
47. Ibid., pp. 226–7.
48. See Wilson, *Bayeux Tapestry*, p. 16: and Cowdrey, "Towards an Interpretation," p. 63, who cites the *Vita Ædwardi* 1.5.30–1, as evidence that Harold's heroic reputation was still being memorialized by the English as late as ca. 1075.
49. Cowdrey, "Towards an Interpretation," p. 64.
50. See Parisse, *La Tapisserie*, pp. 38–40, 55; see also Brown and Herren, "*Adelae Comitissae*," pp. 59, 66–7.
51. Brilliant, "Bayeux Tapestry," p. 99. Indeed William I dated the opening of his reign from his coronation, not from the death of the former king; see Loyn, *Norman Conquest*, p. 188.
52. White, "Value of Narrativity," p. 5.
53. Ibid., pp. 19–20.
54. See S. Lewis, *Reading Images*, pp. 207–208.
55. Parisse, *La Tapisserie*, pp. 36–40; Brilliant, "Bayeux Tapestry," pp. 99–101.
56. See Mickelsen, "Types of Spatial Structure," pp. 73, 76.
57. See Leach, *Rhetoric of Spaces*, pp. 323, 335.
58. Zumthor, *Toward a Medieval Poetics*, p. 47.
59. W. P. Ker, *Epic and Romance* (London, 1897), p. 272, quoted by Evans, "Episodes," p. 131.
60. R. H. Bloch, *Etymologies and Genealogies*, p. 15.

BIBLIOGRAPHY

PRIMARY SOURCES

The Anglo-Saxon Chronicle, E Version. Translated and edited by David C. Douglas and G. W. Greenaway. In *English Historical Documents*, II, pp. 1107–203. London: Methuen, 1979.

The Battle of Maldon. Edited by D. G. Scragg. Manchester: Manchester University Press, 1981.

The Battle of Maldon. Edited by Janet Cooper. London: Hambledon Press, 1993.

The Carmen de Hastingae Proelio of Guy of Amiens. Edited by Catherine Morton and Hope Muntz. Oxford: Clarendon Press, 1972.

Eadmer. *Historia Novorum in Anglia*. Edited by Martin Role. London: Longman, 1884.

Eadmer. *Historia Novorum in Anglia*. Translated by Geoffrey Bosanquet. London: Cresset Press, 1964.

Encomium Emmae Reginae. Edited by Alistair Campbell. London: Royal Historical Society, 1949.

Isidore of Seville. *Etymologiae*. 2 vols. Edited by W. M. Lindsay. Oxford: Clarendon Press, 1911.

John of Salisbury. *Metalogicon*. Edited by J. B. Hall and K. S. B. Keats-Rohan. Turnholt: Brepols, 1991.

Matthew of Westminster. *The Flowers of History*. 2 vols. Edited and translated by C. D. Younge. London: H. G. Bohn, 1853.

Orderic Vitalis. *Historia Ecclesiastica*. 5 vols. Edited by Augustus le Prevost. Paris: J. Renouard, 1838–55.

Vita Ædwardi. Edited and translated by Frank Barlow. London: Nelson, 1962.

Wace. *His Chronicle of the Norman Conquest from the Roman de Rou*. Translated by Edgar Taylor. London: W. Pickering, 1837.

Wace. *Le Roman de Rou*. 2 vols. Edited by A. J. Holden. Paris: Picard, 1970–3.

William of Jumièges. *Gesta Normannorum Ducum*. Edited by Elizabeth M. C. Van Houts. Oxford: Oxford University Press, 1992.

William of Malmesbury. *Gesta Regum Anglorum*. 2 vols. Edited by William Stubbs. London: Rolls Series, 1887–9.

William of Poitiers. *Gesta Guillelmi ducis Normannorum et regis Anglorum*. Edited by Raymonde Foreville. Paris: Les Belles Lettres, 1952.

SECONDARY SOURCES

Abraham, Jeanne, and Letienne, A. "Les Bordures de la Tapisserie-Broderie de Bayeux," *Normannia* 3 (1929): 483–518.

Anderson, Hans Erik. *The Battle of Maldon: Meaning, Dating and Historicity of an Old English Poem*. Copenhagen: University of Copenhagen, 1991.

Bakhtin, M. *The Dialogic Imagination*. Austin: University of Texas Press, 1981.

Bal, Mieke, and Bryson, Norman. "Semiotics and Art History," *Art Bulletin* 73 (1991): 174–208.

Barlow, Frank. *The Feudal Kingdom of England, 1042–1216*. 4th ed. London: Longman, 1988.

The Norman Conquest and Beyond. London: Hambledon Press, 1983.

Barthes, Roland. "An Introduction to the Structural Analysis of Narrative," *New Literary History* 6 (1974–75): 237–72.

S/Z. New York: Hill and Wang, 1974.

Bates, David R. "The Character and Career of Odo, Bishop of Bayeux (1049/50–1097)," *Speculum* 50 (1975): 1–20.

Normandy before 1066. London: Longman, 1982.

"Notes sur l'aristocratie normande," *Annales de Normandie* 23 (1973): 7–38.

Beer, Jeannette. *Narrative Conventions of Truth in the Middle Ages*. Geneva: Droz, 1981.

Bernstein, David. *The Mystery of the Bayeux Tapestry*. Chicago: University of Chicago Press, 1986.

"The Blinding of Harold and the Meaning of the Bayeux Tapestry," *Anglo-Norman Studies* 5 (1982): 40–64.

Berthoff, Warner. "Fiction, History, Myth: Notes towards the Discrimination of Narrative Forms," pp. 263–87. In *The Interpretation of Narrative: Theory and Practice*, edited by Morton W. Bloomfield. Cambridge, MA: Harvard University Press, 1970.

Bertrand, Simone. *La Tapisserie de Bayeux et la manière de vivre au onzième siècle*. Saint-Leger-Vauban: Zodiaque, 1966.

"Le Mont-Saint-Michel et la Tapisserie de Bayeux," pp. 137–40. In *La Normandie bènèdictine au temps de Guillaume le Conquèrant*. Lille: Facultès catholiques, 1967.

Bloch, Marc. *Feudal Society*. Chicago: University of Chicago Press, 1961.

Bloch, R. Howard. *Etymologies and Genealogies: A Literary Anthropology of the French Middle Ages*. Chicago: University of Chicago Press, 1983.

Bloomfield, Morton W. *Essays and Explanations: Ideas, Language, and Literature*. Cambridge, MA: Harvard University Press, 1970.

Bordwell, David. *Narration in the Fiction Film*. Madison: University of Wisconsin Press, 1985.

Brandon, Peter, and Short, Brian. *The South East from AD 1000*. London: Longman, 1990.

Brandt, William J. *The Shape of Medieval History: Studies in Modes of Perception*. New Haven: Yale University Press, 1966.

Branigan, Edward. *Narrative Comprehension and Film*. London: Routledge, 1992.

Brilliant, Richard. "The Bayeux Tapestry: A Stripped Narrative for Their Eyes and Ears," *Word & Image* 7 (1991): 98–126.

Brooks, N. P. "Arms, Status and Warfare in Late-Saxon England," pp. 81–104. In *Ethelred the Unready*. London: British Archaeological Reports, 1979.

Brooks, N. P., and Walker, H. E. "The Authority and Interpretation of the Bayeux Tapestry," *Anglo-Norman Studies* 1 (1979): 1–34.

Brown, R. Allen. *Castles, Conquest, and Charters*. Woodbridge: Boydell Press, 1989.

The Norman Conquest. London: E. Arnold, 1984.

The Normans and the Norman Conquest. 2nd ed. Dover, NH: Boydell Press, 1985.

Brown, Shirley Ann. "The Bayeux Tapestry and the *Song of Roland*," *Olifant* 6 (1979): 339–48.

"The Bayeux Tapestry: History or Propaganda?" pp. 11–25. In *The Anglo-Saxons: Synthesis and Achievement*, edited by J. D. Woods and D. Pelteret. Waterloo, Ont.: Wilfred Laurier University Press, 1985.

"The Bayeux Tapestry: Why Eustace, Odo and William?" *Anglo-Norman Studies* 12 (1989): 7–28.

Brown, Shirley Ann, and Herren, Michael W. "The *Adelae Comitissae* of Baudri of Boureuil and the Bayeux Tapestry," *Anglo-Norman Studies* 16 (1993): 55–73.

Campbell, James. *The Anglo-Saxons*. Ithaca: Cornell University Press, 1982.

Campbell, M. W. "Aefgyva: The Mysterious Lady of the Bayeux Tapestry," *Annales de Normandie* 34 (1984): 127–45.

"Hypothèses sur les causes de l'ambassade de Harold en Normandie," *Annales de Normandie* 27 (1977): 243–65.

"Queen Emma and Ælfgifu of Northampton: Canute the Great's Women," *Medieval Scandinavia* 4 (1971): 66–79.

Chatman, Seymour. *Story and Discourse: Narrative Structure in Fiction and Film*. Ithaca: Cornell University Press, 1978.

"What Novels Can Do That Films Can't (and Vice Versa)," *Critical Inquiry* 7 (1980): 121–40.

Chefneux, Hélène. "Les Fables dans la tapisserie de Bayeux," *Romania* 60 (1934): 1–35, 153–94.

Chibnall, Marjorie. "Orderic Vitalis on Castles," pp. 43–56. In *Studies in Medieval History Presented to R. Allen Brown*, edited by Christopher Harper-Bill et al. Woodbridge: Boydell Press, 1989.

Clanchy, M. T. *From Memory to Written Record: England 1066–1307*. 2nd ed. Oxford: Blackwell, 1993.

Cowdrey, H. E. J. "Towards an Interpretation of the Bayeux Tapestry," *Anglo-Norman Studies* 10 (1989): 49–65.

Culler, Jonathan. *Framing the Sign: Criticism and Its Institutions*. Norman, OK: University of Oklahoma Press, 1988.

The Pursuit of Signs: Semiotics, Literature, Deconstruction. Ithaca: Cornell University Press, 1981.

Structuralist Poetics. Ithaca: Cornell University Press, 1975.

Davis, R. H. C. "William of Poitiers and His History of William the Conqueror," pp. 71–100. In *The Writing of History in the Middle Ages: Essays Presented to Richard William Southern*, edited by R. H. C. Davis and J. M. Wallace-Hadrill. Oxford: Clarendon Press, 1981.

Dodwell, C. R. "The Bayeux Tapestry and the French Secular Epic," *Burlington Magazine* 108 (1966): 549–60.

Douglas, David C. "Edward the Confessor, Duke William of Normandy, and the English Succession," *English Historical Review* 68 (1953): 526–45.

"The *Song of Roland* and the Norman Conquest in England," *French Studies* 14 (1960): 99–116.

William the Conqueror: The Norman Impact upon England. Berkeley: University of California Press, 1964.

Evans, Jonathan D. "Episodes in Analysis of Medieval Narrative," *Style* 20 (1986): 126–41.

"Semiotics and Traditional Lore: The Medieval Dragon Tradition," *Journal of Folklore Research* 22 (1985): 85–112.

Favreau, Robert. *Études d'épigraphie médiévale*. Limoges: Pulim, 1995.

Fentress, James, and Chris Wickham. *Social Memory*. Oxford: Blackwell, 1992.

Fishelov, David. *Metaphors of Genre: The Role of Analogies in Genre Theory*. University Park, PA: Pennsylvania State University Press, 1993.

Fiske, John. *Understanding Popular Culture*. Boston: Unwin Hyman, 1989.

Foley, John Miles. "The Implications of Oral Tradition," pp. 31–57. In *Oral Tradition*

in the Middle Ages, edited by W. F. H. Nicolaisen. Binghamton, NY: Medieval and Renaissance Texts and Studies, 1995.

Foucault, Michel. *The Archaeology of Knowledge and the Discourse on Language.* New York: Pantheon, 1972.

Frugoni, Chiara "L'Iconografia de matrimonio e della coppia nel medioevo," *Settimane di studio del Centro italiano di studi sull'alto medioevo* 24, pt. 2 (1977): 901–63.

Garnier, François. *Le Langage de l'image au moyen âge.* 2 vols. Paris: Leopard d'or, 1982–9.

Geary, Patrick J. *Phantoms of Remembrance: Memory and Oblivion at the End of the First Millennium.* Princeton: Princeton University Press, 1994.

Gellrich, Jesse M. *Discourse and Dominion in the Fourteenth Century: Oral Contexts of Writing in Philosophy, Politics, and Poetry.* Princeton: Princeton University Press, 1995.

Golding, Brian. "Robert of Mortain," *Anglo-Norman Studies* 13 (1990): 119–44.

Gransden, Antonia. *Historical Writing in England, c. 550–1307.* Ithaca: Cornell University Press, 1974.

"Propaganda in English Medieval Historiography," *Journal of Medieval History* 1 (1975): 363–81.

Grape, Wolfgang. *The Bayeux Tapestry.* Munich: Prestel Verlag, 1994.

Greimas, A. J. "Les actants, les acteurs et les figures," pp. 161–76. In *Sémiotique narrative et textuelle,* edited by Claude Chabrol et al. Paris: Larousse, 1973.

Sémiotique structurale. Paris: Larousse, 1966.

Haidu, Peter. "The Episode as Semiotic Module in Twelfth-Century Romance," *Poetics Today* 4 (1983): 655–81.

Halperin, Charles J. "Ideology of Silence: Prejudice and Pragmatism of the Medieval Religious Frontier," *Comparative Studies in Society and History* 26 (1984): 442–66.

Heinemann, Edward A. "Network of Narrative Details: The Motif of the Journey in the *Chanson de Geste,*" pp. 178–92. In *Epic in Medieval Society: Aesthetics and Moral Values,* edited by Harold Scholler. Tübingen: Niemeyer, 1977.

Henderson, Arnold Clayton. "Medieval Beasts and Modern Cages, the Making and Meaning of Fables and Bestiaries," *Publications of the Modern Language Association* 97 (1982): 40–9.

Herrman, Léon. *Les Fables antiques de la broderie de Bayeux.* Collection Latomus 69. Brussels: Latomus, 1964.

Heslop, T. A. "English Seals from the Mid-Ninth Century to 1100," *Journal of the British Archaeological Association* 133 (1980): 1–16.

Hicks, Carola. "The Borders of the Bayeux Tapestry," pp. 251–65. In *England in the Eleventh Century: Proceedings of the 1990 Harlaxton Symposium.* Stamford: Paul Watkins, 1992.

Hollister, C. Warren. *Monarchy, Magnates and Institutions in the Anglo-Norman World.* London: Hambledon Press, 1986.

Iser, Wolfgang. *The Act of Reading: A Theory of Aesthetic Response.* Baltimore: Johns Hopkins University Press, 1978.

Jameson, Fredric. "Metacommentary," *Publications of the Modern Language Association* 86 (1971): 9–18.

———. *The Political Unconscious.* Ithaca: Cornell University Press, 1981.

Jauss, Hans Robert. *Toward an Aesthetic of Reception.* Minneapolis: University of Minnesota Press, 1982.

———. *Untersuchungen zur mittelalterlichen Tierdichtung.* Beihefte zur Zeitschrift für romanische Philologie 100. Tübingen: Niemeyer, 1959.

John, Eric. "The *Encomium Emmae Reginae* and a Solution," *Bulletin of the John Rylands University Library* 63 (1980): 58–94.

Karras, Ruth Mazo. "The Latin Vocabulary of Illicit Sex in English Ecclesiastical Court Records," *Journal of Medieval Latin* 2 (1992): 1–17.

Kellner, Hans "As Real as It Gets, Ricoeur and Narrativity," pp. 49–66. In *Meanings in Texts and Actions: Questioning Paul Riceour,* edited by David E. Klemm and William Schweiker. Charlottesville: University of Virginia Press, 1993.

Kellogg, Robert L. "Varieties of Tradition in Medieval Narrative," pp. 120–9. In *Medieval Narrative: A Symposium,* edited by Hans Bekker Nielsen et al. Odense: Odense University Press, 1979.

Kelly, H. Ansgar. "Interpretation of Genres and by Genres in the Middle Ages," pp. 107–22. In *Interpretation: Medieval and Modern,* edited by Piero Boitani and Anna Torti. Woodbridge: D. S. Brewer, 1993.

Kermode, Frank. "Secrets and Narrative Sequence," *Critical Inquiry* 7 (1980): 83–101.

Kestner, Joseph. "Secondary Illusion: The Novel and the Spatial Arts," pp. 100–28. In *Spatial Form in Narrative,* edited by Jeffrey R. Smitten and Ann Daghistany. Ithaca: Cornell University Press, 1981.

Körner, Sten. *The Battle of Hastings, England and Europe, 1035–1066.* Lund: C. W. K. Gleerup, 1964.

LaCapra, Dominick. *History and Criticism.* Ithaca: Cornell University Press, 1985.

Lang, Berel. *The Anatomy of Philosophical Style: Literary Philosophy and the Philosophy of Literature.* Oxford: Blackwell, 1990.

Leach, Eleanor Winsor. *The Rhetoric of Space: Literary and Artistic Representations of Landscape in Republican and Augustan Rome.* Princeton: Princeton University Press, 1988.

Lepelley, René. "Contribution à l'étude des inscriptions de la Tapisserie de Bayeux," *Annales de Normandie* 14 (1964): 313–21.

Lewis, C. P. "The Early Earls of Norman England," *Anglo-Norman Studies* 13 (1990): 207–23.

Lewis, Suzanne. *Reading Images: Narrative Discourse and Reception in the Thirteenth-Century Illuminated Apocalypse.* New York: Cambridge University Press, 1995.

Loyn, H. R. *The Norman Conquest.* 3rd ed. London: Hutchinson, 1982

Martin, Wallace. *Recent Theories of Narrative.* Ithaca: Cornell University Press. 1986.

McNulty, J. Bard. "The Lady Aelfgyva in the Bayeux Tapestry," *Speculum* 55 (1980): 659–68.

The Narrative Art of the Bayeux Tapestry Master. New York: AMS Press, 1989.

Mickelsen, David. "Types of Spatial Structure in Narrative," pp. 63–78. In *Spatial Form in Narrative,* edited by Jeffrey R. Smitten and Ann Daghistany. Ithaca: Cornell University Press, 1981.

Mink, Louis O. "History and Fiction as Modes of Comprehension," *New Literary History* 1 (1969–70): 541–58.

Minnis, A. J., and A. B. Scott, *Medieval Literary Theory and Criticism, c. 1100–c. 1375: The Commentary Tradition.* Rev. ed. Oxford: Clarendon Press, 1991.

Morse, Ruth. *Truth and Convention in the Middle Ages: Rhetoric, Representation, and Reality.* Cambridge: Cambridge University Press, 1991.

Murillo, Stephen. "Hastings: An Unusual Battle," pp. 220–7. In *The Battle of Hastings: Sources and Interpretation,* edited by Stephen Murillo. Woodbridge: Boydell Press, 1996.

Needler, Howard. "The Animal Fable among Other Medieval Literary Genres," *New Literary History* 22 (1991): 423–39.

Nelson, Janet. "The Rites of the Conqueror," *Anglo-Norman Studies* 4 (1981): 117–32.

Nichols, Stephen G. "Philology in a Manuscript Culture," *Speculum* 65 (1990): 1–10. *Romanesque Signs: Early Medieval Narrative and Iconography.* New Haven: Yale University Press, 1983.

O'Brien, Patricia. "Michel Foucault's History of Culture," pp. 25–46. In *The New Cultural History,* edited by Lynn Hunt. Berkeley: University of California Press, 1989.

Ong, Walter J. "Orality, Textuality, and Medieval Textualization," *New Literary History* 16 (1984): 1–12.

Pächt, Otto. *The Rise of Pictorial Narrative in Twelfth-Century England.* Oxford: Clarendon Press, 1962.

Parisse, Michel. *La Tapisserie de Bayeux: Un documentaire du XIe siècle.* Paris: Denoel, 1983.

Parks, Ward. "The Textualization of Orality: Literary Criticism," pp. 46–61. In *Vox*

Intexta: Orality and Textuality in the Middle Ages, edited by A. N. Doane and C. B. Pasternack. Madison: University of Wisconsin Press, 1991.

Partner, Nancy F. *Serious Entertainments: The Writing of History in Twelfth-Century England.* Chicago: University of Chicago Press, 1977.

Patterson, Lee. *Negotiating the Past: The Historical Understanding of Medieval Literature.* Madison: University of Wisconsin Press, 1987.

Pizarro, Joaquin Martinez. *A Rhetoric of the Scene: Dramatic Narrative in the Early Middle Ages.* Toronto: University of Toronto Press, 1989.

Pocock, John. "The Origins of the Study of the Past," *Comparative Studies in Society and History* 4 (1962): 209–46.

Renn, Derek. "Burhgeat and Gonfanon: Two Sidelights from the Bayeux Tapestry," *Anglo-Norman Studies* 16 (1993): 175–198.

Ricoeur, Paul. *Time and Narrative.* 3 vols. Chicago: University of Chicago Press, 1984–8.

Rosmartin, Adena. *The Power of Genre.* Minneapolis: University of Minnesota Press, 1985.

Ryan, Marie-Laure. "Embedded Narratives and Tellability," *Style* 20 (1986): 319–40.

Ryding, William W. *Structure in Medieval Narrative.* The Hague: Mouton, 1971.

Schapiro, Meyer. *Words and Pictures: On the Literal and the Symbolic in the Illustration of a Text.* The Hague: Mouton, 1973.

Scheub, Harold. "Body and Image in Oral Narrative Performance," *New Literary History* 8 (1976–77): 345–67.

Searle, Eleanor. "Emma the Conqueror," pp. 281–8. In *Studies in Medieval History Presented to R. Allen Brown.* Woodbridge: Boydell Press, 1989.

Predatory Kinship and the Creation of Norman Power 840–1066. Berkeley: University of California Press, 1988.

"Women and the Legitimisation of Succession at the Norman Conquest," *Anglo-Norman Studies* 3 (1980): 159–70.

Smith, Barbara Herrnstein. "Narrative Versions, Narrative Theories," pp. 209–32. In *On Narrative,* edited by W. J. T. Mitchell. Chicago: University of Chicago Press, 1981.

On the Margins of Discourse: The Relation of Literature to Language. Chicago: University of Chicago Press, 1978.

Smith, Mary Frances. "Archbishop Stigand and the Eye of the Needle," *Anglo-Norman Studies* 16 (1993): 197–219.

Smitten, Jeffrey R. "Spatial Form and Narrative Theory," pp. 15–28. In *Spatial Form in Narrative,* edited by Jeffrey R. Smitten and Ann Daghistany. Ithaca: Cornell University Press, 1981.

Spiegel, Gabrielle. "History, Historicism, and the Social Logic of the Text in the Middle Ages," *Speculum* 65 (1990): 59–86.

Sponsler, Claire. "The Culture of the Spectator: Conformity and Resistance to Medieval Performances," *Theatre Journal* 44 (1992): 15–29.

Stafford, Pauline. "The Portrayal of Royal Women in England, Mid-Tenth to Mid-Twelfth Centuries," pp. 143–67. In *Medieval Queenship*, edited by John Carmi Parsons. New York: St. Martin's Press, 1993.

——— "Sons and Mothers: Family Politics in the Early Middle Ages," pp. 79–100. In *Medieval Women*, edited by Derek Baker. Oxford: Blackwell, 1978.

Strickland, Matthew. "Slaughter, Slavery or Ransom: The Impact of the Conquest on the Conduct of Warfare," pp. 41–59. In *England in the Eleventh Century*, edited by Carola Hicks. Stamford: Paul Watkins, 1992.

Sturges, Robert S. *Medieval Interpretation: Models of Reading in Literary Narrative 1100–1500.* Carbondale, IL: Southern Illinois University Press, 1991.

Tanner, H. J. "The Expansion of the Power and Influence of the County of Boulogne under Eustace II," *Anglo-Norman Studies* 14 (1991): 251–86.

Taylor, John. *Use of Medieval Chronicles.* London: Historical Association, 1965.

Terkla, Daniel. "Cut on the Norman Bias: Fabulous Borders and Visual Glosses in the Bayeux Tapestry," *Word & Image* 11 (1995): 264–90.

Thompkins, Jane P., ed. *Reader-Response Criticism: From Formalism to Post-Structuralism.* Baltimore: Johns Hopkins University Press, 1980.

Turner, Victor, "Social Dramas and Stories about Them," *Critical Inquiry* 7 (1980): 141–68.

Van Houts, Eliabeth M. C. "Latin Poetry and the Anglo-Norman Court 1066–1135: The *Carmen de Hastingae Proelio," Journal of Medieval History* 15 (1989): 39–62.

Vitz, Evelyn Birge. *Medieval Narrative and Modern Narratology: Subjects and Objects of Desire.* New York: New York University Press, 1989.

Werckmeister, O. K. "The Political Ideology of the Bayeux Tapestry," *Studi medievali* 17 (1976): 535–595.

White, Hayden. "The Value of Narrativity in the Representation of Reality," pp. 1–23. In *On Narrative*, edited by W. J. T. Mitchell. Chicago: University of Chicago Press, 1981.

Williams, Ann. *The English and the Norman Conquest.* Woodbridge: Boydell Press, 1995.

——— "Land and Power in the Eleventh Century: The Estates of Harold Godwinson," *Anglo-Norman Studies* 3 (1980): 171–87.

——— "Problems Connected with the English Royal Succession, 860–1066," *Anglo-Norman Studies* 1 (1978): 144–67.

Wilson, David. *The Bayeux Tapestry.* New York: Knopf, 1985.

Wissolik, Richard. "Duke William's Messengers: An 'Insoluble, Reverse-Order' Scene of the Bayeux Tapestry," *Medium Aevum* 51 (1982): 102–107.

 "The Saxon Statement: Code in the Bayeux Tapestry," *Annuale medievale* 19 (1979): 69–97.

Wittig, Susan. *Stylistic and Narrative Structures in the Middle English Romance.* Austin: University of Texas Press, 1978.

Yapp, W. Brunsdon. "Animals in Medieval Art: The Bayeux Tapestry as an Example," *Journal of Medieval History* 13 (1987): 15–73.

Zumthor, Paul. *Toward a Medieval Poetics.* Minneapolis: University of Minnesota Press, 1991.

INDEX